Why Men
Like Straight Lines
and Women
Like Polka Dots

Gender and Visual Psychology

Why Men
Like Straight Lines
and Women
Like Polka Dots

Gender and Visual Psychology

Gloria Moss

**PSYCHE
BOOKS**

Winchester, UK
Washington, USA

First published by Psyche Books, 2014
Psyche Books is an imprint of John Hunt Publishing Ltd., Laurel House, Station Approach,
Alresford, Hants, SO24 9JH, UK
office1@jhpbooks.net
www.johnhuntpublishing.com
www.psyche-books.com

For distributor details and how to order please visit the 'Ordering' section on our website.

ISBN: 978 1 84694 857 2

A CIP catalogue record for this book is available from the British Library.

Design: Lee Nash

Printed and bound by CPI Group (UK) Ltd, Croydon, CR0 4YY

We operate a distinctive and ethical publishing philosophy in all
areas of our business, from our global network of authors to
production and worldwide distribution.

CONTENTS

Acknowledgements

I am grateful to Buckinghamshire New University for giving me the time and encouragement to write this book. I would also like to thank a number of people who gave of their time to discuss the issues and whose views are contained throughout. Finally, I am immensely grateful to my colleague, Dr Helena Chance, Reader in the History and Theory design who read and commented on the book prior to its publication. She is an immensely busy person and was so generous in giving of her time and expertise in this way.

My sincere thanks also go to Cath Wright-Jones who produced illustrations 1, 3 and 4.

Part I

Different ways of seeing

Chapter I

Parallel tramlines

Beauty? To me it is a word without sense because I do not know where its meaning comes from nor where it leads to.
Pablo Picasso

Kate and William at the easel

On a summer's day early in July in 2011, Kate and William visited Los Angeles' Inner-City Arts, an organisation that promotes visual arts and performances to inner-city children. After arriving, the royal couple chatted with children from the programme, then sat down among the kids in a classroom to create their own works of art. The newly wed Duke and Duchess of Cambridge were seated at adjacent easels with their backs to each other and started painting at the same time. William painted an abstract shape with straight sides while she focused her energies on a bright red circle, enveloped by concentric circles, adding a neck and head to form a snail. Polka dots were added to the circles to create a light-hearted touch, with tufts of grass to create a natural context.

Two visions which some might take to be individual, idiosyncratic responses to a paintbrush and paint. However, earlier in the summer, Kate's sister, Pippa Middleton, set off for a weekend of fun in Madrid with friends, and she and a female friend were photographed in summer garb – she in a shoulderless dress, white with black polka dots and her friend in a grey dress with white polka dots. Then Kate herself, well into marriage and a few months short of producing royal offspring, attracted media attention in the black and white polka dot dress she wore for a trip to the Warner Brothers studios. The dress was not high fashion with a price tag of just £38, but a few weeks later she was

wearing it again to the wedding of old friends William Van Cutsem and Rosie Ruck Keene. When, a few months later, she displayed her new son to the serried ranks of the world's media, it was in a blue and white polka dot dress.

This was 2013 and I was nearing the end of a house renovation project. A must visit was to the website of the doyenne of floral prints, Cath Kidston. She has a worldwide following with 41 shops in the UK, two in Ireland, fifteen in Japan and four in Korea, and her produce is the feminine writ large with floral furnishings and accessories – including even mobile phones – and no fewer than 15 items in her catalogue decorated with polka dots. Amongst them was the "Bath Flowers Diary" with polka dots on the spine; a tape-measure bright pink with white spots; an apron; a bath mat; duvet cover; pillowcase; towels; oven glove; even luggage tag and wallet, all decorated with polka dots. Meanwhile, in the Littlewoods catalogue, in business since the 1970s, you had to stop counting the number of summer clothing items for women with polka dots. Needless to say not a single one could be found in the Littlewoods men's catalogue.

Why is this? I asked people to picture two patterns, one of stripes and one of polka dots, and asked them if they preferred one over the other. To make it easier, I asked them to picture these designs on a pair of mugs and decide which they would prefer and *why*. The people were a varied bunch – from adults at the supermarket checkout, to friends and colleagues. Of the men I talked to, seventy-five per cent preferred stripes; and of the women, sixty-five per cent preferred polka dots. Chance alone would suggest that equal numbers of men and women would be drawn to each of the two patterns so these results indicated important variations in men and women's responses.

In terms of the reasons for the choices, one man – a shelf stacker at Sainsbury supermarket who was off to China to teach English for five years – said the stripes "give the impression of being taller and more elongated than polka dots." Another man,

an Italian collecting for a children's charity, said that he definitely did not like polka dots and this sentiment was echoed by many of the other men. The most intriguing of comments came from a senior designer whose preference for stripes was explained in relation to their association with "order over chaos, class, classical, golden section, perspective, start/end, engineered – mechanical, spellbound, groove, parameters." For him, polka dots were "hard to contain, anarchic, held by tension, eternal," and while two other men did express a preference for polka dots, one was quick to say that "I'd never wear them, I'd only wear stripes."

What of women's responses? Of the nineteen women in the sample, twelve expressed a preference for polka dots. One doctoral student in psychology spoke of polka dots as "less harsh, softer and less busy and more feminine than stripes which elongate and distort space more than polka dots." A senior account manager at a PR company thought they were "more interesting because in your head you join them up to make a more interesting image." Another described polka dots as "fun, light-hearted and humorous" and able to "merge into the general background" while stripes were "in your face", "quite boring" and "remind me of prison." The principal of a ballet school preferred polka dots and found stripes "angular and visually confrontational."

As we saw, the majority of women opted for polka dots with fewer than a third opting for stripes (one of these was quick to say that she would definitely choose a mug with polka dots). So the results of this quick and dirty survey showed that the majority of men and women's choices were for stripes and polka dots respectively with a small proportion of men and women occupying the middle ground. Maybe it is this middle ground that Bridget Riley occupies with a great but not exclusive focus on straight lines and stripes. Even Damien Hirst has produced the occasional painting with polka dots although he admits that

5

he only painted five of these himself because "I couldn't be fucking arsed doing it" and he admits that in his studio "the best person who ever painted spots" was Rachel Howard.

What this book reveals

The information in this book is drawn from the fields of Psychology, Art Therapy, Fine Art, Education, Design and Marketing and it comes with a health warning. After reading it, the world will never look the same again. If you are up to this challenge, then read on.

Back in the 1990s when I started to chart the territory of men and women's visual tastes, the topic was new and the new science of perception that now unfolds will radically change the way you look at the world. One of the reviewers of an earlier book I wrote on this topic described the new information as an "uncomfortable truth" but you can judge this for yourself. Women control more than 80% of purchases and we really do need to understand whether male and female aesthetics and visual tastes, as well as what they produce, are different or not.

Charting the world of straight lines and polka dots was a journey of many years involving choppy waters since it is politically incorrect to highlight rather than debunk sex differences. Some refute the evidence and speak of stereotyping and relegating women to *kinder, küche und kirche*. This may be true for some areas of sex difference but the magnitude of the evidence available for sex differences in visual *creations* and *preferences*, plus the fact that underlying visual-spatial skills are the most robust of all cognitive sex differences after height, make it difficult to ignore the findings. Of course, while a large proportion of men and women will manifest these differences, there will be a proportion (perhaps 30%) who do not recognise these differences.

A word of caution. The evidence for the new science of perception is presented over two parts with the scientific

evidence concentrated in chapters two to four, and an exploration of anecdote and implications for marketing, architecture, fine art, gardens and relationships in chapters 5 to 10 of the second part of the book. Without giving too much away, you will find that the book reveals:

- **The hunter/gatherer visual divide between men and women**
- **How the world looks through a hunter's eyes**
- **How the world looks through a gatherer's eyes**
- **How to hit a man's visual G-spot**
- **Why men and women may disagree about visual matters**

I do hope that you enjoy the journey as these new waters come into view.

Chapter 2

Noticing the differences:
what men and women produce

The artist does not see things as they are but as he is.
Alfred Tonnellé

There is very little difference between one man and another; but what little there is, is very important.
William James

The burning question

The journey into men and women's visual tastes began one hot summer's Sunday, after a heavy morning of classical landscapes at the Royal Academy gallery in London. The lure of seeing paintings that were brighter and lighter in mood took me to the Annual Exhibition of the Institute of Painters in Water Colours in the Mall, just down the road from Buckingham Palace. This time, all the paintings were available for sale and, with yet another expensive catalogue on offer, it seemed prudent to jot down the numbers of the paintings that struck a chord and then sneak a look at the price in the catalogue at the desk. The person at the desk did not seem to mind; and after entering the names of the artist, it became clear that eighty per cent of the names on the list were women's. Meanwhile, a quick flick through the catalogue revealed that most of the paintings in the exhibition were by men. You don't have to have a degree in statistics to realise that selecting an almost entirely all-female list when most of the paintings in the exhibition are by men is pretty freakish.

It immediately raises two questions one of which relates to whether men and women actually *produce* different kinds of paintings and whether they *prefer* different kinds of visual

artefacts. In fact, a quick glance around the exhibition area revealed something that had not crossed my mind before, namely that men and women's paintings differ in terms of their use of detail, colour, perspective and theme. There were books *galore* on gender differences with *Men are from Mars, Women are from Venus* setting the tone by focusing on men and women's emotional differences and it was fair to assume that there would also be column inches exploring gender differences in visual tastes. However, when I first began to look into this in the 1990s, lengthy searches in libraries and online brought up virtually no research comparing men and women's visual sensibilities.

This gap seemed extraordinary. If other women reacted as I did and if men were to prefer men's visual work, then the implications for the visual world would be nothing short of revolutionary. Think of it. The world's wealthiest living artist, Damien Hirst – famous for his sheep in formaldehyde and live maggots and cow's head – may owe his fame to the fact that the scions of the art establishment are men, a sex apparently drawn to violence and death, even in art. The implications would be immense also for the design and marketing industries which are staffed heavily by men and yet targeting a market consisting largely of women. If men and women produced and liked very different kinds of visuals, how easily could it possibly be for men to second guess women's preferences? The experience at the exhibition of watercolours planted a seed and a few days later, the *Evening Standard* newspaper in London carried an article that helped keep these questions firmly in mind.

The article focused on a female-only script called NuShu discovered in a fertile valley in Southern Hunan, in China. This script was created and used by young women in rural communities who, like other women in traditional Chinese culture and unlike men, were not allowed access to formal education and not taught to read and write Chinese. A system of bound feet and social strictures confined women to their husband's homes after

marriage, but somehow the women in the south-western corner of Hunan province created their own script and way of communicating and liberating themselves from illiteracy.

NuShu literally means 'woman's writing' and while some of the characters are original, some are based on those used in *Hanzi*, the standard Mandarin Chinese language. This is the language that the men of the community could read and write, and one theory is that women created NuShu in the course of memorising the Hanzi script that they saw, simplifying and changing the characters to suit their own style. Intriguingly, whereas Hanzi has square shapes and straight lines, NuShu only used curvy lines. "Is it conceivable," I wondered, "that the differences in these scripts are further examples of differences in the visual creations of men and women?" The drive to find an answer demanded some urgent action.

The first step was to organise interviews with people in the visual world. The first of these was with a London design consultancy where I was able to talk to two designers. Both were asked whether men and women designed differently and the former teacher, after a pause, recalled how "boys liked drawing lines even on brochures and other things when they were not needed." The second designer who had spent their career in commercial design described the tendency for "the male designer to use more straight lines than the female one." A trend seemed to be emerging which provided the impetus to forty interviews in total.

A particularly memorable one was with a lecturer in Product Design at a university not far from London. She was a jeweller herself who had gravitated to the visual arts after discovering that she was dyslexic, and she spoke with animation about a project for pre-degree students to construct a hat from natural objects: "The boys' hats were all highly constructed, all made with twigs and therefore more angular than those of the girls. These, on the other hand, were made with leaves, flower, moss and berries and therefore more organic in shape." The parallel

tramlines were there again and the mounting evidence kept my motivation levels high as I reached out to speak to more people.

Detail

One chat with a designer at a top US design agency took things in a new direction. "Women are more likely to be interested in detail than men," he said and this remark came at around the same time that I had a conversation with Professor Penny Sparke, well-known design historian and now Pro Vice-Chancellor at Kingston University. Not shy of controversy, she remarked that the modernist tradition that underpins today's design teaching "rejects everything identifiable with the feminine such as decoration and display."

At about this time, I attended an annual food exhibition in the Midlands, and walking around noticed a brightly painted gas cooker that was light years away from the 'white goods' available then. It turned out that this cooker had been painted to match the winning entry of a children's colouring competition organised by New World Cookers, the largest supplier of freestanding gas cookers in the world. The competition was open to primary school-age children (i.e. children under the age of eleven) and run in eleven local newspapers so there were large numbers of entries. It would be a researcher's dream to get their hands on this sample!

Fortunately, New World Cookers were happy to allow access to samples from the regions with the greatest gender balance, producing 204 entries, 90 from boys and 114 from girls. This was a researcher's dream. The sample was large and the children had freedom to express themselves in the way they applied colour to the shape provided. It became apparent that there were six ways in which colour could be applied:

- The square shape at the bottom of the oven could be coloured in with a single colour or coloured in using more than one colour.

- The handle of the cooker could be coloured in with the same colour as the surround or coloured in with a different colour.
- The switches could be coloured in with a single colour or coloured in using more than one colour.
- The "New World" logo could be coloured in with a single colour or coloured in using more than one colour.
- The switches at the bottom of the cooker could be coloured in with the same colour as the surround or coloured in with a different colour from the surround.

Analysing the way colour had been used was an entirely objective process (running through the exercise twice helped guarantee accuracy); and after a couple of hours, some unexpected differences emerged. The girls, for example, were much more likely to use separate colours for the knobs, the handle and the surround of the oven door with the chances of the results occurring by chance being no more than 10%.

Of course, willingness to accept this conclusion rests on believing that the differences reveal the intuitive responses of boys and girls and I was later to find that people are not universally minded to do this. However, it is worth noting that a study of 1451 children's drawings by academic Elizabeth Hurlock in the 1940s found that 20% of the girls' but only 1% of the boys' drawings showed the use of patterns. These studies are good preliminary evidence of a taste for pattern and detail, elements that are difficult to explain through social factors alone.

Technicality

A few weeks later, a visit to two museums, first the Crafts Council Gallery and then the Design Museum in London, was to enter two exciting but separate worlds. In the Crafts Council Gallery, most of the exhibits were by women while the bulk of what was on display in the Design Museum were machined

objects by men. To put it baldly, it appeared that the term 'design' was reserved for objects that men liked creating – largely machined objects – while the term 'craft' was bestowed on handcrafted work, much of it as far as the Gallery was concerned textile crafts, an area dominated by women.

Interestingly in an interview with design historian Professor Penny Sparke, she agreed that the current boundaries of design reflected masculine interests. In her opinion, modern design is underpinned by modernism which is masculine "insofar as it based on an appreciation of the machine aesthetic." Not long after this conversation, I had coffee with a professional designer who described men as interested in subjects with a "mechanical basis", a view on which I received interesting insights a few weeks later during a visit to Hasbro, one of the largest toy makers in the world, headquartered in Pawtucket, Rhode Island.

My visit was to the UK Headquarters and after a challenging time finding the firm (its proximity to Heathrow airport presents the driver with a maze of overpasses to be read at great speed!), I was happy to sink into a chair and sip coffee with the designer responsible for the one-time rival to Barbie, Sindy doll, now produced by Pedigree Toys. Much of our conversation focused on the research that the company had conducted into boys' and girls' patterns of play, but she also discussed design issues. My ears pricked up when she mentioned the initiatives of a male designer who had taken over from a female colleague. "He decided to add a special dial on the doll's motorbike." She was not surprised since, in her view, "male designers are techno-oriented" and "gadget-oriented". In subsequent research, I discovered that a technical edge to design is much more evident in male than female-produced design. So, if the designation 'design' is given to work that is technical in appearance, and 'craft' to work that is non-technical in appearance, it is not surprising that design is linked more to men, and craft to women. In a male-dominated discipline like design, men will set

the parameters according to what they are good at and so this was an important discovery. More were to come with my own attempts at craftwork when I saw a class advertised for a papier mâché class at the local arts centre.

Function

It was the summer, and applying wet paper to objects for a week and then applying paint seemed like a fun thing to do. Like all the other women on the course, I had decided to make a bowl and was delighted with the dainty blue object I produced, decorated with a circular frieze of bright yellow fish. One of the men in the group had produced a slate grey vase with no decoration and a lot of angularity and when he saw my bowl, his only comment was "But what's it for?" Strangely, I had not given any thought to its function, only to its aesthetic appeal.

Was this quirkiness on my part? It seemed not. One university teacher of product design said that: "Males are interested in the way something functions. Women, by contrast, react to the experience of the object. They seem to be aware of the experience of the object, not the implications of it. For them, it's their reactions that count." She went on to describe a project carried out by novice students asked to create a hat from natural objects. "The boys were concerned largely with the functionality of the hat, ensuring that it stayed on the head and did not fall down, while the girls were more concerned with the look of the hat – whether it was pretty and decorative."

Another female designer thought that the emphasis on functionality rather than styling had influenced design education in the 1990s when she had studied: "Styling is seen as the poor end of product design and if you started to play with shape, you were made to feel guilty about it – at Art College, styling is a bad word." She thought that women were losing out since they were more interested in styling than men – "were a course to concentrate on styling," she said, "a greater number of women would be

drawn to product design courses."

This was all very reassuring as far as my papier mâché bowl was concerned. A large American study of 31,000 drawings by McCarty in 1937 provided the ultimate certainty that my attitude to bowl-making was not off the wall. For McCarty concluded that the girls' drawings "tended toward the aesthetic" while the boys' "tended toward the mechanical or scientific aspects of life" (more on this study below). Meanwhile, it was back to more interviews.

Three-dimensions

One of the most memorable interviews was with an established designer in London's Covent Garden, an artistic area that is home to Britain's Royal Opera House. After climbing the winding stairs to her office, the designer showed me her designs with the hallmark motif of tiny red hearts. Over a cup of tea, she volunteered that she always drew in 2-D and added shadows "after the event to provide an illusion of three-dimensionality." She added that many men were more at ease with drawing three dimensions than women and that she considered herself to be one of these.

Her thoughts were in fact in line with the results of two studies separated by both geography and by time. The first, by Kerschensteiner in Germany in 1905, compared boys' and girls' drawings and produced the interesting finding that boys' drawings were more realistic than the girls'. Then, the Japanese study headed by Iijima in 2001 found that the boys were more likely than the girls to draw motifs arranged in piles, three-dimensionally or from a bird's eye view (more on these studies below). So, while the boys favoured the realistic portrayals of objects, the girls preferred less realism, and favoured organising subjects in rows. Later, we will see (Chapter 4) the evidence for strong spatial rotation skills in men and this may be an important factor in these differences.

The interviews with designers and fine artists were now

complete and, with forty behind me, it was time to take stock. Did they think that there were differences between the designs produced by men and women? Only one considered that there were no differences, and a further ten (equivalent to 25%) either had no views or were undecided. Of the 29 people remaining – a massive 73% of those interviewed – all thought that there were differences between the visual creations of men and women. Interestingly, many of the differences discussed echoed differences identified in the studies comparing children's and young people's drawings. So common themes related to the male and female use of straight vs. round lines; their relative emphasis on three-dimensionality and functionality and in terms of underpinning themes, the depiction of males vs. females and reference to inanimate or animate subject matter.

All of this suggested that something important was at work here but there had been no systematic attempt to examine the differences and seek out underlying factors. Nor had there been any attempt to examine preferences, and so no way of finding out if my experience at the Gallery was typical or not. So, there was only one consequence and that was to continue with the work in a systematic and scientific way. Design would be my main focus with a first phase looking at *creations* and a second phase looking at *preferences*.

Having an idea is all well and good, but how do you actually compare male and female-produced designs? An obvious way is tracking down samples of student work in art colleges and being based in a capital city was a big advantage since it brings many colleges into the frame. It was not long before I was told of a student project to design a box of luxury chocolates. The students were all doing a foundation year degree – this is excellent since they have not been exposed to three years of art school yet – and by some quirk of fate, there were equal numbers of men and women in the group. What would a comparison of their designs reveal?

Linearity

Although the men and the women were working to exactly the same brief, a detailed analysis of the designs revealed strong divergences in the designs of the men and women. For example, the men's boxes tended to be square or rectangular while the women's were all round or oval-shaped. Again, the men's chocolate boxes had a three-dimensional look to them while the women's all had a flat, two-dimensional appearance. Amazingly, a statistical analysis was completed comparing them; the differences between the genders were off the scale statistically speaking. The chances of the results occurring by chance were one in a thousand, so this was as robust a finding as you could expect from an experiment.

So decisive were the results (in fact, you can find more details later on in the chapter) that I asked the students to design a second box but this time, after detailed briefing on the attributes of male and female-typical design, to design as if they were the other gender. So the students were told of the tendency for men and women to use quite distinct design features: straight vs. rounded lines; 3-D vs. 2-D images; regular vs. irregular typeface; little vs. extensive detailing. The students seemed to acknowledge the differences and the week dragged by slowly in expectation of seeing what the students would produce.

D-day for seeing the new designs arrived and each student unveiled their new design. One of the men whose first box had been octagonal in shape now revealed a new design with exactly the same shape – clearly the allure of a straight-sided shape was irresistible! Then one of the women unveiled a drawing of a triangular-shaped box with the 3-dimensional aspect completely out of kilter. True, she had shed her original round shape but her design was anything but convincing. This was intriguing. Although this was an informal experiment with a small sample size, it suggested that young men and women are drawn to certain shapes and resist moving away from them. Of course, only carefully

constructed experiments could prove this but this was a decisive moment which made me decide to study the topic in earnest.

Later, through my own research, I was to discover men's love affair with straight lines and women with curvy ones, but meanwhile it was time to see more student work. Various features stood out and these are signposted in italics before the heading to each section.

Surfaces

Doing the rounds of student end of year graduation shows was another good way of entering the world of the male and female imagination. One year, Nathalie, a design graduate, stood proudly by the lampshade she had created with real leaves etched into the cotton shade. It had a feminine feel to it although the metal stand looked curiously out of place and unusually long. It turned out that Nathalie hadn't made this herself, but had asked a fellow male student who was skilled at metal work to fashion it for her. Nathalie was not very happy with it – "The base is taller than I would have liked," she said but a wry smile crossed her face as she spoke of her shade. "But I am really happy with the textured shade," she said.

Now, if you think about the mass-produced lampshades you find in most shops, they all tend to have hard rather than soft surfaces. In fact, a designer, Julie, once confided in me that: "women like to work with soft materials and for this reason are drawn to certain crafts such as sewing, knitting, quilting and weaving." What about men? According to Julie, their work is "more precise and hard-edged" informed by the view that "noble steel is OK." So, little reason to be surprised by the use of metal in the base, and the extreme elongation is not surprising either. Why say this? In 1937, the psychologist Erik Erikson invited 150 children to arrange blocks on a table and he found that the boys tended to build upwardly pointing towers while the girls built low, circular structures.

An isolated case? In 1948 some researchers, Franck and Rosen, asked 250 university students to complete the small, abstract shapes that they were given and the men, unlike the women, tended to build shapes up and to elaborate outwards rather than inwards (more on this study later in Chapter 7). So you can see the tendency to elongation coming up here as well. It was time to move on to another graduation show.

Size

The next graduation show on the calendar was an enormous one bringing together new design graduates from universities and colleges right across Britain, all displaying their work and hopeful of landing interest from industry. I started to take business cards from students in order to follow-up on their work and then realised that here, in the exhibition hall, was an opportunity to take a large number of cards with a view to comparing the male and female ones at a later stage. I scooped up a remarkable 227 cards and, after seeing everything I wanted, took my spoils back to my office. In total, there were 83 cards by men and 144 by women and the task of comparing them could begin immediately.

The first set of findings was checked and rechecked before going off to get a cup of coffee to mull over the results. The results related to the size of cards and there was no doubt that there were striking statistical differences on both. Where size was concerned, the men, it seemed, were significantly more likely than the women to adapt the standard size of business card (90 x 55 cm) and the women much more likely to vary the size in one of three ways:

- producing cards with overall smaller or larger dimensions
- increasing the width relative to the height, thus creating a card which was squarer in appearance
- using circles, or other unconventional shapes (for example, a lemon shape)

These were interesting findings and it was time to return to the office for more calculations.

Colour

This time, the area tested was colour and comparing the colour card used by the men and the women. Like the assessment of shape, the assessment of colour is pretty straightforward and another result soon emerged: there were statistically significant differences in colour card used by the men and women with the men much more likely than the women to use white card, and the women to use coloured card. These findings on the cards were later written up with Andrew Colman, well-known Professor of Psychology at Leicester University and writer of many academic as well as popular books on psychology.

Meanwhile, my decision to work full-time on research took me to the University of South Wales (formerly the University of Glamorgan) where there were some dedicated researchers. I used to share an office with Dr Gabor Horvath, Senior Lecturer in Marketing and International Business and during one of our discussions his wife Esther Vass arrived and decided to base her thesis on an element of gender and design. Eventually, she focused on a comparison of men and women's sellers' sites on eBay.

In many ways, the choice of eBay was an excellent one given the breadth of product range and the size of its advertising population. In terms of reach, this is the only shopping facility that will sell you a watch as well as a private business jet – one was sold for $4.9 million – and it carries a huge volume of adverts. This is what you would expect from one of the world's largest online marketplaces, a presence in 37 countries and 233 million registered users, the same number as the population of America. In the end, after a lot of thought, Esther decided to compare the adverts individuals had created for boys' clothes (where 90% of advertisers are female) with those for fishing rods

and king size beds (where 15% and 30% respectively of adver-
tisers are male) and see whether their adverts differed on dimen-
sions such as colour.

In all, she compared 150 sellers' sites, a respectable sample
size, and found that 80% of the men's ads used only black or
blue; while more than 50% of the women's ads used more colours
and 10% contained at least eight colours! Another difference,
but not relating to colour, concerned the greater conventionality
in the text layout and typefaces of the male sellers. So it seems
that the women were much more drawn to using colours than
men.

These findings were no flash in the pan. In 2001, that Japanese
study conducted by researchers, including the lead researcher,
Iijima, at a medical school, compared the drawings of 168 boys
and 160 girls. One of the findings was that the boys used fewer
than six colours while the girls used more than ten. Merely
idiosyncrasies with children and students? One female designer
I interviewed in a central London design consultancy said that
male colleagues often borrowed her sense of colour: "They often
get this wrong and I step in to help." We will see more in Chapter
4 some of the exciting new findings in science that may underpin
this.

Incidentally, Gabor decided to conduct research in parallel on
web design software, examining 3682 free templates and
analysing the look of the website pro formas. He found that
99.6% of the templates used only 2–3 colours for the background
and only 6% of the websites offered up to four typeface colours.
As far as shapes were concerned (you will remember that
straight and curvy lines were associated with men and women's
designs respectively), he found that 84% of the software offered
the option of straight lines with only 15% offering a mixture of
straight and non-straight lines. These were striking findings and
Gabor presented these at an IT conference in Florida in July 2007
that we attended. This was one of several fascinating papers I

was chairing in a session on computer-based marketing and we escaped to Disney World on our two free days. It was hard work in over 100 degrees of heat and high humidity but definitely worth it!

So far, the comparisons of men and women's work had revealed differences in the 'look' of the design, whether in their shape, colour, size, functionality or three-dimensionality. An opportunity to sit in on the final session of a university class on model making was an exciting one since there was the opportunity to observe how men and women treated a single theme, namely that of space travel.

Themes

The model-making students were sitting expectantly as they waited for the tutor to arrive and get proceedings underway. The brief had been to design a model spacecraft; and in this final session, the students presented the finished models that they had been working on in groups all term. Three of them were all-male groups and the fourth consisted of women, the last one to present their model to the class.

The first three groups had all designed rockets, technological marvels hurtling through space in order to vanquish enemy aliens. If you had to sum up the common themes of these all-male groups it would be speed, technical *panache* and military prowess, and there were indeed a very impressive set of rockets. Then, finally, it was the turn of the all-female group and just when you might have been expecting something similar, they unveiled their patchwork-covered rocket, manned by a team of mice, with a mission of collecting cheese from the moon. Whereas the men's machines had all been hurtling through space at breathtaking speeds, this one was still on the ground, resolutely stationary.

We should not be surprised that the women's rocket was not moving. We looked briefly earlier at the 2001 Japanese study that

compared boys' and girls' drawings and this came up with the fascinating discovery that 92.4% of the boys' drawings, but only 4.6% of the girls' included moving objects such as vehicles, trains, aircraft and rockets. From a statistical point of view, this difference in creative output is *highly* significant and unlikely to be the result of chance alone.

Speaking of creative outputs, you might like to pause for a few moments while you produce a drawing yourself! All you need is a piece of unlined paper and pencil with which to draw a matchstick figure – we're not looking for great works of art – and take care to ensure that the person has hair, clothes and a name. Once you have completed your sketch, put it to one side and read on.

In the 1970s, Maria Majewski wrote a PhD thesis comparing boys' and girls' drawings and one of her findings was that each sex tended to draw people of their own gender (more on her study below!). She is by no means the first person to have discovered this since the exercise of drawing a person has produced this result many times. For example, in a test administered to 5,500 adults in the 1950s, a massive 89% drew a figure of someone of their own sex first. This it seems is the norm. In my book *Gender, Design and Marketing*, I list ten other studies in which own-sex figures were produced, one of these by a researcher Jolles in 1952 involving 2,560 subjects. This is a large sample, and 85% of the males and 80% of the females depicted someone of their own gender in the first instance.

So now take a look at your drawing and see if you can infer the gender of the figure you have drawn. In all likelihood, it will be the same sex as yourself since own-sex figures are produced about 70–80% of the time in the 'Draw a Person' Test. By the way, don't worry if your figure shows the opposite gender – there are straightforward explanations for this as you will see if you look at Hammer's book on projective drawings. As with much else about visual creations and preferences, trends in

gender productions tend to relate to around 75% of men or women leaving room for different responses from the remaining twenty-five per cent. It is essential that we allow for individual responses and this presumption underlies all the generalisations made in this book. There will always be exceptions and it is vital to acknowledge that.

Despite that, the substantial evidence on the 'Draw a Person' test shows that the majority of people draw someone of their own gender. In fact, this tendency explains much about the way that visual creations, for example a design or a doodle, bear the imprint of those who have created them. Spontaneous visual creations of this kind are akin to X-ray images of their creators, reflecting personality, self-image and unique visuospatial skills. Not surprising then that Alfred Tonnellé described the process of drawing and designing as one of projection in which the artist sees things not as they are but as he or she is. How would this manifest? Well, the person depicted by a confident person might take up a lot of space on the page, while a smaller figure might be depicted by someone with less confidence. In a similar way, the figure depicted by someone with a poor body image may only show part of the body.

The first time that you see this happening is very exciting. I remember asking a friend's mother to do the 'Draw a Person' test and was particularly intrigued to see what her drawing would be like. The mother was a kind and sincere person, and on the many occasions in which I visited her house she was always wearing a rather drab kitchen overall. It made no difference whether you visited at the weekend, weekday or evening, this overall would conceal the clothes underneath. One day, I handed her a blank piece of paper and pencil and asked her if she would like to draw a person. What happened next was astonishing for she simply drew the head and shoulders of a woman, with the usual presence of the rest of the body excluded. This suggested in a powerful way that as far as this woman was concerned, the rest

of her physical self was unimportant.

You can see from this why some people hold the view that drawings are projections of their creators, leading to the view that you can learn something about other people by taking the simple step of asking them to draw a person. Drawing is a form of self-mirroring and if you trust in the evidence from psychology of gender differences in emotions and aggression, you can understand one of the elements that underpin some of the differences in men and women's visual creations. Of course, commercial designers and architects may be more constrained than fine artists to 'cover up' their natural impulse in an effort to follow the brief, but personal factors are still likely to shine through.

"But," you say, "surely the 'Draw a Person' Test results are misleading? It is not true that men have a greater tendency to draw men than women; think of fine arts and the legions of male painters who have used women as their subject." Well, back in the 1990s when I started research on this topic, I visited the National Gallery with a scientist friend, Dr Rupert Lee, now Head of the Science, Technology and Medicine Search department of the British Library. He was intrigued by much of the research, including the question of whether men really depict more men than women. Did this not fly in the face of the common perception that men's paintings are full of beautiful women!

So, while at the British Library, Rupert conducted a quick experiment in the seventeenth century galleries to ascertain the balance of male and female figures in the 195 male-produced paintings. If you read about the period, the art is described as having "energy", "drama" and "movement" and some of these elements are visible in some of the larger-than-life paintings featuring naked women. Velásquez's famous *Rokeby Venus* depicts the exquisitely curved and undulating back of a supine figure while Guido Reni's *Perseus and Andromeda* features

Andromeda, chained to a rock and arms raised in dismay, with only the flimsiest piece of cloth concealing her nether regions. This degree of female immodesty characterises also the painting of Diana surprised by a satyr, attributed to a follower of Rembrandt, and this delight in displaying the female form might be thought to buck the trend where depicting own-sex figures are concerned.

What did Rupert find in this piece of quick and dirty research? Excluding paintings with more than ten figures, he found that 55% of the paintings were those in which male figures outnumbered females; just 23% were those in which female figures outnumbered male ones, and 21% had equal proportions of male and female figures. When Rupert calculated the total number of male figures, there were a massive 433 male figures compared to just 216 female figures. These figures came as a big surprise and appeared to confirm the tendency to own-sex depiction. Of course, this was only a quick survey in a small part of the collection but the results yielded ran counter to what many people might assume.

Meanwhile, there was the interesting question as to what people liked and the role of gender in this.

$64,000 question: what of preferences?

So far, our focus has been on visual creations and the evidence for divergence in those produced by men and women. The $64,000 question of course relates to preferences and how men and women react to the visual forms that are typically male or female. Are men and women's reactions likely to be similar or different? This was the question prompted by my experience at the Mall Galleries (remember how most of the paintings on my shortlist were by women?) and a vital one since women make around 83% of buying decisions. Currently, in many parts of the developed world, a very high proportion of designs and advertising are produced by men, and if women generally preferred designs by

men, then the *status quo* situation would be optimal. If, however, women preferred designs produced by women, then the current demographics are likely to be suboptimal in terms of maximising preferences.

Moreover, the implications would not stop at purchasing but would extend to all those situations in which visual experts sit in judgement on other people's visual creations. Whether it was prestigious art and advertising competitions, art and design exams, hanging committees or even recruitment and promotion panels for designers, all could be affected by bias in people's preferences. Of course, we would not be speaking here of conscious biases but of unconscious impulses, way beyond most people's awareness. We will follow up on the all-important question of preferences in the next chapter, and will present groundbreaking research that provides us with answers for the first time ever.

Meanwhile, before moving on to that, you might be might be asking yourself what we mean by 'design' and whether what we say about graphic design might also apply equally to other visual forms such as drawings and paintings, buildings and interiors. This is such an important question that we will look at the relationship of these visual forms next. Then, as promised, we will move on to the fascinating question of preferences.

Design and Painting: sister arts?

If you look at the website of the Museum of Modern Art (MoMa) in New York, a museum with the mission of being "the foremost museum of modern art in the world" (http://www.moma.org/about_moma/), you will see that their vast collection includes paintings, sculptures, drawings, photographs, architectural models and design objects. This means that salt and pepper cellars are under the same roof as paintings by Monet and Van Gogh. Does this imply that they are sister arts?

In fact, many respected authorities see no real grounds for

keeping the two disciplines separate. Sir Herbert Read, for example, former Professor of Fine Art at Edinburgh University, in his book *Art and Industry*, claims that the distinction between "fine art" and "applied art" is largely the creation of the machine age and did not exist earlier on. He points out that in pre-Renaissance times no distinctions were made between architecture, sculpture, painting, music and poetry, and in classical Greece only one word "techne" was used for many kinds of art. His conclusion is that the utilitarian arts (objects designed primarily for use) appeal as much to our aesthetic sensibilities as fine art.

His book *Art and Industry* was written in 1934 and you might imagine that thinking on this topic had changed since then. However, an American academic, Richard Buchanan, until 2008 Professor of Design and Head of the department of Design at Carnegie Mellon University, and now Chair and Professor of Design at Case Western Reserve University, pitched in on the debate. His argument is that there is no contradiction between design as something practical and something that appeals to our sense of aesthetic beauty. By way of example, he cites Leonardo da Vinci's speculations on mechanical devices as just another expression of his broad poetic and visual imagination. He also reminds us that marketing departments will tell their designers that style and the appearance of products is as critical to success as how well they perform.

Buchanan's views may not appeal to those who like to make a sharp distinction between emotional and instinctive thinking (which they may think inspires Fine Art) and rational and conscious thought (which they may think inspires Design). However, while most designers will be more constrained than fine artists, a detailed design brief does not stop designers from producing a highly individual, instinctual response. Consider, for example, the work of the celebrity designer Philippe Starck who recently redesigned the computer mouse. He separated the left from the right side with a red line and in so doing put his

own stamp and artistry on the product.

The fact that design is a creative act should not surprise us. Think about the process of learning to write for example. Do you remember the letters that you had to trace and copy? If you were brought up in America, these would have been quite loopy, while in Britain it would have been the chunky Marion Richardson copybook and in France distinctive r's and s's. Despite this heavy programming, chances are that your writing is completely different from what you were taught at school, and something that is individual to yourself. In fact, if you still have any doubts as to the individuality of your handwriting, just think of your signature. So unmistakable a proof of your individuality is it, it is often all that is required to authenticate a legal document or transaction.

So you can see how the design process can involve just as much self-expression as painting. "But isn't design a team process?" you might ask. Some of the time, yes, it is, but this is no different from artistic practices from Medieval times through to the Renaissance when it was common for *objets d'art* to be produced by teams of people. Of course, the master painter put his name to the work but he was often just the lead person in the workshop. Ghiberti, Botticelli, Raphael, Giovanni Bellini, Titian, Tintoretto, Veronese, and the Carracci brothers are all painters who presided over busy workshops in which other artists helped complete the work. Knowing this may shatter illusions about the creativity of the lone genius but you have only to think of modern sculpture and installation art to see this practice continuing into the present day.

The interconnectedness of visual forms meant that if you wanted to get to the bottom of whether men and women's visual aesthetics differed you could draw on studies conducted in a range of graphic fields including painting, drawing and design. This was helpful since I had come across a cache of studies comparing the drawings of boys and girls and other young

people, some of which have been briefly alluded to earlier. The results reported across a range of countries had never been brought together before, and the weight of this body of studies encouraged me to conduct experiments of my own. So important is this evidence that more details follow but if you feel that you have read enough to convince you, you can skip to the next chapter where we consider the $64,000 question of what men and women like in the way of design. Meanwhile, those hungry for more information on the evidence comparing drawings and designs by males and females should read on!

Studies on form, colour and themes

Much of the early work comparing male and female drawings focused on the shapes and colours that they used. One of the first studies, in the early years of the nineteenth century, was by Albert Kerschensteiner who compared the drawings of boys and girls in Germany, interested in finding out the extent to which the boys and girls captured the quality of realism in their pictures and what he found was quite interesting. On a measure of "true to appearance", he found that the boys insisted on far greater realism than the girls. Albert also noticed that the girls were more likely to avoid perspective than the boys and produced more "primitive" looking pictures. So you can understand now why you might have fought tooth and nail with your partner as to which picture to choose!

The first of these studies was by Paul Ballard and dates back to pre-First World War days, in 1912. He examined no fewer than 20,000 drawings by London children aged three to fifteen and found important differences in the subject matter that the boys and girls chose. Thus, twice as many boys as girls aged six to ten drew ships, and girls aged seven to fifteen were much more likely to draw plants than boys; a large 36% of girls' drawings were of plants compared with only 16% of the boys'.

Could the male love affair with ships explain a former

colleague's obsession with models of ships? This was the manager in charge of a massive chemical plant who spent much of his spare time constructing intricate models of ships. All food for thought.

The next major study, in 1924, was by Susan McCarty in the US and analysed an even larger sample of drawings. This study, mentioned earlier, had an enormous sample with 31,000 drawings from children aged four to eight, and big differences emerged between the themes selected by the two genders. The boys, predictably, were more interested in vehicles than the girls, while the girls were more interested in flowers, furniture, household objects and design. McCarty summed it up: "The girls tended toward the aesthetic," she said, whereas "the boys tended toward the mechanical or scientific aspects of life."

Just over ten years later is the fascinating experiment conducted by the famous psychologist Erik Erikson at Yale University in 1937. He set up a play table with blocks and a random selection of toys and invited the boys and girls to imagine that the table was a film studio and the toys actors and sets. He asked about 150 pre-adolescent children to construct an exciting scene on the table. In all, about 450 scenes were constructed. Erikson found (although he did not quantify his results) that there were distinctive differences in the way that the boys and girls arranged the blocks. He described these as follows:

Males: built towers and structures pointing upwards. They emphasised the exterior elaboration of buildings and rarely focused on enclosing space or representing people inside houses.
Females: built low, circular structures and emphasised the openness and peacefulness of house interiors.

Next in the pile was a 1943 study, again from America, by Elizabeth Hurlock of the Department of Psychology, Columbia

University. She had examined the drawings of children and adolescents aged 15–20 and had used an interesting methodology, taking the drawings produced spontaneously, and not under the direction of a teacher.

From the sample of 462 drawings, she found big differences in the use of human figures and caricatures with 365 of the girls' drawings featuring the human figure and only 18% of the boys'; much more popular with the boys was using caricature which appeared in 33% of their drawings and just 2% of the girls'. Predictably, the majority of the boys' caricatures showed male figures with only 7% of the boys' drawings showing the female figure.

Three other big differences emerged from Elizabeth Hurlock's study. The first of these concerned the use of the printed word and the fact that 30% of the boys' drawings used the printed word as compared with just 19% of the girls'. Where they did use the printed word, the girls tended to ornament their lettering more than the boys, while the boys "attempted to print letters with a precision and accuracy that suggested duplicating the work of a professional." The final difference, referred to earlier, concerns the girls' tendency to create geometric figures and stereotyped patterns, something appearing in 23% of the girls' drawings but only 1% of the boys. These are all fascinating differences many of which I have observed in comparisons of male and female-designed websites!

Surprisingly, interest in comparing male and female work waned until the late 1970s when a PhD thesis appeared which we referred to briefly earlier. The author, Maria Majewski, examined the relationship between the drawing characteristics of children and their sex. She chose 121 children from the first, fourth and seventh grades, and arranged for their drawings to be rated against 31 characteristics. Of these 31 characteristics, statistically significant differences emerged on nine, and although this may seem a small number, the differences occur again and again in

previous and subsequent studies. For example, Majewski found that the environment was a more central concern in the girls' drawings than in the boys'. She also found that girls tended to depict other females while the boys depicted other males.

A final but important difference related to the shape of the lines in the children's work, and whether they were rectilinear (based on straight lines and angles) or curvy. Importantly, Majewski found a statistically significant tendency for divergence at all three grades with the girls preferring circular shapes and the boys rectilinear ones. So, next time you and your partner disagree on whether to get a round loo seat (amazingly some clever designer has produced a rectangular one), or whether to blow your lottery winnings on a Bauhaus building or chateau with turrets, think back to Majewski's work and see if the shapes found in your preferred object fit into her findings.

Statistical significance is a test used by scientists all over the world to check whether the results of an experiment could have simply arisen just by chance. If an experiment is said to show statistically significant differences this means that the results are highly unlikely to be accidental, and important conclusions can be drawn. Scientists also distinguish between high and low levels of statistical significance, giving different levels of certainty about the results.

Incidentally, in case you were thinking that studies of drawings and paintings are limited to the Western world, you may remember that a study was carried out in Japan in 2001. This was led by Megumi Iijima of the Department of Paediatrics at the Juntendo University School of Medicine in Tokyo and she was joined by three academic colleagues. Their studies offer fascinating parallels to the Western studies of children's drawings we

have looked at.

One of their studies examined the free drawings of 168 boys and 160 girls (also aged five to six) and compared the organising features of the drawing compositions. The results showed that the most common compositional device used by 74.4% of the girls' was to arrange motifs in a row on the same plane, a device used by only 20.4% of the boys. They were much more likely to draw motifs arranged either in piles, three-dimensionally or from a bird's eye view. Using pile or bird's eye view arrangements was found to be an "exceptional" occurrence in the girls' drawings.

In another study, a comparison was made of the extent to which different colour crayons were used up over a period of six months! The colour crayons used by 146 girls and 143 boys aged 5–6 were compared and the results showed that the only colours the boys used up more frequently than girls were grey and blue. Girls, on the other hand, used up warm colours like red and pink to a noticeably greater extent than the boys. For example, the girls used up 10 millimetres of pink as compared with the boys' 3.5, while the girls used up 15 millimetres of red as against the boys' 10 millimetres.

These findings back up an earlier study by one of the authors (Minimato, 1985) showing the extent to which girls use warmer colours (pink and red) and boys cooler colours (blue and green). Megumi Iijima and her co-authors also noted differences in the way that the boys and girls applied colour with the girls using more colours in a diffuse area in the drawing compared to the boys who concentrated one or more specific colour(s) in one specific area.

In a final study, the team compared the subject matter used in drawings by 124 boys and 128 girls drawn from six separate kindergartens. The researchers found that the girls were significantly more likely to feature certain themes (flowers, butterflies, the sun, people especially girls and/or women) than the boys, with the boys significantly more likely to draw mobile objects

(vehicles, trains, aircrafts and rockets) and mountains. The objects favoured by boys rarely appeared in the girls' drawings and there are striking and obvious similarities between these conclusions and those of many of the Western studies.

Striking congruence in findings

So, here was a cache of fascinating studies with evidence of consistent differences between the visual creations of young people. The studies had not been brought together in one place before but as soon as you did this, you could see remarkable congruence between the results of studies conducted over a vast geographical area spanning the US, Europe and Asia and over a period spanning more than eighty years. These similarities are all the more striking in that many of the subjects focus on the behaviours of young, elementary school children, who, by virtue of their youth, will have had less exposure to societal influences than older children or adults.

Experiments on design

I became interested in this topic in the mid-1990s and at that time, although there was this treasure trove of studies comparing male and female drawings and paintings, no studies existed comparing *designs* created by men and those created by women. Curiosity got the better of me and over a period of many years, I conducted experiments comparing graphic, product and web designs by men and women. We have already looked briefly at the chocolate box designs produced by pre-degree art and design students and I went on to compare product and web designs with the exciting findings on websites to be found in Chapter 8. Meanwhile, a word about the methods used in the experiments comparing male and female graphic and product designs.

In each of these two experiments, there were 12 designs, six created by men and six by women. In both cases, the students, all foundation, pre-degree level, were working to a common design

specification so their output was controlled to that extent. The graphics project, as we have seen, involved the design of a luxury chocolate box and the product project focused on the design of a tomb. The designs were all photographed and a comparison of the designs then involved rating them against different criteria. How should these criteria be determined? In order to eliminate any risk of experimenter bias, third parties were involved in the identification of the criteria using a method based on the "repertory grid exercise" of Dr George Kelly. This involves comparing designs and determining the features that distinguish them, with the most frequently occurring characteristics then being shortlisted for the final rating of the designs, again by third parties. It was important to use people who were outside the world of design for both exercises, thereby removing another source of bias, and the selection of 14 psychology students fitted the bill perfectly. Of course, none of them were told about the true purpose of the experiment, simply that it was an experiment about design.

The students rated both samples of designs against the criteria and the results showed highly significant differences, statistically, between the ratings applied to the male and female-produced designs showing that the differences are extremely unlikely to have occurred by chance. The differences? The male designs were judged to be less colourful, more linear and more technical than those of the women, and not by a small amount but by an amount that in statistical terms stood a tiny 0.1% chance of occurring by chance alone. These were findings to make you sit up and take notice.

As well as looking at formal elements such as shape, colour and technicality, I conducted another experiment which also compared the subject matter used by men and women. In this experiment, foundation-level students could select to create a logo based on one of three notional companies: a theatrical agency named "Top Banana"; a restaurant known as the

"Huntsman Restaurant" or finally one a sole trader design company. A total of 28 designs (both completed and partially completed) were available for analysis, 17 designed by male students and 11 by females and the distribution of themes amongst the male and female students showed some fascinating variations.

For, in total, 41 per cent of the men's and 27 per cent of the women's used illustrated a notional company of one's own. A low 18 per cent of men's but massive 64 per cent of women's designs were based on the "Top Banana" theme while a high 41 per cent and low 9 per cent of women's designs illustrated the "Huntsman Restaurant" theme. Looking at this gender distribution of themes, the greater use of the "Top Banana" theme by women stands out, as also the greater use of the "Huntsman Restaurant" theme by men. In fact, conducting a statistical test (the chi-square test for two independent samples) confirmed that the selection of themes by males and females differed at a level that was statistically significant. These results suggested that a person's sex was an extremely powerful factor in people's choices. In this case, the chances of the results occurring by chance were a mere 5%.

The fact that women are more drawn to depicting plant life and men to using violence as a theme may be seen as corroborating some of the earlier findings on boys' and girls' drawings. In particular, they parallel the findings of an earlier study by Ballard showing that females had a greater preference than males for using themes related to plant life in their drawings.

Meanwhile, over in Holland at the University of Twente, Margot Stilma, a teacher of product design, decided to put my findings to the test in 2008. She asked 64 first year industrial design students (44 male and 20 female) to search for a product designed by a man and by a woman, and to then rate these products using questions drawn from the rating scales I had developed in the experiments just described, as well as in later

experiments on web design (see Chapter 8). Stilma included questions relating to the number of colours used; the shapes – whether mainly round or straight lines or both; the use of detail and pattern; and finally the subject matter and the incidence of male/female figures, plant life or vehicles.

She concluded, "A similar trend as in the research of Gloria Moss could be found," with statistically significant differences emerging on all the elements tested, with the single exception of colour. So, she found significant differences in the preponderant male use of horizontal lines ($p<0.01$); predominant female use of patterns ($p<0.05$); different types of typeface ($p<0.05$); male focus on men; and a strong female focus on depicting women ($p<0.001$). Even if you are not a statistical whizz these numbers make exciting reading since a significance level of $p<0.05$ indicates that there is a 5% chance that the observation occurred by chance; by analogy, a level of $p<0.01$ indicates a 1% chance of error, and a figure of $p<0.001$, an 0.1% chance of error. These figures make a mockery of those who insist that men and women are identical.

What about preferences?

Having now put the spotlight on men and women's creations, we can now move on to look at the $64,000 question concerning men and women's design preferences. Would rigorous experimental methods reveal them to be similar or different?

Noticing the differences: what men and women prefer

There are as many opinions as there are people: each has his own correct way.
Terence

A diversity of views

In many organisations, the most senior people are still men with women experiencing vertical segregation and encountering a 'glass ceiling' in private and public sector organisations in all developed countries. Statistics in the UK back this up with women holding only 32% of managerial positions and 6% of top directorships.

One explanation is that managers in organisations tend to

Thank you for your time, Mr Smith, but we're not sure you have what we're looking for.

recruit other people like themselves. According to John Rust, Professor of Psychometrics and the director of the Psychometrics Centre at the University of Cambridge, "We all have our biases, which makes interviewing candidates very subjective... We need to get around the tendency to recruit people like ourselves. Doing this is vital, he says, since "if you want a good team you need a diversity of personalities."

The tendency to recruit other people like oneself is known in academic circles as the 'homogeneity principle' or even the 'perceptual similarity effect' and of course it is not just gender that is affected. Think about the people you are friendly with and see if you agree with psychologists that we tend to gravitate towards people who are similar rather than different from ourselves. This way of thinking leads psychologist, Ian Kelly, to argue that it is easiest to develop a relationship with someone whose way of seeing the world is similar to our own – something he calls the "sociality corollary" – and Griffitt and Veitch reached similar conclusions in 1974 in an interesting precursor to all those TV reality programmes. They paid thirteen men to spend ten days in a fallout shelter together and discovered that those with similar attitudes liked each other most by the end of the ten days, particularly when they agreed on important issues.

Returning to the workplace, Kirton, a UK-based researcher, identified in the 1970s different ways in which people processed information. At one extreme were those types that he labelled "adaptive" who prefer structure when solving problems, and at the other extreme "innovator" types who preferred less structure and were less concerned with acting in accordance with current standards and assumptions. What Kirton and others found is that human differences on these two measures can give rise to more stress across human interactions than amongst individuals who have more similar styles. In his estimate, the larger the gap and the longer individuals interact, the greater the effort (and stress) would be.

It follows also that the opposite scenario, one in which people of similar type work together, is one which makes for easier relationships. Kirton, for example, argued that in a bureaucratic organisation where the aims are precision, reliability and efficiency, the adaptor personality's ability to find solutions within the structure leads them to be well regarded. They tend to fit in, a fact which would be less true of the innovator whose solutions seem to be more risky and less acceptable in this kind of environment. In fact, "cognitive fit" has been found to be the single most important factor in executives' decisions to leave their jobs.

If you bring gender into the equation, then you introduce a further layer of complexity. For example, one study by Luthar in 1996 showed that men tend to rate the skills of other male managers as higher than those of women, while women did the exact reverse, rating female managers' skills as higher than men's. When you learn that research has highlighted men and women's tendency to exercise leadership in different ways (he preferring to use *Transactional* leadership and she *Transformational* leadership), you can see that this tendency for men and women to ascribe higher ratings to leadership characteristics that mirror their own style preferences is an instance of being attracted to behaviours that mirror one's own.

So important are the issues of leadership that I teamed up with an academic colleague Lyn Daunton to look further into this. What we found was that even where men were being asked to recruit candidates against *transformational* criteria, they unconsciously recruited against *transactional* ones. The single female involved in the recruitment process, the Human Resources Director, had included *transformational* characteristics in the Job Specification but the men doing the interviewing had ignored these. Not surprisingly, in a field of male and female candidates, the successful candidate was a man with all the features of a *transactional* leader – gravitas, a command and control style and

a tendency to ignore people until things went wrong (a behaviour referred to in the literature as "Management by Exception"). The organisation had to wait for his replacement, a woman, to see elements of the *Transformational* style – lack of emphasis on hierarchy, emphasis on the team, the vision, and the people within the team.

Ultimately we can only profit by realising that diversity is a fact of life and that men and women, like other groups, can sometimes see things differently. So, in the case of the organisation quoted above in which the male recruiters unconsciously substituted *transactional* criteria for the *transformational* competences in the Job Specification, the organisation ended up recruiting a male leader with very transactional, command and control characteristics, arguably not what was needed at that moment in the organisation's life cycle. A greater awareness of the relative tendency of men and women to prefer and display transformational or transactional criteria could have ensured the appointment of a leader who displayed the transformational characteristics needed then. So, far from consigning women to the backroom or the job ghetto as so many fear, the acknowledgement of different mental maps in men and women is key to ensuring that these differences are used to best advantage in organisations.

By analogy and moving back to the visual arena, it is vital that organisations understand whether men and women's visual tastes are similar or different so that they can muster resources to 'mirror' consumer needs, a vital principle in marketing. On a personal level, we all need to understand the nature of male and female preferences so that we can manage our relationships and friendships to best advantage. So, are men and women's visual tastes similar or different?

In the previous chapter, we have seen that there are wide and consistent differences in the visuals that males and females produce. Do their preferences for other people's visual outputs

differ too? The great philosopher, Immanuel Kant, writing around the time of the French Revolution, is unlikely to have thought so since he held that "aesthetic judgements are universally held." On the other hand, you might be asking yourself how wide a circle of people Kant could have met in his small hometown of Königsberg. It seems unlikely that he came across people from much further afield, and unlikely that great numbers of women crossed his path.

If you can remember times when you disagreed with the decision of an official jury (remember the last book or art prize?) then you are probably comfortable with the idea that tastes vary and that there is no single notion of what constitutes good taste. Tyler Brûlé founder and former editor of *Wallpaper* magazine agrees that there's been a wholesale democratisation of design and that, as national borders have broadened, and markets globalised, there are now many more potential customers to please. According to him, "If the consumer thinks an object has no function but is a thing of beauty, then they have every right to declare that a piece of design. We used to call this stuff *objets d'art*, but design has subsumed the decorative arts. The definition of 'good' design now includes shipping container graphics and the seats on Russian passenger planes."

Design retailers tend to agree. "Design is anything and everything that surrounds us," says Thorsten van Elten, who runs a design shop in central London. "The stuff in my shop is my taste, so my definition of design reflects my taste." Van Elten stocks a selection of largely contemporary European homewares but also quirky handicrafts and traditional folk objects. Design schools are also reflecting the shift of emphasis towards the consumer experience. "There's a simplistic view of design which is that it's a procedure with clearly defined stages," says Simon Bolton, product design course director at London's University of the Arts (formerly Central St Martins). "But the drivers and influences have changed radically in the last ten years. Previously it was

about form, function and manufacture but now it's about a whole range of softer issues: emotion, culture, politics and so on. It's all about connecting with consumers in new ways."

I had a direct, immediate reminder of the way that tastes can vary when invited in for coffee by a male acquaintance. He took obvious delight in showing me around his house, pointing out the features as he went. In the sitting room, the colours of the ceiling were orange-yellow, the walls a dark cream and the curtains a sludge green and brown. Retro mirrors dressed the walls, supported by chunky chains, and bought at a hefty price at an auction. Thrown together by chance? On the contrary, he explained that he had hand-picked the colours, and used an interior-designer to put his wishes into practice. If aesthetic values are universal, then I needed my eyes testing.

An alternative view to Kant's is neatly summed up in the popular phrase, "Beauty is in the eye of the beholder." If we reckon with the idea that opinions about artistic matters are variable, then we have a way out of this. The view that people's notion of beauty varies is one that found eloquent expression in the writings of British philosopher David Hume (1711–1776). In his essay "Of the standard of taste", he famously claimed that: "Beauty is no quality in things themselves: it exists merely in the mind which contemplates them and each mind perceives a different beauty."

What he is stating here sets him on a collision course with Kant (1724–1804) since Hume is stating that beauty is in the eye of the beholder whereas Kant argued for universal laws of aesthetics. Hume's position defines him as a relativist or 'interactionist', emphasising the role of the interactive effect of the stimulus and the person contemplating it, and such different positions beg the question as to who was right. Hume or Kant?

Before conducting experiments in search of answers, it is useful to sample modern thinking on the topic. If you work in the world of IT, then chances are that you know the work of the

Internet guru Jakob Nielsen. Dr Nielsen co-founded the Nielsen Norman Group with Dr Donald Norman, former VP of research at Apple Computer, and one of his ten principles presents "minimalist design" as a goal for all web designers regardless of target audience. These approaches to design are clearly universalistic in their assumptions and follow in the footsteps of Kant.

Hume's more relativistic way of thinking also finds reflection in modern thinking. Carol Duncan, for example, Professor of Art History at Ramapo College in New Jersey believes that beauty is not actually inherent in objects but is the product of the viewer's response. As she writes: "Art appeals to someone when it meets their needs – to be entertained, flattered, enlightened, charmed, awed and any of the other things people value in art." She goes further: "We may value a work because we find its colours pleasing or because it reminds us of our childhood home." Other factors may play a part: "We may value a work because it makes us feel tension or joy or surprise or because it will enhance our social standing or because it gives us back a piece of our experience in the world in a heightened form."

What Carol Duncan is saying is that it is very easy for people to disagree on the value of a work of art since there are many factors that can draw people to like one work rather than another. From here to questioning the values that underpin the elite art world is a small step and she goes on to discuss how a small group of individuals, whether collectors and dealers or museum and fine art curators influence everything from public policy to art education. She recognises that the views of this special group of gatekeepers can be distinct from other people's, and this is important since these gatekeepers have the power to influence opinions and determine what passes as excellent. Indeed, Carol Duncan's realisation that opinions about art and design can vary from person to person shows that she is in the 'interactionist' camp, in other words a believer in the view that concepts of beauty vary from person to person. So she rejects any

notion that beauty exists as a universal attribute, preferring instead the popular notion of beauty as something in the eyes of the beholder.

Universalist or interactionist visual preferences?

To test which camp you are in, you might ask yourself whether you have ever heard someone offering praise – it could be for a painting, a building, an outfit or for a sofa – while you're quietly thinking, "It's just plain awful." If you have, then you are an interactionist too. The question that had not previously been examined before I was kick-started into this by my experience at the Mall Galleries (see Chapter 2) related to where gender sits in all of this. Ultimately, rigorous experiments were the only way to really map the territory but observations and discussions with people were a good starting point.

Back in 2003, I visited a lecturer friend in her cosy university office. With the bit between my teeth, of course Teresa told me the story of her bathroom. "It's en suite to our bedroom which is decorated in gentle, pastel shades, with *Toile de Jouy* fabric. To me it was obvious to continue the theme into the bathroom. Only my husband didn't agree. He wanted black marble tiles – and wore me down until I agreed. I'm still not reconciled to it."

Something interesting was going on here and further proof came when I had a medical check-up with a doctor in town. I had squeezed this in between appointments and the strain (and chill) of wearing relatively little in the presence of a complete stranger was broken by some casual chit-chat: "What work do you do?" came the question from the young doctor as he started to prod me in strange places. Saying that you are an academic and write books and articles does not always guarantee a flood of interest so a new tack was needed. "For many years, I've been fascinated with differences between people, and over many years have been comparing men and women's designs and design preferences. The differences I have observed are not surprising since psychol-

ogists have confirmed superior 3-D vision on the part of men and superior colour vision among many women on account of an extra colour pigment."

Scarcely had the words escaped than the doctor looked up from his notes and described the battles with his wife regarding home decoration schemes. "She likes patterns whereas I like things plain and she also likes soft round shapes whereas I prefer straight-sided objects. Unfortunately, all this came to a head when we were deciding on a new bathroom since she wanted decorated tiles and a round mirror, and I wanted plain tiles and a rectangular mirror." His facial expression recalled the troubled times but he got his way in the end since he really could not have tolerated the patterned tiles. "It wasn't easy and as for the sitting room..." The receptionist buzzed for the next patient and within seconds I had made my escape. However, the conversation remained with me and over the next few weeks other differences kept crossing my radar.

Colour

It was the season for getting a health makeover and this involved a visit to the dentist. My dentist is an Iranian woman, trained in Germany, and she and her husband acquired 'The garden dental practice' a bus ride from where I live. He was happy to leave the decor of the practice to his wife, Dr Sanan Tehrani, and one day, while waiting for the injection to take effect, she told me how she had insisted that the green paint around the door exactly match the green on the dental chair. "The builders could not get exactly the right colour so in the end they had to apply a coat of silver followed by three coats of the green," she said. "Only then was I happy." I could not do more than make a few enthusiastic noises which I hoped expressed the excitement that I felt.

A short while after this, I started a house renovation project since my house was looking rather tired. The first stage involved work on the bathroom and, since I wanted to create a light look,

I went in search of tiles and paint. Finding tile shops was no problem but every matt tile advertised as white that I brought home had a tinge of grey to it. It was just impossible to find a pure, matt, white tile. In the end, I had to settle for one with a tinge of grey since life is short and there are only so many shops you can visit.

Part of the project involved choosing picture frames and pictures that would complement the brilliant white on the walls, chosen to create a fresh look in a modestly-sized house. I had taupe and brown colours on the floor with some turquoise cushions for accenting a theme of turquoise running through the house and had bought some white picture frames for the walls. The immediate question concerned what colour pictures to put inside the frames and a very good friend of mine, Peter, suggested pictures in shades of orange and bright yellow. To my way of thinking, this would have created a cacophony of colours that would have fought each other and my preference was for accents of darker and lighter blues and greys so that the colours blended nicely together.

Then, when it came to finding patterned rugs for the hallway, hours of searching on the Internet did not throw up anything with pretty colours such as turquoise, light grey and pink, and little with a small repeating pattern as a border. There was plenty of dark grey, brown and black but these colours would not help create a pretty decor. I considered buying a length of carpet and having it edged with a binding tape but the only colours available – again – were black, brown and grey.

Then, one day, I found a profusion of beautiful things on a website with objects shown as handcrafted and one-off, unique productions. Suddenly, the objects that I had imagined in my mind's eye were there in abundance – turquoise mats, an unusual patchwork table mat in wool worked with pink and blues, floor rugs with a craft-like look; a lamp shade with a ruched ribbon around its perimeter – and it was obvious that this hidden feast

of products was coming from websites run by women, some in Alaska, some in Maine, one in Austria. I liked this craft look, denigrated by certain sections of the design community – and thought that maybe this illustrated a like attracts like direction to preferences. This was a hypothesis to hold in suspension until the experiments were over. Meanwhile, it was time to go back to deciding what should go in the white frames.

Detail

I happened to find a shabby chic rose fabric from that wonder of the modern world, IKEA. The design caught my eye since it had grey, impressionistic climbing roses that were very different from the strident, clear-cut blocks of colour in other fabrics in the store. The edging bore the name of the designer, Inga Leo, who has worked for IKEA for many years and lives near Älmhult, the Swedish town where IKEA had its roots. The fabric looks delightful in picture frames and the abundant and impression-istic detail has an evocative and whimsical effect.

Contrast this with the look of so many other curtain fabrics, not just in IKEA but in the zillions of fabric books held by reputable retailers. Bold, clear blocks of colour predominate with pattern set out in an organised, methodical way, rather than in the less rigid rose design of Inga Leo. I was involved in a house renovation project and looking for brightly coloured curtains to complete the project but the majority of fabric had a rigid quality, lacking the whimsical approach to detail in her fabric.

A single example – one of many – are the fabrics of Ian Mankin, an upmarket supplier with a strong online presence. Mankin himself retired from the business in 2007 and the business is now run by David Collinge, with most of the business' range woven in a mill in Burnley, Lancashire in the north of England. Collinge sets out the company's design philosophy on their website, writing that: "Our range is all about timeless classic simplicity and elegance," and crediting Ian

Mankin as "an inspiration" who "always kept things very simple." The simplicity emerges in clean-cut designs, most clearly seen perhaps in the controlled blue leaf forms of the "Union Leaf Airforce" design which, despite the curvy shapes of the trailing branches, lack any of the whimsy of Inga Leo's rose designs. It should be said that an organic theme of this kind is a rarity in the firm's collection since most of the fabric collection consists of striped patterns. You name it, and you will find your stripe with everything from "Vintage stripe", "Oxford stripe", "Henley stripe", "Denim stripe", "Grain stripe", "Blazer stripe" to the "Ascot stripe"!

So, Ian Mankin fabrics are light years away from those of Inga Leo and light years too from those of another female designer, Vanessa Arbuthnott. To see her website is to enter into a world of bright colours, whimsy and abundance of detail. If you look at the sneak view of a small bedroom on p. 40 of her online brochure, for example, you will see no fewer than six separate fabrics in close proximity and you will find something similar in the interiors on pp. 14 and 16. So the detail is there in the overall design and also in the fabric (see for example the light lines joining the birds in the "Dawn Chorus") and also on the website with a border on either side of turquoise fabric with elaborated polka dots.

Inga Leo and Vanessa Arbuthnott's designs can be contrasted not only with other fabric designers but also with big firms' corporate strategies. Take the case of the Dutch electrical consumer firm, Philips, for example, a firm the majority of whose consumers are female. The Director of the Marketing team, a tall, fine-looking man with a clear vision for the company, had decided to take "Sense and Simplicity" as the company's guiding principle, leaning heavily on *The Laws of Simplicity* of MIT Professor John Maeda (2006). To give you a flavour of his thinking, here are a couple of his laws:

- The simplest way to achieve simplicity is through thoughtful reduction.
- In simplicity we trust.

So, leaning on the thinking of John Maeda, Philips used the image of a white, unadorned box as a symbol of its design ethic. In design terms, this is light years away from Inga Leo's designs and it is also light years away from the polka dots that Kate Middleton loves so much. In fact, it is not just the Duchess of Cambridge that likes polka dots since, following the birth of Prince George in July 2013 and her appearance before the world's cameras in a blue and white Jenny Packham polka dot dress, sales of polka dot items hit the roof. On the George of Asda website, 'Polka dot' took the number one spot as the most searched-for term and just over 5,000 polka dot dresses were sold there, more than five dresses a minute. Other items with polka dots did a roaring trade too including pinafore dresses, high-waisted shorts, chiffon shirts, skirts, vest tops, ballet pumps, and the blue and white polka dot bikinis sold out completely!

Speaking of summer wear, my friend Roger popped round for tea one summer's afternoon. Since everyone was in the garden, he went off to make some tea and then brought all the mugs and teapot out on a tray. A quick glance revealed that he'd selected those mugs that were stored at the back of the cupboard and kept only because they were presents from an uncle. They were bulky in shape with no decoration, and in selecting these, he had ignored the more compact mugs with polka dots. Only later, when discovering women's interest in surface detail and men's preference for a plain surface did Roger's preferences start to fit into place. You may remember Elizabeth Hurlock's study in which she compared boys' and girls' drawings, finding that the girls in her sample were much more likely to draw stereotyped patterns than the boys, and a comparison of Roger's and my reactions to the patterned mugs matches these differences, with

a match between *creations* and *preferences*.

In practical terms, these anecdotes and experiences were starting to build up a picture that would provide vital clues for those designing for male and female target markets, and for those of us buying presents for our male and female nearest and dearest. Including a pattern on a birthday card might be a winner for *her* but less likely so for *him*.

Straight lines

While he was in the house, Roger said that he needed a lamp for his spare bedroom and wondered if there was a lamp in the house that no one needed. At the back of a cupboard, hidden away, was a lamp with a small porcelain base and a nice compact velvet-trimmed shade. Unfortunately, you could see in the daylight that the shade had stains on it but Roger gamely took it and went out in the afternoon to find a replacement shade. He came back, all smiles, holding the small compact porcelain base but with a very tall, straight-sided shade sitting on it. To my way of seeing, the small base cried out for something neat and compact but Roger was obviously of a different mind and quite happy with this tubular-shaped shade.

The differences in our tastes were noticeable but not enough to shake the foundations of our friendship. Where these differences occur at work, you can have dynamite as the following story reveals.

Function versus style

It was 2004 and the curator of London's Design Museum, Alice Rawsthorn, organised an exhibition of the shoes of Manolo Blahnik and the flower displays of Constance Spry. Constance was no ordinary florist. A 1950s design radical, she reached out to the masses, showing them how to bring affordable beauty into their homes. In her 1957 book *Simple Flowers: A millionaire for a few pence*, she taught how simple materials (berries, vegetable leaves,

twigs, ferns, even weeds) could be displayed to good effect in ordinary containers (gravy boats, bird cages, and even tureen lids and baking trays). "I do feel strongly," she said, "that flowers should be a means of self-expression for everyone." The flowers and plants were organised in solid blocks of colour, and the fluid forms were customised to their surroundings.

For Dyson, this was a step too far. The museum had become a "style showcase" and had lost sight of its mission to explain the manufactured object. To be honest, you can understand his point of view. Here was a man who had spent five long years perfecting his renowned cyclone vacuum cleaner, producing 5,127 prototypes before he was satisfied and he was clear in his mind as to the winning elements: "It is our technology that has made the product attractive" and his *website defines design as "how something works, not how it looks." So, f*or Dyson, the Design Museum had abandoned its ideal of promoting function-led, problem-solving design and in doing this was "ruining its reputation" and "betraying its purpose." The spat, widely reported in the media, was only resolved by Dyson resigning from his post at the museum in disgust.

Of course, men's love affair with the utilitarian does not begin

or end with Dyson. Socrates, for example, is credited with ascribing aesthetic value in accordance with the practical value of an object. According to Osborne, a leading authority on modern art history and editor of books on aesthetics and art, including the *Oxford Companion to Art* and the *Oxford Companion to the Decorative Arts*, a modern-day development of this argument is that: "if a thing is made to function well, if its construction is well suited to the job it has to do, then that thing will be beautiful." This view is familiarly expressed in the words "form follows function", a phrase famously expressed by Louis Sullivan (1856–1924), one of the most influential architects to come out of the Chicago School of architecture in the late 1800s and often called the "father of the skyscraper". Perhaps its most famous exponent is the Swiss Le Corbusier, who conceived of the house as *a machine for living in*, and in a stroke revolutionised twentieth century housing.

In fact, the allure of the functional and the technical for men became apparent in other ways. I shared an office with a Polish man who was looking for a flat for himself and his wife who had joined him from Poland. When he described the flat to me, he waxed lyrical about the number of satellite TV sockets, the size of the TV stand but absolutely nothing about the décor. Later in the day, she came into the office and launched a series of excited questions about the flat: "What was the colour of the walls?" "What size the bed – single or double?" "What colour are the carpets?" "How much light is there in the room?" All to no avail. His principle preoccupation was the number of satellite TV sockets and the size of the TV stand. She was wasting her breath.

John Gray's *Men are from Mars, Women are from Venus* had prepared us for men's love affair with TV, but not for their ability to apparently screen out all but the mechanical. It was time to probe this matter more deeply: time to explore these themes with science and see if men and women's tastes were polarised as anecdote suggested or whether anecdote was misleading and

there were no real differences in taste by gender. These two possible outcomes – aesthetic agreement or disagreement – reflect the fault lines of thinking on aesthetics over the last three thousand years. Which is correct?

Objective or subjective evaluations

Adjudicating between the age-old dispute about aesthetic values and whether these are universal or relative can ultimately only be done through empirical work. It would take experiments to test people's preferences for designs across a range of design disciplines (for example graphic, product and web design) and ensure that the people offering their preferences were not aware of the underlying purpose of the experiment. Also, the designs shown would need to be rated as extreme male or female examples on a 'gender production aesthetic' scale and would need to be equal in terms of quality so that differences in response could not be deemed to be a reaction to differences in quality.

I conducted these experiments over more than a decade, testing people's responses to a whole range of designs, from graphic, product and web designs to Christmas cards, IKEA products and even underground interiors. Those responding to the designs represented a wide demographic from university students in the UK and overseas to a random sample of adults and children at a civic library. In every case, there was a statistically significant tendency for the men and women, and boys and girls to prefer designs created by those of their own gender. One of the experiments on web design preferences was conducted with my colleague Dr Rod Gunn, a statistician who described the results as "completely watertight. The chances of them occurring by chance are less than one in a thousand."

The results were spectacular but, as they say, the devil is in the detail. If you are not interested in finding out about the ins and outs of them, skip to the next section; but if you are someone

who is interested in the minutiae of methodologies, you might want to look at my book *Gender, Design and Marketing*.

Experiments: Hume vs. Kant

The first experiments I conducted were groundbreaking in the sense that these were the first to compare men and women's reactions to designs created by men and women. To have any credibility, they needed to be conducted with rigour and so the graphic and product designs used as stimuli in the first three experiments had all been rated for the extent to which those created by men and women manifested differences. This rating exercise revealed significant differences between the male and female-created designs and this knowledge would help in the interpretation of the preference results. Importantly, the designs had also been rated in regard to their quality and the finding that they were equal in this respect meant that any subsequent differences which emerged in respect of preferences must be due to factors other than quality.

Having got those issues out of the way, the experiments could now start! There were three sets of 12 designs from which to select – all produced by pre-degree, foundation-level students and so not too influenced by professional training. In terms of the selectors, there were 74 with the proportion of men and women roughly equal, with 39 men and 35 women involved. Remember that they were asked to select their three preferred designs from each of three samples of designs with one graphic design sample consisting of logos for a business; one product design sample consisting of tombs (amazing the topics that art schools set!) and one packaging sample consisting of the chocolate box designs referred to earlier.

The results were nothing short of astonishing. What they clearly revealed was a massive tendency for people to prefer those designs, across the three samples, created by those of their gender. The strength of the result was such that the likelihood of

the results being attributable to chance was just 1 in 1000, in other words 0.1%. This put Hume's arguments in favour of the variability of opinion in a strong light although it was too early to give him game, set and match until a few more experiments were carried out.

Christmas enlightenment

Christmas provided the opportunity for the next experiment. Taking advantage of the surfeit of cards in the shops, it was possible to select two cards by men and two by women on similar thematic material in order to control for subject matter. So three were selected showing a Christmas tree and the fourth an outdoor, snow-filled scene.

To give you a flavour of the sample, you might like to picture in your mind two of the images. One of the female-designed cards showed a light-hearted and childlike evergreen, sparkling with golden stars, set against a white background of Christmas messages ("Season's Greetings"). Interestingly, the messages were written in curly lower-case writing which often cut across the boundaries of the tree. One of the male-produced cards showed a snow-filled scene which, unlike the two-dimensional tree, featured a realistic, three-dimensional image of men pulling horses and carts against a backdrop of sky and farm buildings.

These four cards were shown to 65 adults and children consisting of librarians in a local reference library, shop assistants, acquaintances (including their children) and people attending a charity function. All were asked to identify their favourite card, and the male and female preferences were virtually mirror images of each other with each gender strongly preferring cards created by people of their own gender. The following figures tell the story very clearly, with the results coming out again at an extremely high level of significance and suggesting (with 99.9 per cent certainty) differences in men and women's reactions:

Female preferences: 24 preferred the female-designed card and 7 the male-designed card

Male preferences: 11 preferred the female-designed card and 23 the male-designed card

You might be asking yourself how representative this sample was. It is true that the sample size, though modest, is large enough to pass muster for journal publication – the results were published in the *Journal of Brand Management* and my co-author again was Andrew Colman, Professor of Psychology at Leicester University. In terms of embracing a cross section of people, the sample included several nationalities (English/Scottish, Indian, Turkish, Algerian, German, Italian and American) and occupations (shopkeepers, librarians, lawyers, psychologists, business consultants, secretaries and entrepreneurs). The heterogeneous nature of this sample makes it considerably more representative of the wider urban population than the many student-only populations used in a large proportion of psychology experiments. In fact, it may surprise you to know that 75 per cent of British and American psychological research studies are conducted on students and that the usage is at least 50 per cent in the UK. Despite this extensive use of students, researchers in this field tend to present their results as generalisable to the wider population.

In terms of the aptness of Hume or Kant's approach to aesthetics, the results of the Christmas cards experiment augured in favour of Hume but further experiments beckoned before he could wear the victor's crown.

Testing reactions to everyday objects

In order to further compare male and female reactions, I teamed up with marketing specialist Dr Gabor Horvath to create a design questionnaire to test people's reactions to a range of everyday designs. It can be surprisingly difficult to discover the design

history of objects but, over a number of years, I had built up a bank of designs which had been created by a single designer. Gabor and I selected paired items (with pairs rated as similar in terms of quality and function) and the items in our shortlist include cushions, chairs, drink cans, frozen fish packaging, Christmas cards and underground station designs. In this experiment, we asked respondents in six countries to rate these designs on a scale of one to ten and they were also asked what they liked/disliked about them. Reactions were elicited from 481 men and women in the UK (79), Germany (128), France (137), Hungary (69) and China (68) with the gender distribution of respondents being pretty similar.

In terms of the designs, you can probably easily picture these items from brief descriptions. The first two were from that emporium of modern design, IKEA, and both cushions. They were both rectangular-shaped but covered in very different fabrics – one a floral pattern etched out in turquoise, pink, green and white, and the other a linear pattern with criss-crossing orange lines (no prizes for realising that the first was by a female designer and the second by a male designer!). The second image showed a pair of children's chairs which were visually rather similar with one a single seat in red plastic (with feet wider at the bottom than the top) and the other a small wooden bench in orange and yellow, with animals etched into the back. The similarity of the chairs may, in fact, have detracted from their usefulness as stimuli.

By contrast, both sets of food items were strongly differentiated. Of the drinks cans, the male-designed image was of a black Strongbow drinks can with an armoured man pulling a bow within a square surround. The second can (female-designed) was diaphanous with a rotating band of pink supporting an impressionistic image of a strawberry. As for the frozen fish, the female-designed packet showed the product hovering in mid-air, with a childlike lower-case typeface comple-

menting the absence of three-dimensional space. The male-designed packet, by contrast, presented the fish product receding away from the viewer, so firmly anchored in space, with a realistic image of a fisherman standing to one side and regular upper-case typeface crowning both.

As for the Christmas cards, these were the ones used in the experiment described a few pages ago and the final pair of images showed underground interiors from the London Underground network: one was from Leicester Square station, with vertical and radiating straight grey lines, and the other, from Marble Arch, showed baby-blue and white stripes alternating under red archways decorated with white polka dots. The first was the work of a male designer and the second, one of just three stations on the 270 station network, designed by a woman!

The results of the five-country preference tests? The men in the sample were drawn equally to the designs produced by men and women but the women showed a strong preference for the female-produced items in five out of six cases, demonstrating a massive tendency to what I term "own-sex preference". Significantly, the respondents came from a number of countries, as mentioned before – Britain, France, Hungary, Germany and China – so it is exciting to see these differences manifest across national boundaries. For those with an eye to the data, the numbers are shown in the following table. In terms of the significance of the results, only the responses to the first pair of designs, the chairs, showed no significant difference in men and women's responses: everywhere else, there was a statistically highly significant tendency for men and women's preferences to differ. Even if you don't massively like statistics, the numbers speak volumes and tell a headline-grabbing story.

Another fascinating discovery related to the features that men and women singled out as appealing or unappealing. For example, the qualities in the male and female designs that the men quoted as appealing to them were that the design was

"simple, bold, strong, not busy and traditional" with the women referring to colour as the main attraction, particularly when the colour was a shade of red. When asked what they disliked about the designs produced by men (a fact never revealed to those taking part in the experiment), the men cited elements such as colour (particularly when it was red) while the women referred to "lack of colour", "too plain – no pattern", and "conventional appearance".

As you can see, the women are drawn to products with detail, bright colours, nice patterns and an unconventional (childlike) typography. What they tend not to favour are elements from the male-produced aesthetic such as absence of detail, absence of colour and conventionality. The men, by contrast, are drawn to these very elements showing that men and women's tastes across different countries and continents can be poles apart.

By now, it was looking as though Hume was winning hands down but to declare him the outright winner demands irrefutable evidence. A final experiment beckoned, this time involving the *lingua franca* of website designs.

Consensus on website design?

By June 2010, the Internet user population globally reached 1.9 billion with annual growth estimated at 20%–60% per year. The design of a website has a critical role in attracting people to websites and yet a pair of Israeli researchers, Dr Talia Lavie and Dr Naom Tractinsky of the Ben Gurion University, referred in 2004 to the "paucity of research" on web design. They filled the gap with work assessing the dimensions of perceived visual web aesthetics, but although they documented the reactions of a decent sample of 125 engineering students (this included 89 men and 36 women) to a website, they neither evaluated the website that they were rating in terms of its male/female qualities, nor did they distinguish between the reactions of the men and women in their sample.

Failing to distinguish between men and women's reaction is a serious error. In 2003, for example, a study showed that by 2000, the online gender gap in the US had disappeared with women significantly more likely to use the Internet than men. Moreover, a separate study from this period showed that women constituted the majority of new Internet users in the period 1997–2000. Knowing that women were fuelling much of the growth in Internet traffic made it important to discover whether men's and women's reactions to websites were similar or not.

In these early years of the new millennium, I was working at the University of South Wales (the former "University of Glamorgan") and I teamed up with a superb statistician, my previously mentioned colleague Dr Rod Gunn, to find answers to this question. Rod is a Welshman with a PhD in maths and his idea of a good bedtime read was the latest book on statistics ("equivalent of a novel for me") and we compared websites created by men and women in the UK and then in other European countries. Details of these studies can be found in Chapter 7 but essentially statistically significant differences between the male and female-created sites emerged on 13 out of 24 factors analysed. These related to the use of **colour** (women used more and different colours in the typeface), **linearity** (the male websites manifested significantly more linearity and the female websites significantly more rounded shapes), **subject matter** (each gender tended to show own-gender images) and **tone** (the male-produced websites had a more serious tone than the female and were more likely to engage in self-promotion). Looking at the results, it was not unreasonable to speak about major differences in male and female web design production aesthetics and we say more about this in Chapter 8 later on.

The $64,000 question related to how unsuspecting third parties would react to websites that were typically male or female. In a bid to find an answer, we asked another group of 64 international students (38 male and 26 female) to rate their

preferences in websites which we had assessed as typically male and female. The students had a rating scale of 0–20 and were not told about the real purpose of the experiment – as far as they were concerned, this was a study into general design preferences.

A few days later, the email with the results dropped into my inbox. With excitement, I scanned the numbers and found them tremendously exciting since they pointed to a strong, statistically significant tendency for men and women to prefer websites created by those of their own gender. As if this wasn't enough of an adrenaline fix, the results also showed women resisting all aspects of the male aesthetic (preferring the shapes, pictures, language, typography, colours and layout in the female-produced websites) while the men tolerated the shapes used in both sets of websites and actually preferred the pictures in the websites designed by the women. The results were true at a 1% confidence level.

By now, Hume was winning hands down over Kant. The experiments described here highlight deeply divided opinions, with a striking lack of unanimity on what constitutes excellence in the visual field. Given the evidence supporting Hume's relativistic stance, one might find it strange that people still crave winners and losers in art, design, architectural, gardening and photographic competitions. Is it not likely then that the winners will be selected around the personal preferences of the judging panel?

Implications

The age-old dispute as to whether beauty is relative or universally perceived finds some kind of resolution through the experimental results reported here. The question is no longer one for conjecture but one with robust findings that support Hume's rather than Kant's views. Hume can finally take the victor's crown.

The journey has shown that male and female preferences are equally distinct but in extraordinary ways, never charted before. Essentially, men are happiest travelling on the male tramline and women on the female tramline. So, for a man, the tramlines that work best will be straight-lined, with little detail, little colour, offering views of objects and facilitating movement and lots of it. Envisaging these co-called 'hunter' tramlines, the perfect gift for a man could be a ticket to the North American International Auto show, the docks at Red Hook's Pier in New York City or the St Katherine's Dock museum of shipping in London. Alternatively, you might purchase a ticket for a long and interesting train journey (better make it a return ticket if you don't want your kind gift to be misinterpreted!).

Happy Birthday, darling! I do hope you enjoy this one-way ticket to Vladivostock!

For women, however, the tramlines that work best will be

rounded, etched with lots of detail, colourful, affording views of Mother Nature and creating as little sense of movement as possible. It is not by chance that we give flowers to women rather than to men since the parallel tramlines on which men and women prefer to ride make this a sensible option.

Knowing that tramlines need to operate together to be effective, you can see how problematic these differences can be. It can problematic for domestic harmony and problematic too for men and women in a corporate setting, particularly when they are not aware of the differences in their visual make-up. You end up with people accommodating themselves to the preferences of the other gender, riding on the opposite-sex tramline, creating an imbalance that threatens to derail the tram.

Parallel tramlines

To talk of *visual tramlines* might seem an exaggeration were you not aware of the strong evidence for difference and the magnitude of the phenomenon. "Why haven't I heard of this before?" you ask quite reasonably, and the answer relates to a mixture of chance and fashion. 'Chance' because it was a chance event that ignited my interest and propelled me into running design experiments and rooting out old studies; 'fashion' because the done thing these days is to debunk sex differences rather than highlight them. However, with the visual domain that we are dealing with we are on very safe ground since visuospatial differences are acknowledged to be the most robust of the sex differences after height.

Moreover, a greater understanding of the relativistic nature of aesthetic preferences casts new light on situations. For example, the high proportion of men in curatorial positions and prize juries and their likely tendency to 'own-sex preference' may be a factor in the dominance of male work in art galleries worldwide. Likewise, the high proportion of female art teachers at school level may be a factor in girls achieving higher grades in the 17+

'A' level exams in Great Britain than their male contemporaries. At the same time, with a higher proportion of male than female students receiving first class degrees, the possibility of 'own sex bias' in undergraduate assessments raises its ugly head, an issue I explored in 1996 in an article laying out data supporting this.

Extrapolating from these results to the world of galleries and high-prestige prizes would make the selection of gallery curators and juries absolutely critical. For businesses, the selection of designers and other creatives would be absolutely critical and should be determined in relation to the gender and preferences of the customers. Since the majority of these are female – one estimate puts this at 83% – and since much of the design and advertising professions are currently male-dominated, there are serious issues about the sub-optimisation of the products of these industries for audiences of women and how to improve this situation. We will say more on this later when we look at design and advertising.

Certainly, you can be reassured that the approach adopted here is anything but reactionary. In fact, the logical consequence of the evidence presented here is that men and women's visual skills produce unique forms of creativity which increase the strategic importance of having both in the workplace. This means that highlighting gender differences is by no means to denigrate either gender or to relegate women to a domestic role but to highlight the need for dual tramlines rather than just one.

Meanwhile, having mapped these parallel tramlines we will look at some of the explanations for differences in men and women's visual creations and preferences. Much of what we discover comes from the world of psychology so we leave the shores of art and design for the time being, returning to them in Chapter 5.

Chapter 4

Noticing the differences: explanations

A devil, a born devil, on whose nature Nurture can never stick.
Shakespeare

Heated debate at Harvard

It is February 2005, and conference time. The President of
Harvard, Larry Summers, is addressing a gathering set up to
discuss why more female mathematicians and scientists are not
breaking through the glass ceiling. Unwilling to be just a
figurehead president, he intended to speak his mind and
encourage debate. Eight times as many men as women are in
leading professorships at Harvard, and he suggested that the
under-representation of women in science and engineering could
be due more to "different availability of aptitude at the high
end," and less to patterns of discrimination and socializations.

Professors from across America raise their voices in a chorus
of disapproval and he was forced to leave Harvard after a no-
confidence vote by Harvard Faculty. He had said that he wanted
to "provoke" his audience but Summers, one of the youngest
ever tenured professors at Harvard, misjudged the temperatures
of the waters he was wading into.

Leaving aside the rights and wrongs of his particular
assertion, the strong reactions that it provoked is testament to
the controversy surrounding discussion of cognitive sex differ-
ences. The subject of innate differences between men and
women is at the heart of an intellectual schism in academic
circles as resilient and aggressive as anything Galileo encoun-
tered. As Larry Summers discovered, speaking of sex differ-
ences is construed in many circles as an act of heresy, and the
slightest suggestion that Mother Nature plays a part, has you

shouted down by those who insist that *all* differences between men and women must be attributed to social processes and cultural conditioning. The aspiration can then be one of Equal Opportunities, policies based on a philosophy of sameness, of giving equal opportunities to all, in a practical concern to ensure that men and women have equal access to jobs and promotion possibilities.

The notion of equality, fought for all through the last century by blacks against whites, and women against men, is almost always accompanied by the notion that all of us – black or white, men or women, gay or straight – have an equal right to succeed and should be judged against the same measures. This does not always, however, deliver the hoped-for level playing field since the standards against which people are measured are not always the impartial, neutral values that many imagine them to be. Seeking a thrusting leader who leads from the front and is not shy of making decisions without reference to the group? That may be a model that more men can satisfy than women. Seeking a designer who can pare things down to minimalist proportions and embed simplicity in their product solutions? As we shall see later, criteria like these may be more highly prioritised by men than women, and lead men to more easily demonstrate them in their portfolio than women. So the notion of the 'best' person is ultimately very complex and often modelled, as we saw in the last chapter, on the characteristics and preferences of the most senior people in the organisation.

When it comes to the visual differences we have observed in the men and women's production and preference aesthetics, the sixty-four thousand dollar question is what lies at the root of these differences.

Reasons for differences
I had an inkling that it would not be easy to find answers to these questions as a result of an experience at an academic conference.

The event celebrated the work of a French sociologist who had written on gender, and I had given a presentation on the differences we looked at earlier in the way that the boys and girls coloured in their cookers. My closing remarks were greeted by waving hands. "Surely the results have their origin in the fact that girls and boys are taught in school to colour in differently?" This was baffling since I had certainly not been taught how to colour in and neither had my son (more's the pity!) so the notion that boys and girls receive separate instruction was fanciful. Later on, in the coffee break, I overheard someone asking, "Who allowed *her* into the conference?" and realised that to explain gender differences through anything other than societal influences is heresy in certain circles.

In the sections that follow, we will put political correctness to one side and take a hard look at the evidence on the impact of social and cognitive factors on the gender differences in visual creations and preferences.

Social factors

So why do people prefer designs by their own gender? Could one explanation be that we are drawn to the familiar? Not long ago, I was chatting to a young female photographer who had won first prize in a national competition, and the focus of the conversation was on the winning shot. "It was of a young boy," she said, "and the judge mentioned how much it reminded him of images of himself as a child." This is an example of what marketers call the 'mirroring principle', one in which people make positive responses to images that reflect aspects of themselves. So, it is not inconceivable that the judge had an unconscious preference for the winning photo since it mirrored aspects of himself.

Confirmation of this process is provided by an excellent 2004 study from the Czech Republic. The researchers, Ulrich Orth of the College of Business in Oregon, and Denisa Holancova of the

Department of Marketing and Trade in the Czech Republic, compared the reactions of 320 consumers to adverts showing different configurations of people. Sometimes, consumers were shown photos of two women, two men, or one of each, and they were asked to offer their reactions.

The results were startling. They showed a statistically significant tendency for men and women to prefer adverts showing people of their own gender. This tendency was particularly pronounced in the case of women with their preference for seeing female images even stronger than men's preference for male images. This conclusion is paralleled by research from Toyota showing that recall of vehicles is higher among women when the drivers depicted show women rather than men.

Cognitive factors

Cognition is the process of knowing and understanding things in the widest sense, based on our perception of the world and the sensations we receive from it. Cognitive abilities include, for example, our ability to reason verbally or non-verbally (as in mathematics) and the size of the word vocabulary we use in daily life.

Visual-spatial cognitive abilities are used when we are co-ordinating what we see with our understanding of our position in space – vital to the success of the movements we then make to get what we want or where we want.

Diane Halpern is past-president of the American Psychological Association and Professor of Psychology at Claremont McKenna College. She is the author of a book on cognitive sex differences, *Sex Differences in Cognitive Abilities* (2000), in which she describes

sex differences in the visuospatial as the most robust and persistent of all the cognitive sex differences. Her confidence is rooted in an exhaustive review of the published literature on sex-related differences in spatial abilities in 1995. This study, led by Voyer, reviewed 286 studies of visuospatial abilities and concluded that "sex differences in spatial abilities favouring males are highly significant" and that "sex differences in spatial abilities do exist." So confident were the authors that they hoped their study would "close the debate concerning the existence of sex differences in spatial abilities." Other psychologists have followed in declaring the significance of visuospatial differences, with Melissa Hines, Professor of Psychology at Cambridge University and author of *Brain Gender*, showing 3-D rotation skills as the biggest sex difference after height.

A word on terminology. When psychologists report on 'visuospatial skills', they normally refer to three types of ability namely mental rotation skills, spatial perception and spatial visualization. *Mental rotation skills* measure the ability to imagine the appearance of three-dimensional objects rotated in space, whilst *spatial perception* is understood as the ability to determine spatial relations despite distracting information. The third skill, *spatial visualization*, is one commonly described as the ability to manipulate complex spatial information. The evidence of sex differences on all three areas is extremely robust.

Visuospatial skills: origins and modern manifestations

Superiority in 3-D rotations refers to an ability to imagine a 3-dimensional object rotated in space and would provide superior 3-D vision. Remember how challenged the Covent Garden designers were with three-dimensionality? And remember the male obsession with straight lines which led the male Hanzi script to use only straight lines unlike its female equivalent? The difficulties in 3-D experienced by the female designer may have their origin in inferior 3-D rotational skills, while men's obsessive

use of straight lines may be an evolved trait born of millennia of using 3-D vision to track prey against a distant horizon.

That is not all. Since we know that excellent 3-D vision assists with targeting accuracy, men's superior skills would have assisted in guiding and intercepting projectiles. One study, for example, asked men and women to carry out a timing test that involved pressing a key once a moving target hit a stationary line: not surprisingly, women were less accurate than the men. So who enjoys the computer games most in your home? And who is more likely to enjoy a game of darts, football or golf? Equally important, if *she* likes polka dots, it could be very much linked to the thousands of years her female antecedents spent picking berries while *his* fondness for straight lines links to the millennia his forbears targeted prey against a flat and distant horizon.

Language skills

Professor Melissa Hines compared the strength of different cognitive sex differences and has sex differences in verbal fluency as half as significant as 3-D rotations. The low claims for linguistic differences are echoed elsewhere. Professor Doreen Kimura, for example, wrote an article on sex differences in 1992 in which she offered low "effect sizes" (measurements of the size of the sex difference) for linguistic differences. When you look at how low these figures are, you can see why Deborah Cameron, Oxford Professor of Linguistics, in her book *The Myth of Mars and Venus* (2007) plays down linguistic sex differences.

Colour

Not long ago, I was asked to invigilate an exam. Seconds before the exam was due to start, a student shot up his hand: "Excuse me, but should I be using this mauve sheet?" The other invigilator, a Welshman, paused a second: "Yes... but as to whether it's mauve and not violet or purple, you'd have to ask my wife." This is a Welshman with a gift for slick repartee, but there is more than

a kernel of truth in what he says. Men and women do not necessarily perceive colour in the same way.

Four factors may be involved. The first relates to the fact that, compared to men, women may have a greater variety of cone-shaped cells responsible for colour perception. Men's retinas, on the other hand, will contain 130 million rod-shaped cells (photoreceptors) designed to deal with black and white. The greater proliferation of cones in women will lead them to see more colours than men, and describe them in more detail. While for him it will be 'red', 'blue' or 'green', for her it will be 'aqua', 'mauve' or 'apple green'. This is likely to confound even the slickest of car salesmen. The greater variety of women's cone-shaped cells may also explain why women prefer brighter colours.

The second fact relates to the finding that a larger proportion of men (8%) than women (less than half a per cent) suffer from colour blindness and at least 15% of men suffer from anomalous trichromatism (a problem with all three colour pigments). Expressed as raw percentages, these figures may seem rather abstract, but if you translate them into numbers you get a better feel for the numbers affected. The number of British men with anomalous trichromatism works out at four million, with a further two million suffering from colour blindness. This contrasts with about 135,000 females suffering with colour blindness. If you do the calculations for America, you end up with almost 9 million colour-blind males and 600,000 women.

Interestingly, the level of colour blindness in men is not constant across the world but fluctuates with the duration of twilight. The shorter duration of twilight at the equator leads to lower levels of colour-blindness, while the longer periods of twilight at higher latitudes is associated with a greater incidence of colour blindness. Could this explain why the colours of the Oslo underground struck me, with my female eyes, as so strange? Maroons and pale greens together do not do much for me personally.

Joking apart, we should be careful not to present colour-blindness as a disability, not least because it actually confers an advantage in certain situations. How so? Well, colour-blind people can penetrate camouflage that fools everyone else, offering a great advantage to hunters who can better pick out prey against a confusing background. It can also help in active service against enemy lines, explaining why bomber crews in the Second World War liked to include at least one colour-blind member who could penetrate certain kinds of camouflage on the ground.

A third factor may be involved. The bombshell discovery in the last decade has been that anything between 3–50% of women (that is between 96,000 and 15.1 million women in the UK and between 15 million and 250 million in China) have a fourth additional cone between the red and green cones. This additional cone would give women the ability to see vastly more hues than those with only three pigments and would explain why the American interior decorator, Mrs Hogan, can hold up three samples of beige wall paint: "and I can see gold in one and gray in another and green in another but my clients can't tell the difference."

Extra colour pigment

It may be difficult for those with three colour pigments, run-of-the mill 'trichromats', to imagine what a four-colour world would look like. However, mathematics alone suggests the difference would be astounding, says Dr Jay Neitz, a renowned colour vision researcher at the Medical College of Wisconsin. Each of the three standard colour-detecting cones in the retina – blue, green and red – can pick up about 100 different gradations of colour, Dr Neitz estimated. He went on to say that the brain can combine those variations exponentially so that the average person can distinguish about one million different hues. According to a British commentator, John McCrone, writing in

the British medical journal *The Lancet Neurology*, "many women – perhaps 1% – are in fact tetrachromats" with a fourth eye pigment to supplement the three pigments (red, green and blue) that no man to our knowledge exceeds.

McCrone's estimate is typical British understatement since researchers in the US have estimated the percentage of tetrachromat women as somewhere between three and fifty per cent of the gender! The importance of this cannot be underestimated given the effect of an additional colour pigment. To give you an idea, having a single eye pigment allows you to discriminate between about 200 different shades of grey whereas dichromacy (two pigments) swells your colour experience to about 10,000 different shades; trichromacy, the human norm of three pigments, multiples the total number of hues you can perceive to several million; and tetrachromacy, the preserve of an indeterminate number of women, opens the door to literally hundreds of millions of colours. This is explosive stuff. Setting out clearly the information provided in McCrone's article in the medical journal, *The Lancet Neurology*, you can see the incremental increase in colour perception driven by an additional colour pigment:

1 pigment -> 200 shades
2 pigments -> 10,000 shades
3 pigments (trichromacy) -> several million shades
4 pigments (tetrachromacy) -> hundreds of millions of shades

Why should tetrachromacy be the exclusive preserve of women? The genes for the pigments in green and red cones lie on the X chromosome and, since women are alone in having two X chromosomes, it is only in women that a particular type of red cone be activated on one X chromosome and a different type of red cone on the other. In some women, there may also be distinct green cones on both X chromosomes. So, next time you buy *him*

a tie, you might buy navy blues and bottle greens rather than emerald greens and turquoises. On the other hand, if you buy *her* something in bottle greens or navy blues, you might want to make a quick exit!

Blue and red

A fourth factor relates to the fact (discovered in 2000) that males and females produce different cortical responses to the stimulation of blue and red light wavelengths. This exciting finding is consistent with the older observation that women are more sensitive than men to the long-wave spectrum of light that detects red, and that when looking at a field of uniform brightness women hold the perception of red significantly longer than green (during the after-image study, all the female subjects, but only 50 per cent of the males, reported seeing red). It is not surprising then that women have a significant memory advantage for the purple-pink range of colours.

Two recent studies have confirmed women's love affair with pink and lilac. The first, by Dr Yazhu Ling *et al* in 2004, showed how women single out lilac-pink colours from a range of equally light (i.e. bright) colours. The second by Professor Anya Hurlbert and Dr Ling of the University of Newcastle upon Tyne in 2007 tested the colour preferences of 208 volunteers, and it created such a stir that it was reported in the world's media. In fact, the experiment was beautiful in its simplicity. Equal proportions of men and women aged 20–26 (80% were British white Caucasians and 20% recent immigrants to the UK from mainland China) were asked to view 750 pairs of colours spanning the entire rainbow and click the colour they preferred. The results? The male favourite was a pale blue and the female favourite a lilac shade of pink.

Hurlbert was surprised by the results: "Although we expected to find sex differences, we were surprised at how robust they were, given the simplicity of our test." She had expected British

women might prefer pinker shades since Western culture and toys promote pink for its girlishness and femininity. However, the Chinese women in her study showed an even greater liking for pinkish hues than their British female counterparts and they had grown up without commercial toys like Barbie that promote pink to girls. These findings have led Hurlbert to believe that women's attraction towards pinkish colours is innate.

Yellow and orange

These recent experiments have focused on blues and reds but Hans Eysenck, Professor of Psychology at the UK's Institute of Psychiatry from 1955 to 1983 and the psychologist most frequently cited in science journals in his lifetime, undertook a review of colour studies in the 1940s. There he spoke of yellow and orange colours showing the biggest gender difference with women preferring yellow to orange and men the converse. Eysenck was no stranger to controversy and famous (or infamous!) for linking performance on IQ tests with racial origins. It is good therefore to see art historian and colour specialist, Faber Birren (1900–1988), author of 25 books on colour, state that men prefer orange to yellow and that women place orange at the bottom of their list!

Men's seeming fondness for orange may explain why so many companies, for example Easy Jet airlines, Orange and Sainsbury's supermarket, use orange as their main corporate colour. The sixty-four thousand dollar question is whether these colours are optimised for the all-important female element in their markets. I have my personal doubts and can think of colours that would make a greater impact on this target market.

Colour combinations

Colours do not always appear singly so how do men and women's reactions to colour compare? Back in the 1930s, Joy Paul Guilford, Professor Emeritus of Psychology at the University of

Southern California, teamed up with Elysbeth Allen to compare the type of colour combinations preferred by men and women. They found something of potentially enormous significance namely that close colour combinations (i.e. colours that are close to each other on the colour wheel) are more pleasing to women than to men. We discuss colour combinations in Chapter 9 when we look at art so you might want to keep this in the back of your mind.

Meanwhile, there is another interesting question. Do men and women pay equal attention to colour and form? When I was combing the research literature on male and female vision, I stumbled across research from the early 1930s showing that women may perceive *colour* before form, and *vice versa* for men. This research was conducted at the University of Cambridge Psychological Laboratory and those who perceived shape first were described as "form dominant" and those perceiving colour as "colour dominant". This is a fascinating discovery and we can only hope that the study is repeated again. At the very least, new research might show whether this is a contributory factor in women's attitudes to colour. Remember the additional colours that women use when advertising on eBay? Women might describe themselves as "particular" while men might prefer the word "fussy" when describing women's attitude to colour.

Perceptivity

Speaking of fussy, some might say this about women's desire to tidy things away or remove the crumbs from the table. In fact, American researchers Irwin Silverman and Marion Eals charted the elements at work and found that it had less to do with being fussy than observant. They asked students at York University in Toronto to memorise a picture full of objects, and then attempt to recall them (this is a test of 'object memory' which you may recognise from games you played as a child). In a second experiment, the students were asked to recall the location of objects

they'd seen in a room (this is a test of 'location memory'). On both measures of memory, females performed a massive 60–70% better than the males.

Moreover, in experiments using ecologically valid stimuli (technical-speak for real plants in complex naturalistic arrays!), women have been found to display superior object memory (Neave *et al*, 2005). Dr Nick Neave and his colleagues at the University of Northumberland showed five different plants (one at a time) to 30 men and 27 women and then asked them to find the same plants in five separate locations. In one test, women found the targets significantly faster than the men while in another, women correctly located significantly more targets. So next time you find your man's socks, you can quote this study to demonstrate your superior skills!

So good is women's perceptivity that, according to the bestselling book *Why Men Don't Listen & Women Can't Read Maps*, a woman's brain can allow her to receive an arc of at least 45° clear vision to each side of her head, and above and below her nose, giving her a peripheral vision that is effective up to almost 180 degrees. This helps explain why as soon as she walks into a room she can effortlessly pick up details that are hidden to most men while he, with his better forward vision, can best focus on what is straight ahead. Remember *his* reaction when you asked his simultaneous opinion on six different dresses draped across the bed?

Field independence

To complete the picture on visuospatial differences, we need to mention 'field independence', the extent to which men and women perceive something separately from its environment. There is some evidence that men may be more field independent than women, in other words more likely to perceive stimuli divorced from their surroundings (Hyde, 1981; Halpern, 2000). Women, conversely, are less likely to detach themselves cogni-

tively from their surroundings or to be able to make out hidden figures (Hall, 1984).

The consequence? Men can be happy in outfits that don't match (remember that tie?) or with buildings that stick out like a sore thumb. The San Francisco Golden Gate Bridge, for example, was created by an all-male team in 1933, and the clash between the red of the bridge and the blue of the water makes the influence of field independence a real possibility. Another clear example, this time from the UK, is the controversial spiral-shaped extension proposed in the late 1990s to the Victoria and Albert Museum in London's South Kensington. This museum, the world's largest museum of decorative arts and design, houses a permanent collection of more than 4.5 million objects, and thoughts turned to an extension in which to provide more gallery space.

The so-called "Spiral" of New York architect Daniel Libeskind emerged as the winner in a competition and became an immediate *cause célèbre*. Several observers likened it to a pile of falling cardboard boxes or, in Cecil Balmond's words, to "a Hitchcockian staircase in *Vertigo*." The apparent lack of continuity with the adjoining nineteenth century brick and terracotta building was a positive for Balmond; and for Libeskind too, the lack of connection was the essence of the building's attraction. Writing in his autobiography, *Breaking Ground*, Libeskind stated that: "For me, it's not just about the wow, but also about the experience of dislocation, the shock to the system that comes from seeing something jarringly new or unexpected." In his words, the impact on the viewer was to "feel as if you have arrived in another place, between the known and the unknown."

For many, however, the lack of congruity became a major sticking point, and as time dragged by the possibility of Lottery funding disappeared. Some of the objectors were men, showing the tendency for non-homogeneous responses in all areas of visual taste. The tendency for greater 'field dependence' in

women than men would, however, lead women, more than men, to want objects to 'match'. You have only to think about how long most women spend – in contrast to their male counterparts – looking for the right accessories for clothes and for their home to get an idea of this! In fact, a female friend caught me moving the furniture round one day (I was trying to get the right balance of colours and shapes) and I had already come in for a bit of flack and criticism from male friends. I expected something similar from my female friend, when in fact I heard her say that: "I do this a lot and my husband thinks I am out of my mind. It is good to see that I am not the only one with this habit." If a man does not understand the visual discomfort experienced by the woman, then he well might find her actions incomprehensible and indeed infuriating!

Underlying factors

We have already looked at the biological influences on colour perception and an exciting study in 1999 revealed striking gender differences in the part of the brain responsible for 3-D vision. This is the inferior parietal lobule (IPL) and a study by scientists at Johns Hopkins discovered that, after allowances for men's larger overall head and brain size, men had roughly 6 per cent more IPL than women. Another difference was that men had a larger left IPL than right, and the reverse in women.

According to psychiatrist Godfrey Pearlson, MD, the right IPL is linked with the memory of spatial relationships as well as a person's own feelings, while the left IPL is more involved "in perception, such as judging how fast something is moving and having the ability to mentally rotate 3-D figures." This study in 1999 provided a simple explanation for men's superiority at 3-D tasks. It is all the more powerful when you realise that there is a second factor that predisposes men to good 3-D vision. This is the fact that, on average, men's eyes are spaced 5mm further apart than women's thereby allowing the eyes to rotate at a wider

angle and offering better depth perception and stereoscopic vision. Incidentally, it is not just 3-D vision that is improved but long-distance tunnel vision too. Women, lacking this advantage, have better peripheral vision and near-sightedness instead.

Personality

A reminder of another factor at play emerged in a chance conversation with a school leaver on a train. Susan told me that she was planning a career as an art therapist and was undertaking work experience in a primary school. "There is one girl in the class whose drawings are amazing. When she is angry, the lines on the picture are strident and black. As soon as she calms down, the straight lines give way to gentler, more undulating shapes." Welcome to the missing ingredient, personality.

Do you remember the 'Draw a Person Test' and how people's drawings often reflect aspects of themselves? As Susan showed, it is not just physical features but psychological features that can shine through, and there have been some fascinating studies investigating the psychological links between personality and drawings. Some of the first were by psychologists Gordon Allport and Philip E. Vernon who showed in the 1940s how personality shines through in people's expressive and creative movements.

At around the same time another researcher, Trude Waehner, succeeded in producing accurate descriptions of nursery age children and adolescents by studying their drawings and paintings. The key was decoding the language of colour and shapes into personality features with *aggression* interpreted as having a graphic manifesting in sharp edges with fewer than half of the shapes curved; *energy, impetus and initiative* meanwhile were interpreted as manifesting in greater colour than form variety.

A year after Trude Waehner's study, two art therapists Rose Alschuler and La Berta Hattwick did something similar with the

paintings of 2–4 year old children. Those who used curved and continuous strokes were found to be more dependent, compliant, affectionate, unconfident and fanciful than those with straight lines. Similarly, those who drew circles proved to be more dependent, withdrawn, submissive and subjectively orientated than those who painted vertical, square or rectangular forms. The connections led them to observe that:

> almost every drawing and painting made by a young child is meaningful and in some measure expresses the child who did it. Children tend to draw and paint what they are feeling and experiencing rather than what they see.

Fast forward to the present and Judith Harris. Professor of Educational Technology at the College of William and Mary in Virginia wrote that, "Eighty years of research into projective and non-projective assessment of children's drawings suggests that it is indeed possible for characteristics such as... personality, attitudes, emotions and behaviour to be reflected through children's artistic works."

This quote comes from a fascinating article written by Judith Harris in 2007 in which she discusses teachers' ability to assess children's personalities from their graphic creations. There were three sources to this work – free-hand compositions, computer-generated ones and compositions using a touch-sensitive graphics tablet. None of the teachers knew the children, and yet remarkably 69% of their assessments correlated with the views of parents and class teachers. You may be thinking that it is one thing discerning differences in the writing of children whose writing may vary greatly on account of developmental issues, and discerning differences in the writing of adults. In this case, you will interested to read in the next section about work done to make inferences about personality from the drawings of prisoners.

Analysis of prison inmates' drawings

Similar results came from a study in the UK conducted amongst inmates of a therapeutic prison, Her Majesty's Prison at Grendon. The researcher, Bill Wylie, was Head of Art Therapy at the prison, and he set himself the task of judging, from an evaluation of inmates' artistic work, the extent to which the 'artist' was ready to take part in group work. Although he had never met the creators of this artwork, he judged that five of the ten 'artists' were suited to group work and five not. Remarkably, even though Bill's assessments were not part of any assessment process, the five Bill considered unsuited to group work were moved to a non-therapeutic prison within a year.

How did Bill Wylie manage to be so accurate? Bill wrote that "the style and content of the artwork reflects the psychic state of the person" and he offers clues as to how different artistic elements can be interpreted. A negative emotion, for example, tends to be associated with dark colours (black or brown) while yellow and orange are often associated with positive, happy feelings. Meanwhile, the left hand side of the page is viewed as denoting the past, and the right the future so when black is used on the left and yellow on the right Bill interprets this as indicating a negative past but a positive attitude to the future. He writes that the size of an image is also significant and that "appealing figures are exaggerated in size and potentially threatening figures reduced." So, once you know the rules, you can decipher personality using painterly characteristics.

The next obvious question is whether men and women's personalities differ. If they do, and the transfer of personality characteristics to paintings take place, then this would be another factor influencing male and female graphic expression. So the crucial question is whether they differ or not.

Gender and personality

Looking into gender and personality, like so much to do with

gender differences, is a bit of a quagmire but worth wading into with appropriate safety equipment! One team of researchers asked respondents in 25 different countries across the world to choose from a list of 300 adjectives (such as *aggressive, artistic, bossy*) that they thought characterised men and women, and in every one of the 25 cultures a majority of the respondents described women as "sentimental" and men as "adventurous", "dominant" and "forceful". In 24 of the 25 cultures respondents described women as "affectionate" and "sensitive", and men as "aggressive". These stereotypes, referred to in the psychological literature as *gender schemas*, are well defined and ubiquitous.

The divergence in men and women's levels of aggression are such that even Professor Janet Hyde, originator of the "gender similarities hypothesis" (which holds that men and women are more alike than different), acknowledged that men are more physically aggressive than women. In comparisons of the results of different studies, she found significant differences on aggression of all types – including "direct aggression", "physical aggression" and "indirect aggression" as well as on physical aggression. These are important differences and you might think that they would manifest in the drawings that people produce.

In fact, the art therapists Alschuler and Hattwick, writing in the 1940s about children's drawings and paintings, described how they were able to infer personality from their drawings. They said that the girls' use of colour was more "intense and persistent" than the boys', something they put down to girls' greater emotionality; by contrast, they put down the strong colours and heavy, vertical strokes in the boys' pictures to "masculine tendencies".

Underlying factors

Arguably the most controversial question concerns *why* these behavioural differences occur. I am not ducking the issue if I say that in the short space of this book we cannot go into this too

deeply. My own view, for what it is worth, is that a mixture of nature and nurture is at work, with nature very likely serving the cause of evolution. You will see what I mean in the sections that follow.

Nature and brains

In *The Female Brain*, doctor and psychiatrist Dr Louann Brizendine (2006) explains the dominant role played by hormones in human behaviour. She became aware of this as a student when she asked a professor at Yale about the gender of subjects in a particular experiment. His reply was that they never used females since "their menstrual cycles would just mess up the data." Even so, it took decades for the medical scientific community to recognise that, medically, women were not just small men. "When these patients with PMT problems tried to talk to their own doctors or psychiatrists about how their hormones were affecting their emotions, they would get the brushoff."

Brizendine now works as a gender-specific psychiatrist at the Langley Porter Institute in San Francisco, treating about 600 women a year. In her view, hormones can "create a woman's reality" (p. 3) shaping "women's desires, values and the very way she perceives reality." Early oestrogen can stimulate the female brain circuits and centres for observation as well as communication, gut feelings, tending and caring. "Genes and hormones create a reality in [women's] brains that tell them social connection is at the core of their being." The hormones do not cause the behaviour but "raise the likelihood that under certain circumstances a [certain] behaviour will occur."

It seems that our brains are shaped by hormones. Up to the beginning of the eighth week of life, all brains start as female brains ("female is nature's default gender setting") and then once testosterone kicks in the male brain takes shape. At peak age, around twenty-one, men have eight times the volume of testosterone as women, and if testosterone is administered to non-

human female foetuses late in gestation more typically masculine behaviour results.

By analogy, the Japanese study we looked at earlier showed that girls with an overproduction of adrenal androgen, a male hormone, produce pictures that display "more strongly masculine characteristics in motif, color and figure composition... [with] scanty depiction of persons, dark-colored drawing, stacking, bird's-eye views and mobile objects." The feminine index for the pictures of these girls is *significantly* lower than for unaffected girls.

We should not be surprised by these results. It seems that in utero and postnatal exposure to gonadal steroids (principally testosterone and estradiol) is associated with differential personality and spatial abilities in humans and some animal species. It also appears that exposure to androgen (the male hormone) during foetal life promotes the differences in male vision we have noticed. Moreover, other studies show us that girls with an *overproduction of adrenal androgen* have better spatial ability than unaffected girls, with notably better performance in mental rotation tests.

So, hormones shape our brains; and according to research published in December 2013, there are significant differences in men and women's brains. Part-funded by the National Institute of Mental Health in the US, this is a mammoth piece of research with a roll-call of heavyweight co-authors and nearly 1000 participants. The study's ten authors include Ragini Verma, Associate Professor in the Department of Radiology at the University of Pennsylvania in Philadelphia and colleagues Ruben Gur, Professor of Psychology and Raquel Gur, Professor of Psychiatry, Neurology and Radiology, both Directors of the Brain Behaviour Laboratory in the same University's Perelman School of Medicine.

Verma summarised the results:

What we've identified is that, when looked at in groups, there are connections in the brain that are hardwired differently in men and women. The study found a greater degree of neural connectivity from front to back within one hemisphere in males... women's brains meanwhile were wired between left and right hemispheres... facilitating communication between the analytical and *intuitive* [functions].

The experimental base to these results was massive with research conducted on no fewer than 949 individuals with participants consisting of 521 females and 428 males aged between 8 and 22. The sample size makes this one of the largest ever conducted scrutinising the "connectomes" that link different parts of the brain, with a special brain-scanning technique ("diffusion tensor imaging") measuring the flow of water along a nerve pathway.

Interestingly, the research found that the brain differences between the sexes only became apparent after adolescence, suggesting perhaps a role for hormones. Moreover, while conceding that some individuals will differ, Verma makes the strength of the study's conclusions clear by saying that the differences are "hard-wired" and illustrative of "fundamental sex differences in the architecture of the human brain." The significance of these differences in the connectomes is of course a matter for debate; but according to the article's authors, the greater single-hemisphere connectivity found in men's cerebrum, and greater inter-hemisphere activity in their cerebellum gives men an efficient system for coordinated action including map reading. The reverse system of connectomes in women's brains is hypothesised as facilitating the integration of analytic and intuitive thinking. Of course, we will have to wait for further studies to confirm these consequences.

Controversial territory

Talk of biological differences in cognitive behaviour tends to

cause earth tremors in sociology and gender studies common rooms since they cause havoc with the belief that all gender differences are 'gendered' through social rather than biological activity. Sandra Witelson, Professor of Psychiatry and Neuroscience at McMaster University, in Ontario, Canada, is happy to acknowledge differences in male and female brains since she believes that gender shapes male and female brains but she acknowledges that many will not want to accept this. As she aptly says: "There is a large segment of the population that wants to pretend this is not true," something that she finds "astonishing" since "it is so obvious that there are sex differences in the brain and these are likely to be translated into some cognitive differences."

Another Professor aware of the academic minefield that is discussion of gender differences is Simon Baron-Cohen, Director of the Autism Research Centre at Cambridge University. He waited several years before writing his interesting book, *The Essential Difference*, since it was "politically sensitive" to discuss gender differences. If you look at the website of another academic, Helen Haste, Professor of Psychology at the University of Bath, you can glean a sense of the range of opinions in this whole area since Helen Haste takes the view that "... beliefs about sex difference served the needs of a patriarchal society, and were largely illusory distortions." In her opinion:

> The duality of gender maps on to the much deeper cultural metaphor of dualism which permeates Western thinking, and both reinforces it and is reinforced by it. To challenge distorting stereotypes of gender requires challenging the underlying cultural metaphor of dualism.

Professor Haste's views – appearing on a website with a patterned pink-mauve background! – are at polar odds with those of Professor Baron-Cohen, Witelson and Brizendine but

consistent with those of a significant proportion of other academics. Melissa Hines, previously mentioned Professor of Psychology at Cambridge University and author of *Brain Gender*, is concerned about the dangers of making assumptions about gender differences, something she regards as "stereotyping". She expresses concerns at some of the links described by Brizendine and concern that people will use the information "to indicate that all our stereotyping of males and females are biologically innate." She prefers to emphasise the extent to which "the brain is changeable; it changes all the time" (Midgley, 2006). In fact, the changing nature of the brain is a shared focus of both Professor Hines and Dr Brizendine since the latter points out that biology is just the starting point, with experience also shaping our brains. A 2013 study published in the journal *Sex Roles* by Reilly and Neumann bears this out since it found a link between spatial ability and men and women's identification with concepts of masculinity.

This interactive impact of biology and experience is all-important; and in 2001, as mentioned earlier, I co-authored an article with Andrew Colman, Professor of Psychology at Leicester University in which we touched on these issues. We were presenting our findings on male and female preferences for male and female-designed Christmas cards and, in explaining the strong evidence for 'own-sex preference', we argued that a cultural explanation may have its uses but that it merely pushes the problem back a step. An explanation is still needed as to *why* toys and other cultural objects tend to be gender-typed and *why* culture may have encouraged men to prefer functionality over aesthetics. Our conclusion was that an approach that embraced the importance of experience and biology, nature *and* nurture, offered the best way forward.

This way of thinking led Eleanor Maccoby, Stanford University Professor Emeritus of Psychology, and author of *The Two Sexes: Growing Up Apart, Coming Together*, to argue that

environmental conditions can impact behaviour directly as well as indirectly by altering biological processes. As she puts it, "Nature and nurture are jointly involved in everything human beings do" (ibid, p. 89). Meanwhile, Leslie Brody, Psychology Professor at Boston University, has progressed the debate in her fascinating book, *Gender, Emotion and the Family* (1999), where she explores ways in which males and females express emotions in families. She discusses how certain aggressive or dominant behaviours (e.g. winning a competition) can actually trigger a rise in testosterone levels showing how social processes can influence biology through adjustments in hormone levels. Of course the ultimate example of the way human behaviour has shaped biology is evolution theory; and in the next section, we explore exciting new thinking on the way that evolutionary pressures have shaped our visual-spatial abilities.

Evolution

One view is that men and women's visual-spatial skills emerged as a result of a division of labour in prehistoric society in which women gathered food, constructed the homes, reared the children and ensured the coherence of the group, while men tracked and targeted moving prey against a distant horizon.

The prehistoric period we are referring to spanned 1.7 million years from the oldest part of the Stone Age (the Lower Palaeolithic) to the end of the Pleistocene epoch about 10,000 years ago. At that point, environmental pressures from the last Ice Age brought an end to the hunting/gathering lifestyle and encouraged a move to a more stationary way of life. Until then, and for much of human evolution, men and women's vision evolved to deal with the hunter/gatherer lifestyle.

Such, anyway, is the theory of several prominent academics. The sex differences in brain connectomes, for example, discussed earlier, has come to be called the hunter versus gatherer divide by two of the study's main authors, the husband-wife team of

Raquel and Ruben Gur. Then there is the work of David Geary, Professor of Psychology at the University of Missouri in Columbia and author of the definitive book on cognitive sex differences, now in its second edition, *Male, Female: The Evolution of Human Sex Differences*. Published by the American Psychological Association, this explains cognitive differences as evolved reactions to evolutionary pressures on men and women. This theory is shared by Irwin Silverman, Professor of Psychology at York University, Canada, and Marion Eals whose work on object and memory location we touched on earlier. Remember how women can trace the matching sock much more easily than men? Arguably, these behaviours are rooted in a much earlier period of human existence when women were spending substantial periods gathering food and men were out hunting.

Hunter skills

Professor Silverman has written extensively on the range of skills that would have assisted the successful hunter, and in an article written in 2007, he expanded on the evidence for his theory. Meanwhile, in the same year, an article appeared linking these hunting skills to male-typical design features such as linearity, lack of colour, three-dimensionality and focus on movement. This broke new ground and the authors were myself, Dr Nick Neave, Reader in Psychology at Northumbria University, and his colleague, Dr Colin Hamilton.

Remember the earlier cases of difference? Men's adverts on eBay contained fewer colours than the women's and since much of a hunter's task involves focusing on a distant horizon (where objects look dark) colour vision is not needed. Instead, colour blindness is at a premium since it helps see past camouflage and this may be an explanation for the high proportion of men with this condition. The lower priority given to colour may also be a factor in men's privileging of form over colour.

Then we saw how men's chocolate boxes were more three-

dimensional in shape than the women's, linked perhaps to men's superior 3-D vision. In evolutionary terms, good 3-D vision served a number of functions. It helped hunters with route learning (they need to travel big distances so need accurate directional orientation), helped with calculating the distance of faraway objects, and also helped with targeting prey. It is strange to think that we can see a legacy of these vital skills lies in the contours of a chocolate box!

You may recall also our earlier discussions concerning men's tolerance of visual dissonance? We considered how male-designed buildings and structures in London and San Francisco showed a high tolerance of dissonance and suggested that these structures illustrated men's greater field independence. This is the ability to perceive stimuli independently of its environment and this trait would, like colour blindness, have helped hunters isolate prey from its environment. It is a somewhat chilling thought that men's colour blindness sharpened their killing skills, but then the same could be said of the whole panoply of male visuospatial skills.

Take men's *penchant* for straight lines for example. You probably remember the case of the doctor who spoke of his fondness for squares and rectangles, or the student who repeated the straight-sided octagon shape even when instructed to create something with rounded sides. This apparent obsession with straight lines could well be a hangover from a repeated focus on the distant horizon where things look straight.

Moreover, you may remember men's passion for simplicity and unadorned surfaces – whether it is Professor Maeda's 'Laws of Simplicity', Jakob Nielsen's rules for web usability or the doctor who talked of his preference for plain surfaces – and these preferences could also have their roots in a prehistoric lifestyle in which men's role as hunters forced them to target prey against a distant horizon where detail and bright colours could not be seen.

Meanwhile, women's prehistoric experience as foragers and childminders left a rather different imprint. It is to this that we will now turn.

Gatherer skills

You probably remember that women advertisers on eBay used more colours than men, and this too could have a prehistoric origin since excellent colour vision would be needed for foraging and locating food sources within complex arrays of vegetation across several growing seasons. In fact, the human ability to perceive colour is thought to have evolved 35 million years ago as a way of increasing opportunities for rooting out fruit and leaves for food. The knowledge that a large proportion of men rather than women (8% as against ½%) are colour-blind and that the use of a fourth colour pigment ('tetrachromat' skills) is the preserve of women points to the fact that colour perception and therefore foraging were concentrated in the hands of women.

If you think about it, this is entirely logical. Foraging would demand good colour vision but would also call on the ability to recognise and recall the details and location of objects. In fact, women's superior skills in these areas have been amply demonstrated by researchers. Silverman and Eals, for example, demonstrated women's superior abilities in object location and memory, and Dr Nick Neave and his colleagues at Northumbria University in the UK went further and tested men and women's memory of ecologically valid stimuli such as plants. They demonstrated in a very convincing way that women could locate plants more quickly and accurately than men, and associated women's strong object location memory with foraging for berries. Maybe women's adaptation to picking small rounded objects is a factor in women's fondness for detail and their love affair with polka dots in particular?

So exciting were Nick Neave's findings that I took a four hour train journey up to Northumbria to meet him and his colleague,

Dr Colin Hamilton. Out of this visit came the article that we co-authored exploring the legacy of evolution on male and female design aesthetics. When discussing colour, we noted that women's colour vision was adapted not only to foraging but to caring for babies. Remember how the researchers at the University of Newcastle upon Tyne found a female preference for pinks? Well, the female heightened sensitivity to pink made it possible for women of light-skinned races to pick up on changes in skin colour and, through that, changes in temperature and mood. This sensitivity to colour would also have enabled them to gauge the moods of others in the encampment, a vital skill when men were absent for long periods hunting.

As well as colour, the article also discussed women's *penchant* for round shapes – remember how all the women's chocolate designs were rounded – and how this ensured female bonding with vulnerable and sometimes screaming children. In fact, predisposing women to rounded shapes could have had an evolutionary function, especially since the famous zoologist Nikolaas Tinbergen noticed that the faces of all mammalian young have rounded, appealing faces.

Of course, you must bear in mind that the division of labour which operated over millennia of hunter-gatherer activity is probably different from the division of labour that operated subsequently in more settled, agrarian periods. In hunter-gatherer days, according to anthropologist Robert Briffault, women's responsibilities included painting, pottery and house building as well as foraging and childcare. The long list shows that quoting this research is not to advocate a return to the ghetto of child rearing and the kitchen since women in prehistoric times were the designers and architects as well as childcare experts! In point of fact, authors Professor Sherwood Washburn and Ruth Moore argued, in their book *Ape into Man* (1974), that human biology has evolved as an adaptive mechanism to conditions that have largely ceased to exist. This means that we live with the

biological legacy of an older division of labour and see it reflected in the visual work men and women produce. The gatherer way of life can be seen reflected in rounded shapes, detail, static forms, colourfulness and two-dimensional forms, while the hunter lifestyle can be discerned in linear and 3-D shapes, dark and sparse use of colours, lack of detail and interest in moving forms.

Hunter and gatherer way of seeing

A note of caution is called for. Not all scholars agree with Silverman's Hunter-Gatherer hypothesis. For example, Diane Halpern, Professor of Psychology at Claremont McKenna College, is one with doubts; but a number of scholars are of a like mind, and for good reason. In my opinion, it is a model worth considering as we wait for new research to come to light.

Meanwhile, it is time to put scientific theory to one side and explore the implications of our different ways of seeing for the world around us. As we move into the second part of the book, we draw on the findings discussed in this first part to see what this means for design, advertising, architecture, the Internet, fine art and relationships. In leaving the shores of science, with its justifiable concerns to make observations only from well-

constructed samples, we allow ourselves the privilege of making observations from single examples and anecdote. Reader beware! As you turn the page, and move into the province of anecdote, you are replacing the safe shores of scientific endeavour in favour of observations that are not founded on irreproachable methodologies. This is not science but an informed exploration of the impact of the science on the world around us. I hope that you enjoy the ride into these new territories.

Part II

The implications

Chapter 5

Design

Your products run for election every day and good design is critical to winning the campaign.
AG Lafley, Procter & Gamble CEO, 2005

Choosing garden furniture

It was a freak hot summer and the garden was the obvious place to have our meals. Only problem was that the table and chairs were on their last legs and would not survive the next few months. "No problem," I can remember saying, "I'll pop down to the local store and get a new set."

My house is a traditional one in a leafy area and I was picturing some pretty garden furniture, white with curves but not too ornate. Incidentally, the local store is part of a huge supermarket chain, one of the biggest in the country, and most towns and cities have two or three of these hardware stores, so they have quite a big product range, from paints, to wood, to garden plants to garden furniture. My mood was definitely upbeat when I arrived since I expected to make a quick purchase and return home for a pleasant meal *al fresco*.

This was not to be. All that was on display was wooden furniture or dark brown or grey furniture, all very square in appearance. My vision of a dainty white table and chairs with curvy sides might just as well have been from another planet. These were monstrous, heavy pieces of furniture with no hint of summer about them. As if to complement this dour, wintery feel, the outsized barbecues displayed endless dark and chrome surfaces leaving one wondering who on earth could dream up so many configurations of barbecue – "pedestal barbecues", "square barbecues", "4 burner barbecue" "kettle trolley

barbecue" – and who could possibly be buying them? The blurb for a Swiss 4 burner barbecue, a snippet at 1.5 metres long (4.5 feet) of grey steel was: "The perfect barbecue for those seeking simple sophistication in the garden. Great to look at." Short of a mix-up in the catalogue, one had to assume that this was someone's idea of heaven. Whose?

The catalogue went on to describe the infrared rear and side burners known as grizzlers, "the microwave of the outdoor kitchen". More details followed: "The Grizzler is an infrared searing station that is designed to seal the juice into meats as well as being used for normal grilling or cooking. The Grizzler produces phenomenal instant heat enabling efficient burning."

Could these be aimed at the hunter of the species?

More clues followed from a jokes website *Funny2.com* giving the chain of events for preparing a barbecue:

1. The woman buys the food.
2. The woman makes a salad, prepares vegetables, and makes dessert.
3. The woman prepares the meat for cooking, places it on a tray along with the necessary cooking utensils and sauces, and takes it to the man who is lounging beside the grill – beer in hand.
4. THE MAN PLACES THE MEAT ON THE GRILL.
5. The woman goes inside to organize the plates and cutlery.
6. The woman comes out to tell the man that the meat is burning. He thanks her and asks if she will bring another beer while he deals with the situation.
7. THE MAN TAKES THE MEAT OFF THE GRILL AND HANDS IT TO THE WOMAN.
8. The woman prepares the plates, salad, bread, utensils, napkins, sauces and brings them to the table.
9. After eating, the woman clears the table and does the dishes.

10. Everyone PRAISES THE MAN and THANKS HIM for his cooking efforts.

The clues were getting warm when a thought piece by *Guardian* journalist Mike Power appeared:

> All over the UK, probably the world, the barbecue is now one of the last places where even normal blokes become sexist. What we have here is... a biologically deterministic blizzard... that sees women as salad-spinners and men as the keepers of the grill, the tenders of the flame, lords and masters of the meat!

An Australian experiment provided the final, definitive clue. A man asks a group of men at a barbecue who is going to prepare the salad: "Is that you, mate?" he asks one of the blokes. "Certainly not, that's the lady's job," comes the answer. The Australians should know since more than 70 per cent of Australian homes have a barbecue with half a million new ones sold every year. The concluding remarks of Professor Colin Groves, at the Australian National University, clinch the evidence. According to him, control of the food and the fire was all about power. "Because the possessor of the meat, the source of the prestige food, is the one who's going to impress females," says Professor Groves.

So much for the barbecue. I returned home in pursuit of perfect table furniture and imagined that it was to be found minutes away with an Internet search. Two hours later, I was still looking and beginning to wonder if I would ever find what I wanted. The next day, the search was resumed in earnest and after another two and a half hours, the perfect white set was found. I had been halfway round the world and back before I found this – had seen some wonderful things in South Africa but delivery to Europe was not offered – so it was all the more appre-

ciated once tracked down. It now sits in my garden and fills it with elegance and beauty.

Goodness only knows who retailers think that the modernist-brutalist furniture is aimed at. In actual fact, a survey of 2000 people by the Arthritis Society found that women are largely responsible for sourcing garden furniture and so the predominance – in the UK at least – of the hunter look would seem to be way out of kilter with the customer demographics.

When you consider that few retailers have anything approaching a gender balance on their boards, this is perhaps not so surprising. The *Huffington Post* conducted some research in 2013 regarding the gender balance on retail boards and discovered that fewer than 15% have achieved the target of having women make up 30% of their board, with companies in this category including Tesco (at 30.8%), John Lewis (at 30.8%) and Asda's parent company Walmart with a massive 55.6% female representation at the top. Of the rest, a massive 20 per cent had **no** women on their board – a group that included Matalan and the giant Arcadia Group (Top Shop, Dorothy Perkins, Wallis and others are part of this group) and 30 per cent had just **one** woman on their boards – these companies included Alliance Boots (the owner of Boots), Next, Amazon, Aldi, Primark and Ikea.

The absence of women is just mind-boggling since women will be the majority consumer for all these retailers. In fact, the *Huffington Post* asked business analyst Nick Hood at Company Watch to compare and contrast the 50 retailers, and look for trends between those with mixed boards and those with all-male groups at the top. The results were fascinating since the boards of the male dominated companies have had 70% more risks than the mixed ones and a debt ratio of more than 100%. High debt levels were described by Hood as "toxic in a sector which is hugely capital intensive and has fragile profit margins" which are easily driven down to unviable levels by consumer pressure. Probably

most striking of all, according to the paper, is that half of the male-only retailers were in Company Watch's 'warning area' compared to just 16% of the mixed board companies. No wonder it was difficult to find pretty garden furniture.

Understanding the customer

The irony is that business guru Michael Hammer wrote eloquently back in the 1990s about the importance of shaping products or services around the "unique and particular needs" of their customers. He said that having a clear understanding of who the organisation's customers are is the first step in a marketing plan, and the second is appreciating the customers' needs. Had the store buyers factored gender into their calculations as to the best furniture to supply to the market?

In fact, most market research data is focused on socio-economic and geographical variables and one is hard-pressed to find data on gender in mainstream market research reports. This does not make sense since it is increasingly widely recognised that women make 80% or more of purchasing decisions. Paco Underhill, the retail guru with a client list that reads like a *Who's Who* of retailing, writes in his book *Why We Buy* (1999) that: "Shopping is still and always will be meant mostly for females. Shopping *is* female." He goes on to say that:

Men will breeze through the store and pick up the head of lettuce on top of the pile and fail to notice the brown spots and limpid leaves; a woman will palpate, examine and look for lettuce perfection... women demand more of shopping environments than men do and take pride in their ability to select the perfect thing whether it's a cantaloupe or a horse or a husband.

As a result of this perfectionist streak, he concludes that: "women are capable of consigning species of retailer or product

to Darwin's dustbin if that retailer or product is unable to adapt to what women need and want." The consequences, portentously evoked by Underhill, are "like watching dinosaurs die out."

Some other commentators have recognised the fact that most consumers are women. David Ogilvy, for example, founder of the one of the world's largest advertising agencies, said that: "The consumer is not a moron. She is your wife." And Michael Silverstein, senior partner of the Boston Consulting group in Chicago, has said that: "Today's woman is the chief purchasing agent of the family and marketers have to recognize that." In fact, in 2009, Silverstein vividly painted a picture of the opportunities afforded by the female consumer as: "$5 trillion of incremental spending over the next several years – is larger than the commercial potential represented by the growth of the consumer economics of India and China." So great, in fact, are these perceived opportunities that Tom Peters, author of *In Search of Excellence* and *The Circle of Innovation*, predicted that women will be the future primary consumer.

Many of these commentators are based in the US but not exclusively. Two leading commentators, authors of *Why Women Mean Business*, are based in Europe with Avivah Wittenberg-Cox in France and co-author Alison Maitland in the UK. Their book leads with the memorable battle cry that "Gender is a business issue, not a 'women's issue'," framing gender as a matter of strategic rather than ethical importance. "The under-use of women's talent has an impact on the bottom line," they say and much of my own work on design and marketing bears this out.

The starting point for much of this thinking is the realisation men and women in particular have significant importance as consumers. I discovered this back in the 1990s when I started this research and there was very little data on the gender of consumers, conducting primary research to find answers. Starting with consumption patterns in the UK and analysing data from the Target Group Index and the Family Expenditure Survey

(a survey of 7000 households in the UK), I found some fascinating data on sectors to be dominated by female purchasers:

Products in which men are the main purchasers or decision-makers
Alcohol, garden tools, petrol, records and DVDs, sports goods and video cameras, computers, fridges, washing machines and SLR cameras.

Products in which women are the main purchasers or decision-makers
Groceries, homes, books, china and glass, cosmetics, kitchen equipment, furniture, chocolate, jewellery, cameras, small electrical goods, stationery and toys.

There are of course also markets in which men and women play a more equal part in the decision-making and purchasing process, the case for example with telecommunications, online banking, higher education and, as we saw earlier, green electricity.

Moving from the UK to the US, we find women described as the "majority market" and controlling "far more money than they ever have in history – $7 trillion in consumer and business spending combined, to be exact – a number that exceeds Japan's economy" (Warner, 2005). Women's financial power spurred the *Economist* to coin a new phrase, "Womenomics", and Danish international guru Benja Stig Fagerland in a similar vein refers to the "SHEconomy" and the fact that "more women as leaders means a strengthened bottom line!" Many commentators, Benja included, write about women's massive purchasing power and the prediction that over the next ten years women will control two-thirds of the consumer wealth in the US.

Data like this is vital. Once companies know who their customers are, they can plan how best to target them, something

impossible without a single-minded focus on the customer and the target market. It has been amazing to see in the course of working with big companies how few have an understanding of the demographics of their customers. So, when asked to run a workshop on website design for one of the largest global car manufacturers in 2007, my first question was for a gender breakdown of the target market. Weeks later, a sketchy report arrived from a bijou marketing agency but with little hard data on purchasing patterns. No wonder that this company's website had a boy's own look to it, similar to that of many football teams, with photos of gleaming cars set against a square background. During my workshop, I passed on the all-important information that more than half of all new car buyers are female, the company made moves to change the character of its website, showing images of women opening car boots and waiting for roadside assistance. These may always be images of women in their twenties (eye candy for men!) but it is a first step in recognising and reflecting the target market.

So important is the motor industry, in fact, that it is worth spending a few moments considering the products it designs for a changing demographic. From there, we will go on to explore other sectors. In the next chapter, we will put the spotlight on advertising and consider how responsive this sector is to a changing demographic. Meanwhile, back to the motor industry and the attitudes that I encountered. How typical were these?

The motor industry

It turned out that the challenges I encountered with the global motor company were not one-off problems. According to Dr Andy Palmer, executive vice-president of Nissan, half of women are unhappy with their cars as well as the sales process (the sales patter of predominantly male showroom salesmen is the problem area), and he talks of his industry "failing the largest and most influential customer segment in the world." The vast majority of

cars are designed by men and only rarely will you come across the odd (in some people's estimation, very odd) one designed by a woman.

Andy Palmer is not alone in identifying the "mega trend" of female car buyers. In France, Vincent Dupray of the Automotive Department at TNS Sofres estimated that women had a strong role in car purchases: "One motorist in two in France is female and women account for one-third of the new vehicle market" (*Peugeot Citroen* Magazine, 2008). Women also make up 40 per cent of the main users of a vehicle in France.

In Britain, according to the Technical Director of the Royal Automobile Club (RAC), David Bizley, the latest report on the changing demographic of drivers shows the number of licensed female drivers rose by 23 per cent in 1995–2010 with the number of young male drivers actually falling. In his words, this is a new situation since "until comparatively recently, there were always more male than female drivers". He acknowledges that the old situation caused "a level of bias in terms of vehicle design" but how easy can change be?

Ford now has a Women's Product Panel while Renault's customer knowledge department and General Motors' interior design department are headed by women. Despite these efforts, however, Nissan's Andy Palmer says that: "generally the car industry is not seen as female friendly." David Ahmad, course leader on the MA in Car Design at London's prestigious Royal College of Art, concurs when he says that the macho culture in the car industry means that a woman would have to "brave the boys-and-toys world if she wanted to succeed."

So, apparent signs of change can in fact be misleading. Jane Priestman, for example, the eminent designer who used to advise Jaguar cars on design, told me that she was only ever allowed to offer advise on the *inside* trim of the car. A similar story relates to Anne Asensio who, in 2000, was appointed Design Director for medium-sized cars at Renault and then

moved to General Motors as head of GM's brand studios' designers in charge of Cadillac, Chevrolet, Buick, Pontiac, Oldsmobile and GMC. However, at the time she left GM, her job had shifted to Executive Director of Interior Design, showing that the company had moved her to a role focusing on the car interior, a fate that echoed that of Jane Priestman in Britain. Reflecting on the position of women in the industry, she told the *Automotive News Europe* Congress in Prague in 2007 that if the motor industry did not involve more women in its product decisions, it risked becoming irrelevant. "The industry doesn't need cars designed for women but by women," she told the gathering.

What would this mean? According to Valerie Nicolas, Colours and Materials designer at Citroen's styling centre: "Women do not have the same expectations as men. They are more receptive to criteria such as safety – particularly for children – economy, respect for the environment, easy maintenance, compact dimensions, convenience and easy handling. And, of course, women are highly sensitive to styling, often more so than to power and performance." Statistics prove Nicolas right since, according to Girlmotor.com, more than 80% of women drivers choose their first car solely on the hue of the paint. "Colour sells cars," says motoring journalist and broadcaster Quentin Willson, so it makes business sense to pay even greater attention to colour.

With colour we are talking about style and this is the area which is nearly always an all-male preserve. Remember the Women's Product Panel established by Ford? Well this is concerned largely with practical issues such as the handling of the car and the reachability of the instrument panel. Decisions concerning the 'look' of the car exterior are rarely shared with women and this is potentially a big mistake given the differences in male and female aesthetics exposed by the new science of perception. So, whilst we know what cars produced by men look like – 99.9% of cars are designed by men – what do cars by women look like? To the best of my knowledge, only one female-

designed car has ever gone into commercial production, but two concept cars have been created – one by Volvo and one by a French artist. All offer fascinating glimpses into an automotive world that we rarely see.

Take the commercial car. The exterior of the BMW Z4 2009 sports car was designed by Juliane Blasi who studied transportation design at Germany's Pforzheim University, one of the oldest design programmes in the world. The car was a great commercial success and is absolutely beautiful. "If the car wants to be emotional and sexy, it needs to speak the language of people and not the language of a product," she says. "I wanted the car to be balanced and flat all over," and she speaks eloquently about two lines on the car body: "We have a line from the headlight to the side of the car, and then you have the other line which is very short and which shows the overall proportion: these two lines work perfectly together." Significantly, the lines are curved and do not form a single straight line but work together in magical counterpoint.

The concept cars predate this by just a few years. In 2004, Volvo went the extra mile and created a car, 80% of which is designed by women. Volvo is no shining light where women's careers are concerned since only one in ten of its managers are female, compared with twice as many in its parent company Ford. However, a dismal record of sales to women in Europe is what it took to get this project off the ground, showing that poor sales can be a great incentive to change.

What is this new concept car like? Many of the new features are practical ones, often the main focus of manufacturers seeking to draw in the female user. For example, the surface has a dirt-repellent paint finish which behaves like the coating on a non-stick pan. This means that dirt finds it hard to cling to the surface and, if it does, will wash off fairly easily. A simple idea but one that the Volvo team found in New York in the paint used to coat garbage trucks. Other ingenious features include special

compartments inside the car's bodywork for an umbrella, key and coins, and back seats that fold down like cinema seats. There are even gull doors that make it easier to climb in, and an aperture near the nozzle in which you can pour in screen wash.

Not everything that's new about this car is practical, however. Some of the features that you won't have seen anywhere else are purely aesthetic in value. Where else, for example, would you find a silvery roof fabric that can shift its colour from green to gold or blue to yellow depending on the interior décor? Where else would you find a selection of carpets and seat covers that you could use on different occasions and weathers?

You may think that this is a one-off, and that we should not infer too much about women's tastes from this one car, but you might be mistaken. Remember, Girlmotor.com claims that more than 80% of women drivers choose their first car solely on the hue of the paint. Since there are so few women working in the automotive industry, we have to get our clues as to what they like from elsewhere.

Tucked away in an art gallery in the exclusive Place des Vosges in Paris are some precious clues. The paintings on the walls show flowers painted in vibrant colours, but on the coffee table are scrapbooks describing the life of the artist. Swirling handwriting tells the remarkable story of Céline Chourlet who held her first exhibition at the age of sixteen and went on to open this gallery at just 24 years of age. They also reveal what you are least expecting and that is that she was commissioned by Chrysler cars to paint a Chrysler PT cruiser. The end result is unlike anything that you will have seen in a car showroom. If you are curious, you can see it on her website (www.chourlet.com) or go to Detroit to the Chrysler Museum to view the real thing. Detroit is the epicentre of the car industry, the place where close to one million cars were produced in the last century. However, even Detroit is unlikely to have seen anything like this before.

For a start, the car is covered in flowers, and why not? Céline

describes the car as a "garden on wheels" and the workshop where she ("a dressmaker for the car") created it, as a "beauty salon" for cars. While some readers may recoil at this, they would at least recognise that this is at least a departure from the techno-obsession and aggressive imagery found in motor magazines. Here, for example, is a description of the same CPT model from *Canadian Driver* magazine "… this 'gangster' car, all wrapped in bulging fenders, flared sills, wide wings, bullet-shaped tail-lamps and deliciously brilliant chrome door handles has a lot to offer…"

You can see that the two approaches are worlds apart and we should not sit in judgement as to which is better. Neither approach is better, just worlds apart. These differences in men and women's tastes came to the forefront when I was chatting to a Russian Market Research expert with a PhD in psychology from Oxford University. "I've found that women I know like cars like the Nissan Micra, the Nissan Figaro and the Mini, cars that are small and round," he went on. "Although these are good from a technical point of view, I wouldn't want these if you paid me." His colleague, Anthony, fresh from a Master's in Human Computer Interaction, nodded approvingly. "These don't seem like serious cars – more like toys. A real car would be the Lamborghini Countach." This is a boy's own car, the sort that Action Man would not be without.

Maybe, with time, the designed world will reflect better these different worlds, and you, as consumer, will have more choice. Meanwhile, the car industry is going through a difficult patch. In 2013, Europe has seen the lowest car sales on record with the statistics making gloomy reading. As the author was putting the final touches to the book in September 2013, the European Automobile Manufacturers' Association announced a drop in new registrations between January and August of 5.2 per cent, corresponding to a drop of 7.8 million cars. Some countries were hit worse than others with sales in Spain slipping 3.6 per cent,

German sales dropping by 6.6 per cent, Italian by 9 per cent and French sales by 9.8 per cent. Cumulatively, Fiat, Ford, General Motors and Peugeot are expected to post a combined £5 billion loss in 2013 in Europe. Interestingly, premium brands such as BMW, Mercedes-Benz and Jaguar Land Rover saw sales grow so the downturn is not inevitable.

So much for the world of cars. What of the world of household goods? Are these perfected to their end-users?

Grocery products

Fish finger packaging may seem banal after reflections on that icon of modern life, the motor car, but the story that follows encapsulates the Hunter/Gatherer divide in the design world. It was a spring day, and I had been invited to a graphic design firm in London. You can picture the scene – down a mews, past the beautiful receptionist, and into a cavernous room with brilliant white walls. Chic young designers sit around a table, and two of them produce the graphics they created for fish finger packets. One designer is a man, and the other a woman, and his design is serious, with a three-dimensional feel to it. You can see that it uses contrasting colours – orange and blue – with pink and yellow thrown in for good measure. The typeface is regular, symmetrical and contained within the background shapes around the text. Finally, surprise, surprise, a male figure has been included. The woman's design, by contrast, is more light-hearted. It has more of a two-dimensional feel to it and the colours are harmonious rather than contrasting. The typeface is wacky, irregular and wanders over the whole available area, rather than being contained. A beaming male figure has *not* been included.

If you judge them in terms of the market – a massive 80–90% of groceries are bought in-store by women – then hers is likely to have the edge simply because there aren't that many men buying fish fingers (how many have you come across?) and the wacky design has elements that are likely to have greater appeal.

Certainly, in the preference tests described earlier (see Chapter 3), men and women's reactions to the fish finger packs were sharply polarised with strong evidence of 'own-sex preference'.

Toothpaste is another product worth considering. This product must sit in many an elegant bathroom, and is bought largely by women who do most of the grocery shopping. However, except for children's toothpaste and non-standard toothpastes, toothpaste tubes tend to have large typography etched right across the surface. Remember Hurlock's study showing that 30% of boys but only 19% of girls using the printed word in their drawings and you can see this as a manifestation of the male production aesthetic.

Trips to shops can become monotonous, but you can enliven your visits by playing the following game. As you walk around, ask yourself questions about the products you see: "Who is it aimed at? Has the designer got under the skin of the target consumer?" If you are out with your partner, you can use this game to diffuse tension and disagreements. It may salvage a nice shopping expedition and stop it turning into the sort of battle of wills that accompanies such trips. The following story illustrates the dangers.

James and Martha wanted to replace their old saucepans, and the prospect of something better put them in a fine humour. Each was feasting on their own fantasies as to how this was to transform their kitchen. He wanted the orange "Le Creuset" range – "They're well insulated and will stand the test of time." This hit the wrong buttons with Martha. "The orange will clash with the blue and mauve tiles," she said. "And besides, they are much too heavy – I know I'll think twice before taking them out of the cupboard. No, I really couldn't live with those saucepans."

It would have been better if James had anticipated Martha's reactions and gone for a saucepan that offered technical excellence and also a colour she liked. It may not be easy to find (my last trawl around the saucepan section produced innumerable

variations on chrome) but it is worth the trouble of looking. Meanwhile, saucepan manufacturers would be well served designing saucepans that don't weigh a ton and that come in more than just orange and chrome.

Telecommunications

How many of us could live without telephones? Mobile phones took a while to move away from black and chrome; but in Finland, Nokia's chief designer, Frank Nuovo, was inspired by the need for product designers to meet customer expectations. In doing this, he may have taken his cue from Jorma Ollila, the head of Nokia, who focused the company on the role mobiles played in people's lives and ease of use, an approach that is all the more remarkable for occurring at a time when rivals like Motorola and Ericsson were concentrating on engineering products that concentrated on technical wizardry.

The results? By 1998, Nokia owned a quarter of the mobile phone market and, by 2000, it was making one in three mobile phones worldwide; by 2007, its share of the market in handsets had increased to 38 per cent, nearly three times that of its nearest rival, Motorola. It was when it failed to maintain its technological edge that its handsets division was taken over by Microsoft in September 2013. How it is faring is open to debate but the Nokia Lumia 1020, launched in the same month, is a good guide. Marketed with the promise of being "reinvented around you", the handset is divided (like earlier models) into black-framed boxes, has a yellow case and prides itself on the superb quality of its camera. An advert showing a football game playing out on the handset carried the words "41 megapixels puts you pitch-side" and the combined effect is to call into question the gender neutrality of the "you" around whom the product is reinvented. All the signs are that this is male even though unconscious bias on the part of the designers may shield them from this fact.

This is by no means an isolated case. In Britain at the end of

the 1980s, the telephone utility British Telecom adopted as its logo the red and blue pan player, and up until 2003 you would see it on everything from vans, to stationery, to product information and telephone directories. It was the work of a well-known, London-based, corporate image consultancy and the designer there, when interviewed, described the brief as being "to design a pan figure that was neither markedly male nor female but hermaphrodite." He looked up. "You can see this in the finished figure I think."

The pan player he had designed showed a muscular figure of a youngish male and it was difficult to relate what he had said to this rather masculine figure. To check whether this impression was shared by other people, I asked 37 subjects to describe whether the figure appeared to them to be male, female or hermaphrodite as specified in the designer's brief. What this survey revealed was that a tiny 13% considered the figure to be hermaphrodite and massive 74% considered it to be male with the remaining 13% undecided. Clearly, the designer's best intentions of producing a sex-neutral figure had not worked in practice and he had ended up, predictably, designing someone of the same gender as himself. Since roughly half the market for telecommunications is female, and women allegedly spend seven times longer on the phone than men, it might have made more sense to have a figure with more female attributes.

Retailers

After 72 years of showing a woman on the cover, the British retailer Littlewoods recently made advertising history by putting a man on the cover of its mail order catalogue. Selling everything from clothes, furniture, sports to electricals and appliances, they reckoned that the 47% of men who won't go high street shopping might pick up a catalogue instead. We will have to wait and see if this strategy pays off but they seem ahead of the game in realising the importance of holding up a mirror to their customers.

At the end of the day, what many of us are looking for – whether in an ideal partner, or in a piece of graphic design – is a reflection of ourselves. So when a pub found that its clientele was dropping off, they placed mirrors on all the walls and, within a short time, the numbers stepped up. However, against this one astute firm are companies, too numerous to mention, who offer to customers products that appeal first and foremost to people within the company rather than to the target market.

Examples? Not long ago, I picked up a brochure advertising a family railcard and found that all the people featured there were males, even though the majority of people buying the product were women. The brochure was designed by a group of male designers and, from what we know about gender preferences, the predominantly female market would be more likely to respond positively were the brochure to illustrate female figures. Another brochure, this time from a Tesco petrol forecourt, featured a man at a petrol pump. Since more than 70% of the people using petrol stations are men, projecting an image of a man is a great way of connecting with the company's male customers. Well done, Tesco!

In terms of retail interiors, we probably don't need Paco Underhill to tell us that men and women stay in stores different lengths of time. As many a woman will testify, men's tolerance level for confusion or time spent in a store is much shorter. Perhaps in recognition of men's reluctant role as shoppers, the UK high street retailer Marks and Spencer initiated the male crèche, a shopping-free sanctuary complete with sofas, DVDs and toys such as Scalextric sets. So, given all this, what general lessons are there about making a retail environment appeal to men and women?

My own research shows that many women don't want products placed in uniform rows (for example banks of televisions), don't want boring signage and want colours interfacing in the right colour combinations. How to appeal to men? More

metal, more wood, louder music, and simplify the store so that men would not get too impatient. James Adams, a prominent American store designer, recommends going "narrow and deep" and presenting ready combinations of accessories so that "most of the colour story goes together." "This is important," he says, because "guys are always screwing the colors up." After all, hunters are hunters, not gatherers. But women are happier gathering their own look. US clothes retailer Banana Republic say they would never be so direct as to match women's scarves to jackets in the store, as women prefer to put their own look together.

Several years ago, Adams was asked to try and increase sales for a flooring company. He found the sales staff selling the product on its functional virtues – it didn't scuff, it was easy to clean, and it was long-lasting. It was being sold by men to men, as if it was a car or a telephone. "Wrong!" said Adams. "They have got too caught up in the man's way of thinking. Women are the decision-makers on flooring and it's not what she's looking for. Selling it as a wonder product technologically appeals instantly to men, but women are more interested in the fashion, color and design implications."

Small electrical products

The category of small electrical products covers products such as toasters, kettles, mixers, cameras and computers, and men and women's share of this market 43 and 57 per cent respectively. In the US, the size of this market had a value in 2003 of $96 billion, according to the Consumer Electronics Association, so it is a market in which men and women's preferences – and given the consumer demographics, the latter in particular – need to be satisfied. The importance of satisfying women cannot, in fact, be underestimated since women buy these products largely for themselves rather than other people and so may be even more particular about the items purchased. What is more, studies have

revealed that even where men are the primary *purchasers* of products, women can still have a significant influence on the purchase. An example is the fact that women influence 75 per cent of the purchases of high-tech goods such as DVDs, flat-screen televisions and complex stereo systems.

Despite this importance, a meagre one per cent of women surveyed by the Consumer Electronics Association in 2003 thought that manufacturers had them in mind when creating products. This is a dismally low figure but the picture is not entirely bleak since some companies are noticing the demographics and taking appropriate action. At Sharp, for example, the Vice President of Marketing, Bob Scaglione, noticed that the female population was being ignored a bit and redesigned its flat-panel TVs with them in mind – the product line was renamed AQUOS to connote fluidity and a softer touch. It also changed its TV advertising policy by expanding its TV advertisements beyond sports and prime-time slots to Lifetime, the Food Network and The Learning Channel. By 2004, the company claimed to have more than 50 per cent of the market for LCD flat-panel TV screens and these design changes may have been a key factor. Another case relates to Sony's LIV line, a product range that includes CD players for the kitchen and shower radios. This product range was introduced under the direction of Ellen Glassman, a director of Sony, and was targeted specifically at women. As she says, "The first question we ask is 'Who are we designing it for?'" and, once the target market is determined, the designers can focus their attention on factors such as style, function and technology. The LIV product line was inspired by Ellen's philosophy that: "The smaller designs should fit better in a home," and it sounds very much as though she has an awareness of women's field dependence and the desire for products to blend in with their surroundings.

It remains the case that, like cars, most small electrical goods are designed by women. The kettle, the most used utensil in the

UK household, picked up on average fifteen times a day and with a pattern of sales that has remained stable since a high proportion of kettle sales (one in five) are replacements. In terms of their design history, kettles have progressed from the old 'Copper Kettle', to the whistler and the immersed element kettle of 1907 created by Peter Behrens of AEG Electric. From there they moved on to the automatic kettle that switched itself off when the water reached boiling point, the creation of Russell Hobbs in 1954, to the plastic Kenwood kettle designed by Pentagram's Kenneth Grange. In another twenty years, there was 'The Rainbow' kettle of Hoover's Paul Moss followed, in 1979, by Max Byrd's jug kettle of 1979. The final changes came with Richard Seymour and Dick Powell's cordless kettle in 1985, followed by the advent of the 'pistol grip' handle – now there's a concept that will really appeal to the female majority buying the kettles.

This is quite a long list of male designers and it put me in mind of the conversation I had with the Design Director at Morphy Richards. "I tried," he said, "to recruit some female designers but the quality of the girls' work was not really up to scratch," he ventured. Could it have been that he simply preferred the boys' work?

The dearth of female product designers makes it difficult to compare male and female-produced kettles; but to get a better idea of how male and female-produced kettles might compare, I asked three female designers to design an electric kettle. One of these actually went on to work as a designer for the Terence Conran's "Habitat" chain of furniture stores and the sketch designs that they produced revealed a completely new look to kettles. Instead of bulbous, bulky objects in a single colour, we had compact shapes, closer in style to a rotund teapot, with the body of the kettle in a different colour to the spout and handle. Pink, bright yellow and turquoise were the dominant colours and, in some cases, the handle was decorated with polka dots and the spout with colourful stripes.

These kettle designs were so different from the designs produced commercially that I embarked on an experiment. I set these designs alongside photographs of jug kettles dating from the 1990s – square-shaped objects with square-shaped handles, in a bottle green or navy coloured plastic, and asked 30 male and 30 female users of a university library to indicate which kettle they preferred. Of course, there were methodological weaknesses in this experiment since the images, although similar in size, were not similar in quality (some showed design sketches and some finished kettles). However, despite these weaknesses, the results gave pause for thought since they showed that 62 per cent of the females' choices were for kettles designed by females, while 52 per cent of the men's selections were for male-designed kettles. Once again, the results pointed to clear evidence of 'own-sex preference' and since the majority of purchasers of kettles are female, the results suggest that kettle manufacturers might do well to add elements of the female production aesthetic to their products. How long will it be before we see them resplendent with polka dots?

The DIY market

There are parts of the world where DIY is not the in-thing (Turkey is an example) but it flourishes with thirty-something women spending more than any other age group in the UK on home improvements, outspending all male age groups. Something similar is happening in Australia and America, too.

You can see why, women, when you hear of my friend's sense of affront that a builder who came to tile her new designer kitchen had chosen *white* grout for her *beige* tiles! She eventually took herself off to a DIY shop in order to get the *right* shade of beige. Even common-or-garden nails can become an issue between men and women as Salli Brand, author of *Girls' Guide to DIY*, points out. "Women," she says, "are more interested in the aesthetics. When she buys screws, she'll pick out the prettiest

ones. He'll buy the strongest ones."

Women make eighty per cent of the buying decisions in the home and one store that is responding proactively is DIY store B&Q. According to Nathan Clements, the director of organisation development, the organisation is addressing the gender imbalance in opinion-forming functions, including store, regional and general managers, and a concern to recruit more women into senior roles. As Clements says, this means ensuring that shortlists for recruitment are "reflective and balanced from a gender point of view." A more gender inclusive approach also meant more emphasis on DFY ('done for you') and not just the more "blokey" DIY, Clements added.

In the US, similar changes are afoot. The Home Depot company, which until recently used to market its power tools and drywall to men, is now aggressively pursuing women. One of the ways it does this is through teaching women how to do home repairs, and it is also pursuing entertainment partnerships with home improvement TV shows that are widely watched by women.

DIY can become a bit of a passion and, in February one year, I was asked to give a keynote speech on gender and design at a Global Diversity and Inclusion conference in Barcelona. The event had attracted Heads of Diversity from around the world and from top companies including Shell, Unilever, L'Oréal, HSBC and Bayer Pharmaceuticals. Sitting at lunch on the second day, I found myself next to Michael Stuber, a Diversity expert from Germany. His American clients include Ford, Hewlett-Packard, Johnson & Johnson, Kraft Foods, Motorola and his European clients include BP, Credit Suisse, the Sandoz Group, Swiss Post, UBS and Vodafone. With a client list as long as this – and the list excludes the German companies he has worked with – conversation was bound to be interesting.

We were staying in a beautiful hotel and, before long, the conversation turned to home improvements. Michael recounted

how back in 2003 Bosch discovered that people like us – sporadic DIY enthusiasts – were a large but neglected group. The firm undertook market research amongst this group which included both men and women, and found that what people wanted was small and simple, easy-to-use tools without many special features. Faced with this information, Bosch decided to set up a gender-mixed development team with international employees in order to create an electric screwdriver that would satisfy a variety of customer needs. The end result is the small cordless screwdriver IXO and subsequent marketing, targeting men and women alike, showed both genders using it in different everyday situations, for example opening a bottle of wine, lighting up the grill or fixing the (shoe) cabinet. The tool became the global no. 1 best-selling electric tool and, according to Bosch, the gender distribution reflects sensitive targeting to a demographic with a fifty:fifty male/female split.

Advising companies

Some companies are quick to see the advantages of under-standing men and women's points of view. I have advised several companies and many stand out. In the late 1990s, I went out to Germany for a meeting of European Marketing Managers at Canon Cameras and showed them images of cameras produced by male and female students. The cameras designed by the men were all rectangular-shaped and without colour but those designed by the women were all rounded in shape, some coloured in pink. The men – for they were all men – were silent as they observed these and slowly realised that the path they had pursued may have been wrong. For the majority of purchasers of non-SLR cameras are women and it dawned on them, at this time of black, rectangular cameras, that there was another way. Shortly afterwards, the IXUS camera was born with its curved and silver sides.

Another enlightened company was Bounty, the people who

provide a bag of baby products for all new mums in the UK. We ran a workshop with their web designers – all male as it happened – and they were quick to see the case for change. The original website consisted of boxes of information with a predominant colour of blue, and after the workshop the new site gained new colours and detailing, and immediately attracted more hits.

A brief postscript. Months after running a workshop for a local authority which likewise was quick to perceive the need for change, I returned to their website. Immediately after the workshop, they had been quick to make changes to their website so that it would be less box-like and unicoloured and have greater appeal for their mixed male and female demographic. Several months down the line, the website was reverting to its original form which shows that one-off injections of help may not be sufficient when dealing with an all-male design team. Hunters will be hunters and produce hunter vision, and only regular coaching can steer the impulses in a different direction.

Chapter 6

Advertising

Above all else, align with customers. Win when they win. Win only when they win.

Jeff Bezos, CEO, Amazon, 2012

The advertising agency

It was a summer's day and the advertising agency was ready to unveil its concept boards for clean energy. This was a niche agency with creatives from some of the UK's top agencies and they had invited outside experts who could offer their opinions on the marketing campaign. The young creatives sported open-necked shirts and trainers while the client, a natural energy producer – a visionary who had devoted his life to harnessing energy from renewable sources, was dressed in a light linen suit. Everyone waited expectantly for the white sheets to be removed from the boards around the room.

Commanding the show was the advertising MD, a casually-dressed man in his early 40s with sleeves rolled up. He stepped back while his assistant, a slightly younger man, took centre stage. "We have sourced images which will impact strongly on the energy consumer," he explained, "and our aim is to effect a significant consumer shift from regular energy suppliers to greener sources." The sheet from the first board was removed. It showed an image of the founder of the company gazing out at the grey wind turbines that stood immediately outside the window of his empty sitting room. The MD then moved to the second concept board. The sheet was ripped away to reveal a wave of energy decorated with numbers illustrating the Fibonacci sequence, the elegant mathematical formula that lies behind many of the structures of the natural world.

The MD then moved to the final image and a flourish of the hand unleashed a gasp from everyone in the room. All eyes were on a foetus with a gas mask, which was floating in the dark stratosphere encased in a bubble. This was the chilling future awaiting consumers if they did not buy into green energy.

"Any questions?" asked the MD as he looked around the room, focusing his gaze on the cluster of experts in one corner. With this clear invitation to the experts to contribute to the discussion, my hand shot up. "Yes, who are these ads aimed at?" Glances were busily exchanged as it became clear that this question was not anticipated in the briefing notes. As the seconds ticked by and the silence became burdensome, I asked myself how advertising messages could be created without a clear idea of the target market. Yet here was an advertising MD with an excellent track record feeling perfectly fine about presenting ideas which needed no external reference point. Is this acceptable practice or not? Is the creative an artist or a craftsman who adjusts his work to suit the desires of the customer?

The Importance of the customer

If you asked that question of American guru, Michael Hammer, the brains behind the concept of Business Process Reengineering (BPR), he would be unequivocal in his answer. BPR taught businesses worldwide about the need to reconfigure their activities so that the customer was always centre stage, warning companies that business survival depends on shaping products and services around the "unique and particular needs" of their customer (Hammer, 1995). One of the results of BPR was to increase the salience of the customer in the eyes of business so Hammer might well have attempted to change the thinking of the solipsistic creative to become more customer centric.

This focus on the customer means that successful businesses are those that keep their customers in view and deliver products matched to their needs. The first step in this process is to identify

who exactly is making the purchase decisions about a product, defining them as closely as possible. Traditionally, market research has defined the customer in terms of their social class, age and geographical location, but played scant attention to their gender. Now, after many years out in the cold, a fourth variable, gender, is receiving increasing attention. Some organisations are now taking an important step forward and asking whether their customers are men or women, although (as we shall see later) much market research is still rooted in variables such as age, class and location.

Arguably to ignore a person's gender is to omit vital additional information and this explains why the first substantive plenary session of the 1999 Alpbach European Forum on economic and social trends – a symposium attended by business leaders and politicians – was dedicated to the issue of "gender differences".

If you think about the posters that were unveiled, many elements there came straight out of the male production aesthetic – the fact that only a male figure was displayed, that there was an emphasis on the technical and on fear and faces without smiles – and given what we know of the mirroring of production and preference aesthetics, were likely to have strong appeal to the male creative and other men. The campaign would be excellent if this was the target market, but there was no data to check this against at the meeting.

Back in the office, I undertook a search and, within a short space of time, had some answers. Jan Pahl, an academic from the University of Kent and an expert on male and female expenditure patterns, confirmed that the rather dubious honour of settling household bills falls largely to women (2000). Unfortunately, Pahl had not studied the question of energy decisions but a Canadian survey conducted in 2002 by Daniel Scott of the Meteorological Service of Canada together with Ian Rowlands and Paul Parker of the University of Waterloo near Toronto provided a strong lead.

Their study showed that men and women were equally interested in green energy, a conclusion which, if it holds true worldwide, has vast ramifications for the £400 billion a year global electricity market. This market has been opened up to global competition and a detailed understanding of customer demographics offers competitors a distinct advantage.

Against this background, it was clear that the marketing concept could have been substantially changed to appeal to the women in the market. "In what way?" you ask. Well, since we know that drawing female figures and smiling faces are both part of the female production aesthetic (revealed as we saw in Majewski's 1970s study), and since we know that preferences mirror production aesthetics, it would have made sense to include these elements.

Was this experience just a one-off, a blip, or typical of the sector? If it is typical, we might all be asking: are there any guidelines on how things could be improved?

A look at the advertising industry was a good place to start.

The advertising industry

The worldwide market for the conception and development of advertising campaigns is in the area of $45 billion with three main advertising centres in the world, namely New York, Tokyo and London. The US market dominates and the UK is the fourth largest advertising market in the world in terms of revenues after the US, Japan and Germany. The UK advertising industry employs around 92,000 people.

Where gender demographics are concerned, a survey by the Institute of Practitioners in Advertising of the media buying, advertising and marketing communications sectors showed that women make up approximately half of the workforce but only 15.1 per cent of managing directors or chief executives. According to this survey, the percentage of women at the top of the advertising industry has more than doubled from a low of 7

per cent in 1998, but increased by only one percentage point since 2004. Meanwhile, at lower management levels, the survey shows female representation in the industry to be under 30 per cent.

The results of this survey are not surprising since the picture it paints of low female representation in the higher ranks and in creative functions has been shown before. In 2000, for example, research by the UK's Institute of Practitioners in Advertising showed that while women's presence as account handlers had increased from 27 per cent in 1986 to 54 per cent in 1999 (with women accounting for half of those in planning and research), just 14 per cent of art directors and 17 per cent of copywriters were women. In 2005, an article on advertising by the *Observer* features journalist, Carole Cadwalladr, showed the figures largely unchanged with 83 per cent of creatives quoted as men, a figure said to be worse than 30 years ago.

It is not surprising, given the male domination of the creative side of advertising, that commentator Jamie Doward should refer to women's representation in creative roles as "a closed shop when it comes to bridging the gender divide." It is not surprising, either, that Jamie should describe the creative arm of the advertising industry as one that "does not seem to be too keen on thinking out of the box on gender issues." A contributory factor, according to a report on women in the advertisement industry by Debbie Klein, Chief Executive of WCRS, may be the "stereotypical laddish atmosphere which is said to be still very much in existence."

So much for the UK. In the US, as we have seen, a 2002 survey of advertising staff by *AdAge* found that on average 35 per cent of creative staff were female. Even if this figure is almost twice that of women in creative roles in the UK, this is still a low figure. So, we can see that on both sides of the Atlantic, the creative side of advertising is dominated by men. As we know, the vast majority of consumers are women and a key question relates to how a person's gender will affect their advertising preferences. A first

step is to look at previous research and the next step to look at the views of advertising creatives.

Research on gender and advertising

In 2007, I conducted a study with Dr Rod Gunn and Sylvana Azzopardi of the University of South Wales looking at the advertising preferences of business people in Malta. We circulated a questionnaire on bank advertisements to members of professional and business organisations in Malta, hoping to get responses from at least one per cent of the 50,000 membership. Luck was on our side since we had replies from 510 people, 28 per cent from females and 72 per cent from males, and what their responses revealed was very interesting. For, there was a strong statistical tendency for the men to prefer simple factual and rational information (significant at the $p<0.01$ level) and an extremely strong tendency for women to prefer original advertisements (significant at the $p<0.001$ level). Interestingly, when dealing with advertisements with a reasonable level of originality, the men in the sample appeared to have greater difficulty understanding the message than the women with the differences in the male and female understanding also statistically significant (at the $p<0.05$ level).

Statistics may not be everyone's idea of fun but they can be invaluable in highlighting tendencies. Certainly, this study was telling us that what men and women liked and understood in adverts were very different, showing that effective targeting of men and women would ideally involve different treatments in the adverts. This ignited my interest in seeing what other people had discovered.

Interestingly, one of the first studies that I came across dated back to the 1990s and was written by an American Professor of Marketing, Elizabeth Hirschman. Her message was a disappointing one since she claimed that women's views were excluded from all but a small proportion of consumer research, a

view echoed at the time by other male and female marketing academics. Hirschman was writing twenty years previously and I imagined that things must have changed since then, but I could find only one study that compared men and women's reactions to adverts after 1993.

The study was by Sanjay Putrevu, Professor of Marketing at the University of Albany. This is a value-for-money study with three main findings. The first is that when encoding advertising claims, men concentrate on no more than one or two features (Putrevu, 2004) and so prefer advertisements focused on a single-attribute. Women, he found on the other hand, are more comprehensive processors, attempting to assimilate all available information before rendering judgement. This finding runs counter to the qualities displayed in a sample of adverts scrutinised in a 1997 study by Whissell and McCall, who found that advertisements in magazines aimed at men are more wordy and complex than corresponding advertisements aimed at women. This finding, if it reflects modern practice, suggests that advertising agencies have some way to go in applying these findings.

His second finding is that women prefer advertisements focused on the product and its relationship to its product category, what Sanjay Putrevu calls "category oriented ads". He therefore recommends that advertisers should present category-oriented messages to a female audience, highlighting how the advertised brand compares with other brands; for a male audience, he recommends using attribute-oriented messages, emphasising those features that are unique to the advertised brand.

His third finding is that women have a preference for advertisements featuring harmonious relationships suggesting that adverts targeted at women should depict people in a collective rather than individualistic situation. The opposite would be the case for advertisements aimed at men.

These are pretty specific findings which lead him to the

strident conclusion that: "there is strong and unequivocal evidence that men and women exhibit sharply varying reactions to identical print advertisements."

In academic-speak, he neatly sums up his findings by saying that:

> women specifically show superior affect and purchase intent toward advertisements that are verbal, harmonious, complex and category-oriented whereas men exhibit superior affect and purchase intent toward advertisements that are comparative, simple and attribute-oriented.

The implications for advertising agencies? Again, he neatly summarises these by saying that:

> ... this research suggests that men and women are likely to respond more favourably to messages that are in tune with their respective information-processing styles... men show a preference for advertising messages that feature competition and engage in brand comparisons, whereas women favour messages that emphasize harmony and show importance to self as well as others. Furthermore, men prefer simple ads that focus on one or a few key attributes, whereas women prefer complex ads that contain rich verbal and visual information.

The lesson for advertisers according to Professor Putrevu is to:

> create gender-specific ad campaigns that feature differing levels of hard versus soft sell, as well as differing levels (and types) of verbal and visual information.

To what extent are advertising agencies producing the gender-specific adverts recommended here?

The world of adverts

Views on how well advertising is doing to appeal to its target market can be found on both sides of the pond. In the UK, Tess Alps, the Chairman of media agency PHD, says that men "just don't value the kinds of ads that women write and that women like." Rita Clifton, chairman of Interbrand, describes how women in the advertising industry are working within a masculine culture that provides the framework to what they create and how they are judged. The shortage of female creatives is "absolutely bizarre and extraordinary" but trying to change things by parachuting women in will not necessarily solve problems.

Tom Jordan, former Chairman and Chief Creative Officer of HY Connect, a Communications firm with offices in Chicago and Milwaukee, writes eloquently about the fact that the male majority in advertising need to change: Writing on his blog, he says that, "It's time all of us men stop looking in the mirror and start projecting what will appeal to women" – the people who according to his research influence 80–90 per cent of all purchases. No slacker, he has tracked women's opinions on a multitude of existing and reconfigured adverts and written eye-opening commentary on the world of advertising and the processes in the industry.

A few opening examples illustrates his thinking. In 2008, *Newsweek* ran an advert for a car, the Mercury Sable, at a cost of nearly half a million dollars. The ad showed a front view of a moving, tilted black car on a brown road surface, with no landscape or driver or passengers visible. The single-line text to the right of the vehicle read "Proof our engineers are control freaks" and below, in smaller text were the words: "AdvanceTrac Stability control, a system that constantly monitors driving dynamics to help you stay on course."

Tom reckoned that the ad would be ignored by virtually every woman who saw it – he doesn't mention men's reactions but I suspect that its simplicity and focus on key attributes would

make it a real hit – and so created and tested a new advert aimed at women. The new one showed three frames: an image of a road winding through hills with the headline "How it is"; an image of a straight road winding through hills labelled "How it feels" and a final frame showing the stationary car outside the house, with a smiling woman embracing a small boy. Next to her was text reading "Experience the all new Mercury Sable with AdvanceTrac electronic stability control."

Tom tested the original and new ads with various groups of women and his version outscored the original in "likability" and "intent to purchase" by about 8 to 1. Remembering Putrevu's advice, you can see why Tom's ad has greater appeal since it is visually complex, emphasises harmony and also importance to self and others. That is not all. Drawing on other research, including my own, you could highlight the presence of animate images (pictures of hills), smiling people (including a woman) and a stationary rather than moving car. The test results show how the presence of certain features in the ads can influence reactions, and this is where understanding the science of perception is so important.

Unfortunately, an online survey by Greenfield in 2002 found that over 90% of all women feel that marketers don't understand them. Tom Jordan's book *Re-Render the Gender* includes data on women's reactions to a range of adverts, and a close look at three of these provides insights on the gap between current adverts and women's preferences.

The first is an advert for superglue showing a toy model of an amputee soldier with an arm missing. Unfortunately, women hated this ad and it does indeed seem a strange way to endear yourself to women who may be looking for a glue to mend a teapot or the handle of your favourite coffee mug. A second example is a "Cup a Soup" advert featuring smartly-dressed parents being told by their son's teacher that his problems are caused by the fact that: "Tim doesn't get enough personal

attention." "Who?" asks the father, clearly confused as to the identity of the person in question. The final scenes show a personalised cup a soup mug emblazoned with the name "Tim" and father and son sitting together on a sofa, mugs in hand, and the father's saying, "This is nice, Tim." The humour in a father forgetting the name of his son was completely lost on the women who participated in the experiments to test reactions.

Likewise, an advert for Shredded Wheat (with real straw-berries) was also lost on the women to the point that they actually took it to be a hoax! The advert features a man and woman in a kitchen – he is all-man wearing a wife-beater T-shirt while she is provocatively perched atop a kitchen cabinet in a short red dress and matching high-heeled shoes. Bearing a red bowl of cereal, the advert asks: "What satisfies a hungry woman?" Is the sexual innuendo needed for a product that can provide nutrition for the whole family?

Of course, you may be thinking that an advert like this comes from the dark ages of sexist advertising in the 1950s, but a sister advert with the same rhetorical question and a similar long-haired brunette appeared in 2008.

This time, the brunette is kneeling on a bed with a bowl of cereal in one hand and a spoon in the other. She is wearing a white nightgown with a red satin robe over her but falling off one shoulder. As in the other advert, her fingernails are the same colour red as is the bowl and a man is in the background, this time asleep on the other side of the bed.

Many of the products described here are from big-budget companies and you might be wondering how we end up with adverts like these. This is such an intriguing question that I asked Tom Jordan to sketch out answers in a chapter for a book I had been commissioned to write, *Lessons on Profiting from Diversity*. What follows is a glimpse into the extraordinary picture he provides of the advertising industry.

The truth about the advertising industry

Tom Jordan's starting point is that 80–90 per cent of consumer purchases are made by women, serviced by an advertising industry in which over 90 per cent of advertising directors are male. The consequence is "advertising created by men and approved by men, that generally appeals mostly to men." He goes on to say that to succeed: "women have to create award-winning advertising that appeals to men." The big question, of course, is why a disconnect has been allowed to develop between purchasers and advertisers.

One of the reasons is the incentive to win a prestigious award at one of the international creative competitions, for example a "Lion" at the Cannes International Advertising Festival. Winning can enhance reputation, job advancement and salary, and so the big question is what it takes to be a winner at Cannes. The answer is simple according to Tom, an ex-winner himself: "You have to convince the incredibly hip, nearly all-male, nearly all-white judges that your commercial is so hip, so irreverent, so counter to traditional advertising that you deserve a Lion." It follows that: "Ads are not viewed with an eye as to how effective they may be at reaching their target market but merely on their ability to entertain, influence and impress the judges of these festivals." As if that is not bad enough, he goes on to say that: "the motivating factor for the advertising creatives is to become famous by doing advertising that is *not* advertising."

"But," writes Tom, "it gets even worse." While waiting the whole year to see if any of their ads are worthy of international recognition, advertising creatives want their work to look worthy of publication in the award manuals. An example is *Archive* and *Communication Arts*, two publications printed quarterly that display the world's most exotic and unusual creative work. You will find very little mention, if any, as to whether or not these ads helped build a brand or sell a product. As Tom says, "The functional purpose of the advertisement is of secondary impor-

tance to its artistic function," explaining the constant battle to keep the logo small, the copy brief or non-existent and the concept edgy.

"But," writes Tom, "still it gets worse." According to him, there are schools that teach writers and art directors how to do award-winning work. These are known as 'portfolio centres' since the students hope to leave with a portfolio of ads that will get them hired at medium to large advertising agencies. The schools, according to Tom, will teach its acolytes to follow their gut instinct rather than base their ads around facts supplied by the client.

The way ahead

Ultimately, it is clients who are paying for the agency's work or taking on advertising, and change must be driven by them. A better advert that connects with the purchaser will achieve higher sales and greater profitability. It is in their interests to ensure that advertising does more than provide a royal route to success for the creatives and that they drive a change in thinking. In recessionary times, an advertising overhead that cannot justify its approach should be jettisoned and replaced in favour of something more effective.

An example of a trailblazing organisation is NBC Universal Networks International that has commissioned research for its TV station in Asia Pacific to better understand its female viewers. Christine Fellowes is Managing Director of its Asia Pacific operation and says:

We see the majority of our audience, who are women, scaling up in education, earning power and aspirations over the last few years. The ASEAN region has the highest proportion of women in senior management roles in the world – at 32% versus the global average of 21%. 31% of women in Asia are chief income earners and purchase over 60% of traditionally

male products. It is fundamental that advertisers listen to the needs of this critical demographic and yet we hear from women that they don't feel engaged by today's ad campaigns.

The research, conducted by High Heeled Warriors, involved over 3000 female participants (aged 20–44) from Singapore, Malaysia, Philippines, Indonesia and Hong Kong, and five distinct segments were uncovered. Fellowes emphasises the importance of the research for the regional operation, "allowing us and advertisers to effectively engage with women across Asia." To engage successfully would be a big win since Asia's pay-television females are big media consumers.

As marketing experts know (or should know!) and as Ann Handley, author of *Content Rules*, has said, "knowing who you are selling to – and why and how they buy – makes your job a whole lot easier." Handley is dubbed "one of the most influential voices in online marketing" but taking the next step and framing the product or service around what you can discover can try the patience of many. Take a trivial example. I was in the parking lot of the second biggest supermarket in Britain and discovered, for the second or third time, that there was nowhere in the long parking lot to return the trolley to (and get back the coin deposit) and that the trolley had to be taken the length of the parking area, back to the front of the store. If you had wheeled the trolley to your car at the back of the parking area, then this was an inconvenience you could do without. When I bumped into the store manager with this nugget of information – after all, solving it would lead to more satisfied customers – I had the usual array of reasons why this was not a priority. If organisations resist something as simple as this, how will they handle a shift in the way that products are marketed and advertised?

For, a shift like this could well involve a change in marketing and corporate culture and that can be very challenging. As Kathy Gornik, former chairwoman of the American Consumer

Electronics Association, has said: "There's a lot of inertia when things are done in a particular way. You are talking about having to change the entire orientation and culture of a company." She is absolutely right but the prize awaiting companies who can do this is greater sales and more contented and loyal customers. A first step is understanding Hunter and Gatherer vision, and the next is the long and difficult journey of shaping recruitment and promotions so that they deliver advertising to match the preferences of the customer.

Chapter 7

The physical environment

What is food to one man is bitter poison to another.
Lucretius

The municipal swimming pool

In the early 1990s, a new public swimming pool appeared in a north London suburb. This is not the sort of area that any self-respecting tourist will ever visit but the building had a special allure. As you entered the pool area, you sensed that this was somewhere that had escaped the surrounding drabness, and that this was a mecca of space and light. Large, rounded windows poured beams of light on to a turquoise pool surrounded by brilliant white floors, walls and tables. Even the signage conveyed a feeling of lightness, with curvy lines under the yellow and turquoise lettering. As you swam up and down, you could contemplate the fine high windows, and enjoy the coherence of the design. The turquoise of the water was complemented by the turquoise and mauve of the poolside cubicles, and the light streaming through the windows was complemented by the white floors, and table furniture. Inquiries revealed that the architect was female.

As the months passed, changes appeared, one by one, into this otherwise perfect building. First it was the replacement of the white tables and chairs by dark blue ones. "They are easier to maintain than the white ones," said the man at the council. Then it was the appearance of a gigantic orange mural (the work of a male artist) showing octopi and other sea life. After this, there was no stopping the changes. The light-hearted signage gave way to dark green signage with a more regular typeface. The square surround in the signage was echoed in the rectangular

dark blue tiles that appeared across the previously all-white walls, blocking off the arched windows. As if that was not enough, I turned up one day to find the mauve and turquoise cubicles and lockers replaced by dark blue ones. The pièce de résistance came with the installation of a sandwich bar with along its length a straight line of orange. A once perfect building which once hung together visually was now irredeemably altered, and not obviously for the better.

The planning department of course produced reasons for everything. "The dark blue furniture replaced the white because it did not show up scratches," and "the new signage had to be introduced because it was standard across the borough." As best one could see, the need to replace a few lockers because of vandalism was the pretext to replace the turquoise and sometimes mauve doors with blue ones, and the windows needed to be blocked so that long lines of blue tiles could cover up some more of the formerly white wall.

If you looked at this objectively, you could say that the gatherer way of seeing had been vanquished by that of the hunter. The signs? Dark blue tables standing out against white floors (*remember male field independence and use of dark colours*), strong use of orange (*men like orange*), and straight lines dominating in both the signage and the blue tiling (*legacy of observing a distance horizon*), blotting out the roundness of the windows (*appreciation of round shapes is an adaptive mechanism for child bonding*). The pool had become the centrepiece of a clash of design aesthetics, hunter and gatherer. The gatherer emphasises harmony between elements, lightness of hue, non-linearity and non-containment of visual elements (all the signs are under-scored by a wavy line which runs right through the script). The hunter emphasises linearity, dark and contrasting colours, regularity, and containment of visual elements.

The impetus behind this all was the world of urban planning which is predominantly masculine. In 1996, publicly available

figures for the Royal Town Planning Institute in Britain showed that 78% of members were male. More than ten years later in 2008, Clara Greed, Professor Emerita of Inclusive Urban Planning at the University of the West of England, said that: "most of the planners and urban decision-makers are still men." Had the planners known that they were imposing a hunter, or male way of seeing on the gatherer, or female view of the original architect, they might not have done this. After all, public buildings are there for everyone and statistics show that women outnumber men in terms of their use of swimming pools. However, if you are not aware that there is a hunter and gatherer way of seeing, then you might easily assume that your way of seeing is universal.

Going underground

In the 1980s, the graffiti on the New York Subway would have made a big impression. They were everywhere – on the walls and on every one of the 6,000 cars of the Transit Authority fleet (only the Midtown shuttle escaped this). The 15,000 annual felonies on the subway system deterred many of the best people from seeking employment there, and the frequent derailments and unreliable service meant that customers were unhappy too.

In his best-selling book, *The Tipping Point*, Malcolm Gladwell describes the measures the authorities took to turn the situation around. A new subway director, David Gunn, organised a blitz on the graffiti, while another recruit, William Bratton, head of the Transit Police, had plainclothes policemen positioned by the turnstiles to catch fare dodgers as they passed. These would be left standing on the platform in a daisy chain until the police had a "full catch". According to Gladwell, it was these initiatives that reversed the crime epidemic on the New York subway. What he does not explain is the role played by art in winning the war against crime.

In 1991, a report on the 722 mile system recommended

including painting and decoration to inject a sense of brightness and cheerfulness. The "Arts for Transit" programme was established under the directorship of Sandra Bloodworth, and has resulted in 140 works of public art. Her philosophy is simple. "The art should reflect its readership," and the "diversity in the riders," she says. This enviable philosophy (how many product designers follow it?) provides the opportunities for engaging in the sport of guessing the gender of artists. Probably, modern-day gender experts would be horrified at this suggestion ("reductionist stereotyping; sheer nonsense") but they would be missing the point. Their attempts to explain everything through social influences flies in the face of important evidence on cognitive sex differences. As we have seen, these are particularly significant where visual abilities are concerned. So, we have an eight part quiz that will allow you to decide for yourself whether such a game makes sense.

New York subway quiz

Our quiz starts in the south of Manhattan at Brooklyn Bridge Station on the number four and five lines. You will find there a classic engineering design showing black railway lines and the cables in the Brooklyn Bridge. The designer? Mark Gibian.

Nearby in the passageway that connects the Broadway/Nassau Station with the Fulton Street Station is round, stainless steel ceiling lighting depicting the constellation of the stars. Several stations to the north is 42nd Street Station with stainless steel tubular lighting zigzagging in consecutive V shapes and serving – in the words of the artist – as "functional sculpture". The artists? Nancy Holt was behind the passageway and Christopher Sproat behind 42nd Street.

A few stations north of here is the Grand Army Plaza Station with its female winged victory figure. Then at 57th Street Station are photos of male musicians. The artists? The first is the work of Nancy Spero and Jane Greengold, while the second is that of

Christopher Wynter and Josh Scharf.

Close by at 59th Street, Lexington Avenue Station, is a glass mosaic mural *Blooming*. This shows pink trees with extended branches, and meandering trails of steam flowing from yellow mugs, all dressed up in a hazy look. The artist? Painter Elizabeth Murray who wanted an image to illustrate the neighbourhood of 'Bloomingdale' and create what she calls a "dreamy underworld", separate from the realities of the street above. The bright colours, light-hearted and two-dimensional quality to the work are all pointers to its female artistry. A few steps further north will take you to 66th Street on the one and nine lines with its female images of Artemis, acrobats and divas. The artist? Nancy Spero and Jane Greengold. Then, finally, go north to 110th Street Station with its glass mosaic and mural made up of squares and rectangles and featuring a man's face. The artists? Christopher Wynter and Josh Scharf again. This light-hearted game will help occupy you as you rush onwards to your destination.

London underground quiz

A similar diversionary game is available to the 150,000 daily travellers on the London Underground system and we suggest that you start your tour at Embankment Station to the south of London, not far from Waterloo Station.

At Embankment, the platforms are decorated with isolated lines of colour arranged at different angles against a white background. This is a minimalist representation of multicoloured streamers in celebration of the 1951 site of the Festival of Britain. Was the designer of this a man or a woman? You would be right if you thought that the relative lack of colour or linearity denoted the work of a man since the artist responsible for this was Robyn Denny. He trained in the 1950s at St Martin's School of Art and the Royal College of Art, and completed this platform mural in 1984.

Just a short hop from Embankment on the Northern line is

Charing Cross. The platforms show black on white engraved figures (mainly men) constructing the medieval Eleanor Cross with just a few women looking on. The artist behind this? David Gentleman, another graduate of the Royal College of Art. He spent much of his life designing stamps for the Royal Mail as well as producing engravings and watercolours.

Next, head north on the Northern line in the direction of Tottenham Court Road, noticing the straight line at Leicester Square Station, and once at Tottenham Court Road change in the direction of Marble Arch. Get off at Marble Arch and consider this time the rather light-hearted round archways formed from bright red tiles, filled with large white polka dots. The artist? You may not be surprised to discover that this was the work of a female designer, Annabel Grey, completed in 1985. Finally, take a trip up to the north to Finsbury Park. Here you will find large, rounded air balloons, filled with lots of detail using gold and coloured mosaics. The artist? Once again, you may not be surprised to learn that the artist was female – Annabel Grey again.

Street signage

Not a million miles from Finsbury Park lies the London Borough of Barnet. This is the largest borough in London but it is not just size that singles it out. In the late 1990s it introduced a new design of street signage that sparked off waves of protest throughout the Borough. Instead of the former Victorian street signs, unobtrusive with their simple black lettering, they imposed new signage incorporating the Borough crest and bright turquoise surround found in other corporate identity materials. As you might imagine, the objections came thick and fast. They were particularly strong in conservation areas where you cannot so much as erect a garden shed without following convoluted planning procedures. You can understand some of the indignation. Barnet Council had consulted neither the Conservation

Officer, nor the Trust responsible for maintaining architectural standards in the conservation area, nor English Heritage, the body set up to oversee historical architectural standards across England.

Instead of this, the only justification for this action was presented to the press by the elected representative responsible for this, Brian Coleman. To quote:

> This is the new corporate image for the Borough and will cover *all* signs, publications, posters, notepaper and everything else. I like the new signs as they include the Borough crest for the first time. They will be rolled out eventually to all roads in the Borough.

The Press Release added that the new style "improves the image of Barnet's roads and give the borough a unique identity that will differentiate itself from the surrounding areas."

Unfortunately, the councillor is falling into the common trap of taking his own preferences as a barometer of other people's. This is distinctly unwise given all we have seen earlier (see Chapter 3). In this specific case, the fact that some men may be more field independent than women makes this particularly problematic since some men may be less sensitive to clashes in colour hues than women, and the difference between the turquoise in the sign and the green of the surrounding trees would disturb them less than it might several women.

So much for the street environment. What about buildings?

Buildings

Do men and women design different kinds of building? This is a difficult question to answer since the majority of people designing buildings have had architectural training, and this is likely to influence the way people design. To carry out a meaningful experiment on men and women's 'natural' tendencies,

as against 'trained' tendencies, would involve looking at controlled samples of work produced by students early on in their training, as I had done earlier in the case of graphic design.

Controlled experiments

The closest we have to a controlled experiment is one referred to earlier and carried out by the well-known Swedish psychologist, Erik Erikson, in 1937. Erikson was born to a Jewish mother who never told him the true identity of his biological father. One of his greatest concerns, in his life as well as in his theory, was the development of identity and this experiment offers fascinating insights and is worth exploring in some detail.

What Erikson did, as we saw earlier in Chapter 2, was set up a play table and a random selection of toys and building blocks and then ask about 150 pre-adolescent boys and girls to imagine that the table was a film studio. The only instruction was to create exciting scenes on the table and this must have fired up people's imaginations as about 450 scenes were constructed. From this, Erikson noticed that the boys and girls arranged their blocks in distinctive ways: the boys built towers and structures pointing upwards, while the girls built low, circular structures.

These results are strangely prophetic of the results obtained about ten years later by two American researchers, Franck and Rosen. We touched on this briefly earlier (see Chapter 2) and discussed the experiment in which they asked 250 students to complete a variety of shapes. The fascinating results showed that the men often elongated the shapes, transforming them into skyscrapers, while the women transformed them into round-shaped rooms and houses. This experiment provides a spring-board into looking at buildings created by men and women in different parts of the world and at different times. A word of warning. This foray into the world of building may change the way you look at buildings forever.

The last hundred years

An Internet search on the topic of famous buildings designed in the last century produced a list of buildings all designed by men. Frank Lloyd Wright was a name that kept cropping up, whether it was in relation to his Arts and Crafts buildings in America, or to his post-1910 modernist style buildings. The *leitmotif* of these buildings is linearity and almost a complete absence of external decoration. When you read that Lloyd Wright's mentor was the architect Louis Sullivan and that his slogan "form follows function" was changed, in Lloyd Wright's hands, to "form and function are one", you can understand how he made the journey from Arts and Crafts to Modernism. The journey was broken up by his wide-roofed Prairie Houses and abutted in the straight-sided structures seen in his "Fallingwater" House, dramatically situated by a tumbling waterfall. This building is often quoted as an example of his ideal of 'organic' architecture with a marriage between the site and the structure, and a union between the context and the structure. Yet, dramatic though the setting is, the straight lines of the house are curiously at odds with the graceful movement of the water and surrounding trees.

The modernist movement

The doyen of the modernist movement, of course, was Walter Gropius, the founder of the Bauhaus movement. He stood firm against the use of details, so out went cornices, eaves and decorative details, and in came flat roofs, smooth façades and cubic shapes. Colours are white, grey, beige or black and the backbone behind all of this is functionality. So, if you read the arguments in favour of the flat roof, it has nothing to do with aesthetics but everything to do with practicalities – cheaper maintenance, amenity value (since you can use the flat roof as a recreation area) and rebuild opportunities. There was also a strong ideological underpinning to his work, driven by the belief that people's lives could be improved through good design. Since

the leaders of the modernist movement, Gropius and Mies van der Rohe, fled to America to escape Nazi persecution – rebuilding a better future for people becoming a major driver – the modernist came with them. The American version of Bauhaus architecture is known as the "International Style" after the 1932 book of this name by Henry-Russell Hitchcock (historian and critic) and Philip Johnson (architect).

This international style is now the favoured architectural style for office buildings, and if you wanted to pick well-known examples, you might pick the famous Seagram Building in New York, a glass and bronze building designed by Mies van der Rohe with Philip Johnson in 1957. You might also pick buildings by the Chinese born IM Pei with the Louvre pyramid amongst his most celebrated buildings. His *oeuvre* also includes the National Center for Atmospheric Research in the Rocky Mountains – brown, interconnected rectangular shapes – as well as the John Fitzgerald Kennedy Library in Boston, Massachusetts, a large, dark glass square-shaped building. The linearity, lack of detailing and dark colours that we see in these buildings are all typical of the male aesthetic response. Another typical feature, according to Erikson's interesting experiment, is of course the skyscraper.

An early example of the skyscraper was the 1897 Singer Tower in the US, standing tall at 612 feet and therefore taller than the Pyramid of Cheops or Cologne Cathedral (tall buildings have ever been a male thing whether in Gothic or modernist architecture). In 1930, however, it was dwarfed by the Chrysler Building which, at 1046 feet, made it the tallest building in the world. This building was the brainchild of William Van Alen who wanted to outdo his ex-business partner, Craig Severance, and create a showcase for Chrysler and the automobile industry. Decorated with various automobile and other symbols and topped by a steel pinnacle, the building uses thousands of tons of a steel used then for the first time – "Nirosta Steel" – but better known today as stainless steel. The spire at the top resembled a

sword and although Van Alen won the contest, he was pipped to the post the next year by the design of the Empire State Building which stood tall at 1454 feet. If Erikson's experiments are a barometer then this is the ultimate boy's own building.

Fortunately, or perhaps unfortunately, the modernist style migrated into the domestic sphere where it became known as "Art modern". The look is unmistakable and you can find a good example in the home that Gropius designed for himself in 1937 near the Graduate School of Design at Harvard University where he taught. You could not imagine a more beautiful spot with its setting atop a hill, surrounded by an orchard of 90 apple trees. Into this idyllic spot, Gropius placed a modernist icon, made up entirely of square and rectangular shapes. Another example is the home that the distinguished Finnish architect Alvar Aalto built in 1938–41 for friends. The house has the rather quaint name of "Villa Mairea" but, despite its idyllic forest location, it is in fact anything but quaint. Billed as "one of the finest houses of the twentieth century" its predominant shape is rectangular, even to the point of having rectangular chimneys. I think that a large proportion of the female population would argue that, location apart, this is far from their idea of a dream home. Men, however, are likely to feel just the opposite so the stage is set for a head on clash of ideals.

Do men and women like the same kind of buildings?

Someone who is exceptionally well qualified to talk about this is Dr Penny Sparke, dean of the Faculty of Art, Design and Music and Professor of Design History at Kingston University in London. She is a prolific and important writer on design and speaks of the "re-masculinisation of the world of material culture." Although her observations are not based on controlled samples (as my own work sets out to do), many of her judgements chime with our own conclusions. Here she is, in her book *As Long as It's Pink*, speaking of men's fondness for linearity,

absence of colour, functionality and lack of detailing. Women's proclivities, according to Spark, are for roundedness, colour, art for art's sake, and detailing.

Penny Sparke does not mince her words. According to her, the modernists evolved a language and a philosophy of design "which denied the validity of all the characteristics linked with feminine culture." She illustrates this by discussing how the controlling hand of the professional (male) architect and the designer worked in tune with modernity, and how, since modernism was defined in masculine terms, this has not served women well. She suggests that it is only when women have "decided to join its ranks and adopt its values as their own" that they have profited. This point is very similar to those made by Tom Jordan (see Chapter 6) about what it takes for women to succeed in an advertising agency when he said that they "have to create award-winning advertising that appeals to men."

One might ask, given the impetus to conform to the ideals of modernism, how the natural, untutored impulses of men and women can be revealed? One way, as we have seen, is by studying controlled samples of work by men, women, boys and girls, although in the case of buildings this may be less easy. Erik Erikson laid the groundwork with his interesting experiment with blocks but my experience is that obtaining controlled samples of student designs of buildings is less easy than obtaining controlled samples of other types of design (say graphic, product or web design). So, in the absence of controlled samples, all we can do is look at built structures that are not part of controlled samples. Our sketch of architecture in the last century revealed the emergence of the modernist movement from a number of *male* exponents. What, you might ask, would a primarily female building aesthetic look like?

Female building designs

A period of visiting art schools followed in the hope of finding

controlled samples of work and comparing the male and female output. I was strangely lucky to find a project to design a tomb from students on a pre-degree foundation course and amazed to see the results. Two of the five students were women and both their buildings were rounded! One of these was a circular crenelated structure with an external staircase following the curve of the building. The second was a serpentine structure with coils of stone arranged in a spiral shape. The men's designs had none of these features. One consisted of interposed triangles reaching a narrow apex. Another consisted of an elongated horizontal shaper and the third a filigree metal structure built around a mini Eiffel Tower.

I then tried an architecture school but had no luck there since all the students were following different projects. I don't know that I was really missing much, though, if the experience of one ex-architecture student was typical. This woman was working in a field unrelated to architecture but recounted that, earlier on, she had studied architecture. "I dropped out after two years since my own creative impulses were being squashed and channelled into directions that were not my own." If her experience was common, then samples of men and women's work at degree level would not be helpful, showing the importance of sampling pre-degree work. This is precisely what I had done (described earlier in Chapter 2) in order to compare graphic and product designs produced by men and women.

These were isolated examples and it was important to compare more samples. How to find them? A passage in a book by the anthropologist, Robert Briffault, jumped off the page since he listed societies in which women were the main builders. The societies he mentioned were the nomads of Central Asia, the Andaman Islanders, the Omaha Native Americans of northeastern Nebraska, and the Seri of California, and I was fortunate that the Anthropology Library at the British Museum was just a bus ride away. What did these people's buildings look like?

Nomads of Central Asia

The search began with the nomads of Central Asia. These people inhabited an area stretching from Mongolia and Manchuria to the south Russian steppes, and lived in portable dwellings known as yurts. These had to withstand severe weather conditions and be readily transportable on two or three camels, so an appropriate design was called for. The solution was a basic structure with a central pole surrounded by an expandable circular lattice wall, giving the whole structure a circular shape. A felt roof, often decorated in bright colours, was laid over the top and the sides.

The key question was whether Robert Briffault correctly identified women as the principle architects of yurts. According to a work on Afghan domestic architecture, published in 1991, "the yurt is erected in about an hour by four or five women." The men in the community did not appear to know the names of the various parts of the framework, and were quoted as saying that this was "women's business". This is circumstantial evidence to corroborate Briffault's supposition as to female responsibility for their construction. Moreover, although the nomadic way of life has been in decline in Afghanistan for the past forty years, traditional felt-making activity continues in the production of floor coverings. Interestingly, these are still made by women, often for their own or their daughters' weddings, and use a profusion of detail and colours.

The Andaman and Nicobar Islands

Next was a search for the dwellings of the Andaman and Nicobar Islanders. This group of islands lying off the west coast of Thailand, in the Bay of Bengal, was tragically affected by the two tsunamis in that region. As a result, many of the islanders were subsequently moved to other islands, and the kind of houses offered for temporary rehabilitation by the Indian Administration consisted of quantities of nuts and bolts, GI sheets and aluminium pipes. This type of dwelling stood in

complete contrast to the beautiful huts I saw illustrated in the books in the British Library. The photos showed thatched homes, beehive in shape, and erected on poles, and these were the buildings that Briffault credited the women of the islands as building. My feelings were divided between the poignancy of seeing what was now lost to the world, and the excitement of realising that another female building was rounded in shape. Were these, as Briffault stated, definitely the work of women?

An old book contained a description of how the dwellings were erected and this appeared to further corroborate women's involvement insofar as the men's input seems to be a pretty last minute affair. Here is the relevant passage: "The Nicobarese erect their dwellings on poles. The roof framework is completed and then the men are summoned to assist in raising it to its position. They are rewarded for their help by a feast of pork."

It is interesting that the men only get involved right at the end of the process since this suggests that it must have been women who were involved at the other stages. So it looks as though Briffault got it right after all.

The Omahas

It remained just to investigate the homes of the Omahas. The people ultimately referred to as the Omaha Tribe of Nebraska came to the Great Plains hundreds of years ago. By the late eighteenth century, the Omaha had established themselves in what is today north-eastern Nebraska, and their homelands consisted of millions of acres of land. The American government pursued a policy of pushing native peoples on to reservations and into the liberal, democratic and capitalist mainstream. Since 1960, this policy had the effect of leaving less than 30,000 acres of their former homelands in the hands of Omaha people.

Traditionally, the Omaha peoples lived in tents ('tipis') or earth lodges, both of which were circular dwellings. The tipi had a circular framework of poles with a semicircular covering of

buffalo skins while the earth lodge, with walls about eight feet high, had a dome-shaped roof. Could these be the work of women, as Briffault suggested? The books in the Anthropology Library confirmed what Robert Briffault had said, namely that all the work on these dwellings was carried out by women, with just the marking out of the site and the cutting of heavy logs carried out by the men. Significantly, both types of dwelling, whether tipis or earth lodges, were circular in shape.

The Pueblos of the Seri and painted buildings

Last on Briffault's list were the pueblos of the Seri, a people who lived by the Gulf of California. Richard Felger and Mary Moser's book, *People of the Desert*, describes the pueblo or brush house as the most usual kind of dwelling built by the Seri. These were constructed with a framework of three to six arches which were subsequently covered in plants producing a rounded type of structure. Significantly, they said that it was "usually built by women".

It had been a useful day in the library and it was now clear that not only was Robert Briffault right about women's role in house building, but there was a particular thread running through the type of housing women built: unlike men's buildings which were elongated, linear and sparsely decorated, these were compact, rounded, and in the case of yurts, highly decorated. This point about decoration interested me since, in the course of these searches in the library, two other books had came to light.

One of the books, by Gary Van Wyk, described painted houses from the high plateau in South Africa below Johannesburg. This area is known as the Highveld and Gary Van Wyk's book contains wonderful photographs of the houses, painted and decorated by Basotho women. You might have thought that the images would have taken their inspiration entirely from religious symbolism, but this was only part of the story. According to Gary, one Basotho woman was asked why she had chosen a particular motif

such as suns or moons, and she replied that: "they were chosen either because they were beautiful or because the ancestors had dictated their design [to them] in dreams." The Basotho women's mural art is called "litema" and can consist of engraved patterns (created by carving designs into wet plaster), mural paintings, relief mouldings or mosaics. The paintings use bold colours and it is striking how little they rely on regular shapes: what a contrast with modernism!

The second book on painted houses – *Painted Prayers* – is also beautiful to leaf through. In the south of India, women paint their houses daily, weekly in the east of India and elsewhere less often. Characteristic of the style used are the intricate patterns as in the elephant whose body surface is covered in polka dots. The use of relief is also apparent as in the use of mud to create a carved lintel to adorn a simple doorway.

Although the houses we have looked at are all created in different corners of the earth, they have much in common. They share shapes that are round and materials that are soft and natural. In some cases, they also use detail to break up the surfaces and also use vibrant colours. In many ways, what the architects of these buildings are doing is the polar opposite of the acclaimed modernists who celebrated linearity, functionality, monochrome surfaces, and lack of detailing, and they might politely be shown the door in a school of modern architecture, bound as it is by modernist conventions. Once again, we say, neither is better than the other, just different. Hunter buildings and gatherer buildings diverge but both should be allowed to exist since we are a mixture of hunters and gatherers.

The office environment

If modernism has had a stranglehold on twentieth century architecture, it has also had an enormous impact on the office environment.

According to Jeremy Myerson, Professor of Design Studies at

the prestigious Royal College of Art in London: "Behind their concrete-glass-and-steel façades, office buildings continue to be filled with rectangular reception sofas in black leather, sharp-edged steel filing cabinets and miles of lookalike systems of furniture in shades of grey and beige," he says. "Most people would be hard-pressed to differentiate a facsimile machine from a photocopier from a laser printer at more than five paces, such is the modern technical aesthetic's stranglehold on the office." Office interiors, with desks carefully laid out in rectilinear patterns, have become machine-like in the modular assembly of their component parts.

In fact, not quite everywhere needs to be like this as we shall see.

A different type of office

One day, I took a turning off the grey corridor to visit a female colleague. Inside, I found a softly striped turquoise and pink dhurry, plants in ceramic pots, fine art postcards, and woven wall hangings. The occupant had been given the same box-shaped room as other staff but she had created a home and a personal space.

One weekend, I was leafing through a Sunday magazine when I came across an office interior that was not a million miles removed from this one. Located at the Danish Ministry of Culture, you saw a feast of bright turquoise with all the chairs, desks, carpets, post boxes, wastepaper baskets, lamps, hooks – even curtains for privacy – in matching hues. Adjoining offices were similar but in candy floss pink in another. There was a homely, rather than office feel to this, perhaps on account of the soft curtains separating areas, and the gentle folds of the fabric ceiling lights.

It came as no surprise to find that the people responsible for this were two women, product designer Marianne Britt Jørgensen, and furniture designer Louise Campbell. What was

the main driving force? "My fascination with how furniture can affect space and people hopefully shines through in my work," said Campbell, and an important aspect of the project was seeing how design can influence people. For the Head of the Secretariat, Jesper Rønnow Simonsen, on the other hand, the interest of the project lay in something different – modernity. As he said, "We wanted to convey the message that the ministry is modern in outlook and unafraid to try something new."

The lure of modernism

The other two offices featured in the article were pure exemplars of modernism. One, the London offices of advertising agency, Mother, is located in a concrete warehouse designed by architect Clive Wilkinson, a native of South Africa now based in Los Angeles. The concrete fabric of the building provides a *leitmotif* with a broad concrete staircase sweeping up to the second level studios, and a sequence of concrete tables – 12 metres wide! – on the third. When you get to the top floor, leased to small media companies, the space is divided by heavy plastic curtains from a meat market. With this kind of environment, is it any wonder that the advertising agency's mantra is "survival of the fittest"?

The other office was in Eindhoven, Netherlands, occupied by a firm of graphic designers and publishers. The designers were Ad Kil and Ro Koster, and they chose stacked honeycomb-cardboard components (picture light brick and you'll have a fair idea) to reflect the type of businesses using the space. The impression is of square and rectangular blocks of space, with rectangular alcoves giving way to individual workspaces. The colours are light and dark brown, and if you were seeking a hunter office, you would need look no further!

Offices and productivity

In an introduction to workplace design for the British Design Council, Professor Jeremy Myerson discusses the link between

the office environment and productivity: "Innovative workspaces can have a direct and beneficial effect on staff productivity and creativity. It's not just staff performance that can benefit. Good workplace design can also help shape your organisation's culture and improve corporate image, speed up information flow and nurture innovation."

Myerson makes no reference to gender but I ask you, reader, which type of office you would sooner work in? Where are you most likely to burn the midnight oil? The homelike environment of the Danish Ministry of Culture or the concrete cornucopia that, anachronistically, is the base for a company entitled "Mother"?

I know which one I would choose but you can have fun comparing the impressions of the offices of bosses and colleagues.

Chapter 8

The virtual environment

We say no to a lot of things so we can invest an incredible amount of care on [what we do].
Jonathan Ive, Apple, Senior Vice President of Design, July 2012

It was the third week of a sell-out exhibition at London's Royal Academy of the work of the Turks over the period 600 to 1600. The queue disappeared outside the gallery and around the corner and only a few tickets were available on the day. Most people had been advised to book ahead to avoid disappointment, either by the Internet or by telephone. I had bought my tickets by telephone and was waiting to exchange my reference number for a proper ticket. In the queue I noticed an old lady leaning on two sticks and heard her as she tried to get the attention of the man behind the counter. "I'm really sorry but my server is down and I can't do the usual things such as buy tickets online."

I observed this with disbelief since I had not realised that an octogenarian could so easily have integrated the Internet into her life. This surprise probably says more about me than anything else but I have to say that I was just as dumbfounded when my five-year old son begged me on many occasions to go on to the Internet to buy him a Spiderman suit. With your computer having permanent residence in your home this gives the phrase 'pester power' a whole new meaning. Being exposed to it by the sweets at the checkout counter is child's play compared to this. It demands a whole new set of skills.

At school, children as young as four are being introduced to the World Wide Web and the result was my five year old pestering me to download a website selling toys. For him, traditional catalogues are without doubt yesterday's materials.

These anecdotes testify to the reach the Internet now has to young and old. All this, in fact, is part of the steady encroachment of the Web into our lives. The statistics tell it all. Since 1998, the Internet has experienced an annual growth rate of 20% per year; and in 2008, the annual growth was estimated at 50–60%. By June 2010, the global Internet user population reached 1.9 billion: (http://www.allaboutmarketresearch.com/internet.htm). This is not really surprising.

We all flock to the Web because of its ease and convenience. Not surprising then that surveys show customers' marketing value goes beyond adding another selling channel, for it is estimated to produce ten times as many units sold with one tenth of the advertising budget. Already it seems that customers are more loyal to websites than shops and catalogues, and return to them more often than they would revisit the store or reread the catalogue. And the flexibility of the Internet is an enormous boon to manufacturers of products with rapidly shrinking life cycles: marketing material and inventories can be changed, literally, overnight in the virtual world of the Web.

Increasing competition

Only thing is, there's masses of competition out there and how the site is designed can have a critical impact on whether you decide to stay or move on. It has long been recognised that slow loading times or poor content might lead you away from a site. Some spanking new research that I conducted with Dr Rod Gunn in 2006 alerted people to the importance of design and the fact that websites designed by men look very different from those designed by women. When the results of this research were published, the news travelled like the proverbial bush fire all around the world. The *BBC*, the *Wall Street Journal*, *New York Times* and the *Washington Post* all took it up enthusiastically with another 80 newspapers and websites, from around the world, in tow.

We all use the Web and this research showed that websites can look dramatically different from most of the commercial websites produced. Equally importantly, this research, and subsequent studies, showed that the vast majority of websites that we see on a day-to-day basis are anchored in the male way of seeing with the female completely off the map.

There are analogies here with the newer research field of web usage, where recent studies have found that the visual attractiveness of a site has a strong influence on our judgement of its usefulness and also the satisfaction and enjoyment we gain from using it. These factors have led Human-Computer Interaction (HCI) researchers to attempt to understand the elements in web design that we value, and those that just make surfing a bad experience. Hans von Iwaarden and his colleagues, studying websites from the Netherlands and the US, have identified ten factors which create this sense of disappointment among users, and one of these factors is graphics – the visual impression of layout, typeface and colours chosen by the site designer. Have you ever thought about the design of the websites you look at? Which ones do you prefer, and which features grab your attention?

The study of web aesthetics is relatively new and there is currently very little research examining the factors that appeal to us. What little research there is tends to approach the topic from the assumption that the aesthetic appeal of something will be the same for everyone (see Chapter 4). The contrasting belief, the so-called 'interactionist' perspective, says that aesthetic appeal is observer-dependent and a product of empathy between the object, its creator and the person viewing it.

The idea of mirroring

If we take this interactionist view, which we do throughout this book, then the concept of *mirroring* becomes very important. Mirroring has been studied intensively in the field of product

branding because purchases are thought to offer us a vehicle for self-expression, amongst other things. So when designing a product of any kind, there should be a harmony, a mirroring, created between the brand personality and the consumer's concept of themselves, in order for the product to be appealing. In social psychology, psychologists call this mirroring '*similarity-attraction*', where the more people are similar, the more attention they pay to each other, and the more attraction there is between them.

An investigation of people's tweeting behaviour illustrates this interactionist principle rather well. A tool called Twee-Q ("Twitter Equality Quotient") measures how many of a user's recent retweets, taken from their last 100 posts, were originally written by men or women (in other words, what proportion of the tweets that they forward to others are written by men or women). The site delivers a score out of 10; and the lower the score, the more likely the more biased towards a certain gender the tweets are. People who score a 10 tweet male and female opinions equally, but any score less than 10 shows a bias in retweet behaviour. Justin Bieber, for example, has a score of 4.6 showing that 69% of his retweets were from male accounts. President Obama has a low score of 1.4 showing the retweeting of male opinions in 87% of cases. Importantly, real-time statistics show that more than 47,300 people have used the tool and that the average Twee-Q score is 4.7 showing a very high tendency to 'own-sex' retweeting.

The importance of the interactionist tendency in people's reactions cannot be ignored and yet, as we saw earlier in Chapter 3, previous studies of web aesthetics adopted a universalist position – looking for a one-size fits all pattern to people's aesthetic choices – and failed to test for an interactionist effect. Given the compendious evidence in favour of the mirroring principle, this is a major gap. Of course, were Internet usage to be skewed in favour of men, then this gap would not be of practical

importance so it is vital to know more about Internet demographics. To what extent are men and women spending time online?

The audience for the Web

A trawl through web usage statistics shows that similar proportions of men and women use the Web in both the US and the UK. In mainland Europe, female use of the Web is slightly lower, at 38%, but the picture overall is one in which website providers have an interest, all things being equal, in appealing to men as well as women. Of course, certain sectors appeal to a larger or smaller proportion of men and women, and their interest in having appeal to both will vary according to the target demographic. For example, the target demographic for beauty sector and social networking websites are predominantly female, while that for football or angling websites will be predominantly male. In between, with roughly equal proportions of male and female viewers are higher education websites. So it is only those websites with a predominantly male audience that will have no interest in understanding gender aesthetics; the rest should really be sitting up and questioning whether the universalist principle is one on which they can rely.

As noted in chapters 2 and 3, I did battle with the question of whether the websites created by men and women differ in any significant ways and also whether third parties have any particular preferences as between the websites created by men and women. Doing this was a way of finding answers to the age-old debate about aesthetics and whether these follow universalist or interactionist principles, with hoped-for answers relating to what men and women *create* as well as to what they *prefer*.

Websites created by men and women: are they different?

When it came to comparing the websites that men and women create, a first experiment compared a random selection of male

and female-created student websites stored on the Oxford University website. I rated these, together with Dr Rod Gunn, against 24 elements relating to navigation, language and linguistic features, and significant differences emerged on 13 of these elements. "When I analysed the results, the differences stood out a mile," said Rod. "To discover statistically significant differences on two or three elements is one thing, but to find them on thirteen is striking to say the least."

The differences spanned the three areas examined, namely visual elements, language and images. Where visual elements were concerned, the ratings showed that male-typical websites included a straight horizontal line at the top of the page while women avoided this; where typeface colour is concerned, the men tended to stick with black and blue typeface with the women using yellow, pink and mauve; where images were concerned, men tended to show photos of men (except where sex comes into it) and women of women.

If the visuals were worlds apart, so too was the language. In terms of the formality or informality of the language, the men's language tended to be considerably more formal than the women's, and tended to play up their achievements while the women went in for self-denigration. So, the undergraduate girl whose opening line was "I like knitting" turned out to be pretty typical. Remarkably, all these differences, as Rod said, were very significant from a statistical point of view.

Our next study took the research one step further by comparing student websites produced in the UK, France and Poland. Over half of the characteristics in the websites from these three countries – such as use of expert language, typefaces, the range of colours, the dominant shapes and lines and use of male or female faces showed again an astonishing difference between male and female sites. The possibility that these differences arose purely by chance was shown statistically to be less than one in a thousand.

As for men and women's *preferences*, you saw earlier in Chapter 3 how experiments testing men and women's preferences for male and female-designed graphic, product, packaging and website designs produced strong evidence of own-sex preference. These results showed quite clearly that if you wanted to appeal to a man or a woman you had present them with their own, unique way of seeing.

However, a study I conducted with colleagues looking at the websites created for sectors where women constituted 50% or more of customers showed that very few companies are actually doing this, so the female web browser was not getting much in the way of the mirroring of her 'gatherer' tastes while the male would have been in his element with the ubiquitous use of the 'hunter' look. Let's consider a few sectors so that you have a sense of what this means.

Websites – how fit for purpose are they?

We will start with universities, a sector in which there are more or less equal proportions of male and female customers, but with a slight skew in favour of women. If the websites were adapted to this target market you would expect them to reflect elements of the male *and* female design aesthetic, wouldn't you? In actual fact, an analysis by myself and Dr Rod Gunn of a random sample of university websites in Britain revealed the presence of a predominantly male aesthetic (corresponding to a gender coefficient of 0.72 as opposed to the optimised 0.50), with most websites being very boxy in appearance. If you want to check this out, take a look at the websites of these universities and you will see what we are talking about: University of Leeds (three boxes on the home page and the rest of the page white); University of Birmingham (one rectangular image at the top of the page and the rest white); University of Westminster (no fewer than ten boxes of rectangles on its home page); and the University of Bangor (nine boxes and five rectangular links!).

A similar look prevails around the world. If you look at Harvard's website, for example, you will find fifteen boxes on the home page; Sapienza University in Rome has a central box divided into several thin rectangular lines provided with links; Caen University boasts ten boxes; Tel Aviv University has six boxes with plenty of white space around them. The fact is that the use of a male aesthetic in a sector in which at least half the customers are female suggests that these websites are unlikely to be optimised for this market of men and women.

If this is true of university websites, a sector in which women constitute a little over 50% of customers, it is very much more the case for sectors in which they constitute the vast majority of customers. The grocery sector is one of these and a glance at the websites of Safeway, America's biggest supermarket (twelve boxes); Kroger, second in the list behind Safeway with a number of chains to its credit including Fred Meyer is one (sporting eight boxes/rectangles on its website); Monoprix (with ten boxes); Tesco (seven boxes excluding the rectangular links); Sainsbury's (topping the charts with eighteen boxes). My goodness, what these companies couldn't do to make their sites more attuned to the preferences of the target demographic, women!

If you take the case of Tesco, for example (see www.tesco.com), it is slightly surprising to find the company name etched in brown knowing that its demographic is largely female. Surprising, also, to find all its links in blue and in its "Food News" section, photos and features focusing largely on men. So, we are introduced to *Harry Irwin*, Chicken farmer, with a photo; we are introduced to senior buyer, *Mark Grant*, again with a photo; there is likewise a photo and text of *Gareth McCambridge* who works for G's Growers, who has been supplying lettuce to the company for more than 30 years. Then we are introduced to Gillian Singleton who works on a fish counter but no photograph to accompany the text. Are there no stories about senior women in the company or even photos of other women working there?

Over eighty per cent of grocery shoppers are women and, as we've seen, each gender likes to see images of people of their own gender. The web design profession is male-dominated and those working for Tesco would naturally relate to images of people of their own gender. However, effective marketing demands moving beyond personal preferences to understanding those of the target market.

This point is particularly important in the competitive and tough market of supermarkets in Britain. According to Graham Ruddick, journalist on the *Telegraph* newspaper: "Compared with other countries, such as Australia, the supermarket industry in Britain is mature. For the major food retailers, this inevitably means life has got tougher, because there is no fundamental reason why food sales should grow ahead of GDP." He says that in a super competitive environment, "supermarkets must demonstrate to customers why they are unique in order to attract sales." How many people at Tesco have asked themselves what women, their main customers, are looking for? I write this at a time that the company is changing some of its front-of-store logo colours to black, blue and red, a step back from the earlier more light-hearted blue and white with a broken underscore which you can see on its website.

If the character of supermarket websites falls short of what could be provided to satisfy a predominantly female demographic, this is also true of websites of small and medium-sized beauty salon businesses. Market research for this sector indicates that women constitute the main customer demographic. The differences in male and female take-up is particularly pronounced in the case of sun tanning treatments (in Britain, they are three times as likely as men to have this) and eyelashes/eyebrows tinted or shaped (eight times as likely as men) and hair removal treatments (ten times as likely) but men are half as likely as women to have beauty treatments in general. Despite the tiny proportion of men likely to visit beauty salon websites, the

aesthetic is a predominantly masculine one, with a gender coefficient of 0.68 according to a paper I published with Dr Rod Gunn. This means that close to seventy per cent of the aesthetic was at the male end of the design spectrum, so pretty hunter in feeling with little space for the gatherer. In fact, telephone interviews revealed that seventy-eight per cent of the websites were produced by male designers so one's hunch was correct!

Finally, let us consider for a moment social networking sites, a sector with a predominance of female visitors. Pingdom has collected figures from Google's DoubleClick Ad Planner showing the proportion of men and women accessing sites and you can see here a sample of their figures:

Goodreads 30/70 (M/F)
Facebook 40/60 (M/F)
Twitter 40/60 (M/F)
WordPress.com 40/60 (M/F)
LinkedIn 47/53 (M/F)
Hacker News 76/84 (M/F)
Slashdot 88/12 (M/F)

These percentages show that just over half of the users of Facebook and Twitter are female and yet the design of the sites is firmly anchored in the male aesthetic. Facebook, for example, has a plain background in light blue with its name set in a darker blue linear strip across the top of the page. Twitter also uses a plain light blue background with information organised in white boxes. LinkedIn with a near 50/50 audience of men and women has a completely white background with a small amount of blue edging. Is there any justification, given the demographics, for using a palette just of blue for these sites? My guess would be that the designers of these sites are mainly men and they are creating sites that appeal to them!

This is not meant to sound critical. On the contrary, the

perception that websites in many sectors could be given a bit of a facelift and a nudge in the gatherer direction offers space for many organisations to improve their game and reap the benefits from doing that. After all, our understanding of gender aesthetics is from recent work, and marketing and design directors may not have been exposed to it. Once they became aware of the new evidence, however, a whole new palette opens up and new tools become available for wooing the customer. Creating new-style websites becomes good for the customer as well since they are presented with visuals that match their taste so the new information helps create a win-win for both parties.

Incidentally, I am not alone in taking issue with some of the current ways of presenting things on the Web. Michelle Miller commented in April 2007 on the American Airlines *Women Travelers Connected* webpage, a page devoted to female travellers with travel tips, lifestyle travel packages and business ideas. The design had all kinds of boxes, sharp corners and tiny type and Michelle noted how: "the design leaves me cold... my first impression when visiting the page was 'Wow... good idea, but it certainly doesn't speak to me.'" She concludes that: "if you're going to give women something to hang their hat on, it has to have substance... You have to go deeper – understand a female consumer's needs from within, and learn the language she speaks."

That language has, to a certain extent, been understood by the beauty giant, L'Oréal. The world's largest cosmetics and beauty company, L'Oréal boasts brands such as Lancôme and Yves Saint Laurent and appears to do a better job than the supermarkets, not least because its website boasts smiling, beautiful women, the main target demographic. The general look and feel of the website may be masculine – information and photos are presented in boxes and there is a lot of white and also black in the background – but the preponderance of images of women, and smiling ones at that – remember Majewski's research

revealing women's tendency to depict smiling faces and the tendency for women to be drawn to female-typical visuals – are likely to have a powerful impact on women. This company chalked up net profits of more than seventeen per cent in 2012 which is an impressive result in recessionary times.

L'Oréal is a company that has a strong awareness of diversity – it presented alongside myself at the big Global Diversity and Inclusion Conference in Barcelona in 2013 – and this awareness is clearly feeding through into its website. To find a website that has elements of the female aesthetic is, though, something a rarity, despite women's massive purchasing power. As this book was going to press, and I needed a new photograph of myself for an article I was writing (on gender and websites of all things!), I was searching the internet for a photographer who could help out. One website immediately caught my eye – http://www.clarewestphotography. co.uk/ – both because of the quality of the website and its slightly homespun character (if you scroll down to the bottom of the page, you will see four links displayed in slightly irregular-shaped rectangles, each with a different, attractive colour) and because of the extraordinary quality of the photographs. Looking at the engagement photos, you really could imagine that you were a fly-on-the wall and observing an intimate moment in people's lives. So, I had my photo taken by Clare West and was delighted with the result.

Back to L'Oréal. It is no accident if a website chimes with the preferences of the end-user and the culture of an organisation, and who they employ will be critical factors in determining the kind of designs that they will produce. So, who is designing the websites that you visit on a daily basis?

Who are the web designers?

You would think that with something as important as the Web, there would be a mass of information on the web design sector and who the designers are. In fact, there is a dearth of infor-

mation with almost nothing published on this all-important sector so one has to do investigations of one's own to get any information. One of the people I talked to was David Dinsdale, the person who until fairly recently was responsible for two of the biggest Government websites in Britain, Business Link and Directgov, the second providing a shop window to all government services. In February 2013, after he had moved to Atos, we gave a presentation on Gender Marketing at a Global Diversity conference in Barcelona and he had included a video in which the site's teamworkers are introduced one by one: "There's Nick, Shodan, Mark, Kiel, Phil, Carl, Uttan, Gareth and then there's Megan." So, the majority of the team were male (and young!) and this left a big question as to how common this was.

Since there was no published data on this, it was time to go back to the drawing board and conduct more interviews, this time with human resources people in top interactive agencies. These chats turned out to be highly informative with the chief finding being that web designers had a background either in computing or in Graphics. An understanding of the demographics of these two industries would therefore shed light on those of the web design industry.

I decided to tackle graphic design first. This transpired to be yet another black hole with almost no demographic information available. Fortunately, the Chartered Society of Designers (CSD), a professional body with international membership, allowed me to access their membership figures for 2006 and these showed that 56 per cent of graduate members but only 21 per cent of Members and 12 per cent of Fellows were female. These figures paint a picture of a profession dominated at middle and senior levels by men and so if graphics experts are migrating to web design, chances are that a high proportion will be men.

The computing industry next. This time there is a mass of demographic information showing that, starting in the 1990s, men constituted on average 78 and 81 per cent of the workforce

(Robertson *et al*, 2001). The data showed a dominance of men at all levels and across the three fields of information systems, information technology and computer science, with the situation varying only by country and by IT specialisms. For example, in the US, the proportion of women among computer professionals fell in the 1990s from 35.4 per cent to 29.1 per cent. In the UK, figures for 1994 showed women making up 30 per cent of computer scientists, 32 per cent of systems analysts, 35 per cent of computer programmers, 10 per cent of IS directors, 18 per cent of project leaders and 14 per cent of applications development managers (Baroudi and Igbaria, 1994/5). These numbers are similar to those in the start of the period examined in the US and if we factor in the knowledge that there was a sharp decline in the number of women pursuing undergraduate and postgraduate degrees in computer-related fields in the course of the 1990s in the UK ((Igbaria and Parasuraman, 1997), then you are looking at declining numbers of women going into web design from computing. Coupled with what we know of proportions of male and female graphic designers, it is fair to conclude that web design is a male-dominated area.

Can this situation be reversed so that the web design industry has a more even gender demographic? It seems that this will not be easy. One reason is that the skewed distribution of men and women in IT has produced a "masculine computer culture" with a "masculine discourse" and a prioritization of technical issues (Robertson *et al*, 2001), all of which are likely to deter women from entering or remaining in the field (*ibid*). The authors suggest that it is only by including a "broader set of skills and discursive practices" that a more diverse group of people can be attracted into the profession, and that the masculine nature of the culture can be changed.

This could have a powerful impact on websites. We saw a little while ago that the team producing the Directgov website were predominantly male and web analytics provided by the company

Alexa show that the majority of people visiting the site are young males aged 18–24 with no children. The website was intended for the general population but was being used by the very group producing it. If you look at the audience for car websites you will see something very similar, even though the buying audience consists of marginally more women than men.

The lessons are clear. If powerful companies could produce websites that really mirrored the preferences of their end-users, then customers would be happier and the big corporates would catch a bigger share of the market that they were targeting. The current vicious circle could be turned into a virtuous one, with benefits for customers and organisations alike. It would just take some work on the demographics – creating a more gender-diverse web design team – or providing regular injections of training. I say "regular" since (as we saw at the end of Chapter 5) I ran a workshop for a team of male web designers, helping them discover ways of making the company's website more appealing to its predominantly female market. The team did a fabulous job changing the 'hunter' look of the website into something more attractive to its 'gatherer' audience and succeeded in attracting substantially more hits from women. However, when six months later I revisited the site, I saw that it had reverted to a 'hunter' look. There are reminders here of Bernard Shaw's play, *Pygmalion*, in which the phoneticist Henry Higgins discovers limitations in his ability to transform Eliza Doolittle from street flower seller to an elegant society lady. This parallels the realisation that, in the world of hunter-gatherer designs, a man can be taught to think like a woman but the effects will be short-lived!

Chapter 9

The world of art

Men of each psychological type tend to admire the art produced by artists of the same type.
Joan Evans

Cave paintings

In 1994, a Frenchman named Jean-Marie Chauvet discovered a cave in the Ardèche Valley of south-eastern France. Now called the "Chauvet cave", it contains paintings of animals dating back 32,000 years, making these the oldest cave paintings yet discovered. In terms of quality, they were said to rival the legendary cave paintings at Lascaux.

Who were the artists? Commentators made up in eloquence what they lacked in precision. Jean Clottes, a French cave expert, said that he "was standing in front of some of the great artistic masterpieces of mankind" and that these were the work of the "Leonardo da Vinci of the Ice Age". He took it as read that the artists were male. Gombrich, author of *The Story of Art*, was moved to offer the laconic comments that: "Man is a great miracle." Underpinning these flights of eloquence is the assumption that the artist was male and the British press illustrated appropriately with sketches of prehistoric man.

In itself, this assumption is nothing new. Paul Johnson, author of *Art: A New History*, has a discussion of cave art and describes cave artists as "great men who gave themselves airs." He has enormous admiration for them and assumes that these were people with high social status. His logic is convincing. According to him, artists must have worked by torchlight and, since torches consume animal fats in large quantities, they must have been held in high esteem to be granted use of such precious resources.

Secondly, whilst some of the best cave paintings must have been painted either standing up, lying down or squatting, others, painted on a gigantic scale or at heights many feet from the cave floor, would have required elaborate scaffolding. At Labastide in the Pyrénées, for example, an immense horse towers 14 feet above floor level. At Font de Gaume, the famous painting of a woolly rhinoceros is high up on a huge cave wall. At Lascaux, the evidence of scaffolding is provided by sockets cut into the walls.

Another argument for the elevated status of the artist lies in the fact that prehistoric artists probably had a large staff to assist them. The evidence for this is rooted principally in the magnitude of the task, and scale of support tasks needed before the artist could even begin their work. At Lascaux, for example, the big cave vault known as the Picture Gallery is over 100 feet long and 35 feet wide. At Rouffignac, the cave runs over six miles into the mountain, and some of its huge collection of drawing engravings are nearly seven feet long.

An abundance of support tasks would have been needed to underpin work of this scale. Lamps would need to be filled, torches held, scaffolding secured and brushes made from twigs, feathers, leaves and animal hairs. Moreover, paints would need to be mixed on a regular basis since some dried quickly and needed to be used quickly. Without this backup, it is unlikely that the artists could have transformed these cave interiors. Jean Clottes and Paul Johnson make the assumption that the high-status individuals commanding these resources must have been men. Are they right?

Using the evidence we have collected for this book we can do some detective work to infer from the style and thematic content of the paintings information something about the gender and personality of the artist. In terms of themes, we find that expressions of life are preferred to expressions of violence with depictions of pregnant animals and the peaceful portrayal of dangerous adversaries such as fierce felines and cave bears. The

depiction of a man felled by spears is an exceptional instance of violence, and the relatively greater emphasis on themes connected with life is more suggestive of female rather than male artistry.

A further clue as to the gender of artists in the Palaeolithic comes from the hundreds of statuettes and carvings found from the Russian steppe to south-west France and northern Spain. These rotund so-called 'Venus' figurines all have exaggerated breasts, hips and abdomen. It is unclear exactly what their significance was but the choice of gender may be significant since very few, if any, figures have been found in the shape of men. Remembering that men and women have a tendency to depict their own sex, one could see how, if the artist had freedom to choose what they depicted, these could easily have been produced by women.

So much for themes. The shapes of the figures and figurines depicted also provide vital clues. If you look at the shape of the figurines, for example the famous *Venus of Willendorf* from Austria, you will see that it is made up entirely of round shapes and detailed beading around the head. The same rounded shapes occur in the depiction of animals in the caves, where there is a conspicuous absence of straight lines. The artists seem to take pleasure in depicting the curves of animals, their underbellies and their horns. The curves and the level of detail is just what you would expect women to produce.

One final factor can help us in this detective work. It concerns small ochre-red handprints found in several caves. In a fascinating article in art magazine *Leonardo*, the French scholar Michel Schmidt-Chevalier expresses the view that these would appear to be women's hands, and he goes on to argue from this, as well as the plethora of female statuettes, that the artists in many of the caves in south-west France must have been women. If the evidence on shape and peaceable subject matter is also brought into the equation, then the case for female artistry becomes compelling.

Several thousand decades later, during the late Neolithic

period, around four thousand years ago, a simple tier society took over, with the big chief and his men at the top, women and adolescents in second place, and children at the bottom of the structure. The art of this new society shows a mass of abstract geometrical ornament, and few attempts at representing animals or natural objects. It seems that the era of female dominance in art is over.

Cave art to modern art

It is tempting to take this exploration of primitive art forward to the art of modern man (and woman) and apply the same analytical techniques. We could ask what painterly fingerprints men and women leave behind in their work. This is speculative work and is not 'scientific' in the sense of not using controlled samples. This proved much more difficult to achieve in the case of Fine Art than in Design, so I decided instead to select pairs of artists linked by family or marriage. Our investigation starts in the seventeenth century.

Seventeenth century flower paintings

We start with flower paintings, those exquisite but botanically improbable collections of blowsy tulips, roses, lilacs and lilies, spangled with jewel-like insects. As a fashionable person in seventeenth century Holland, you would be familiar with the names of Willem van Aelst and Maria van Oosterwyck, two of the most sought-after flower painters of the period. Van Oosterwyck was Van Aelst's pupil and legend has it that she responded to his offers of marriage by proposing that he court her for a year and paint ten hours a day before they marry. Faced with this hurdle, it is not surprising that the romance never blossomed.

Despite this lack of conjugal success, both painters had much in common. Both specialised in flower paintings and both earned well. His work was said to fetch 'abnormally high prices' while hers earned her enough to make it possible for her to donate

major sums of money (1500 and 750 guilders) to free three Dutch sailors imprisoned as hostages by Algerian pirates.

How do their paintings compare? They both produced asymmetrical flower arrangements with van Aelst being one of the first to do this apparently; but if you compare their paintings, you will see subtle differences. In Willem's paintings, the flowers tend to be large, whereas Maria painted a mixture of sizes, from large to very small with small blooms like lily of the valley and lilac filling up the space between some of the larger blooms. You will be hard put to find this in Willem's paintings.

There are subtle differences in colour too. In Willem's paintings, colours which stand opposite each other on the colour wheel (and are known as contrasting, or complementary colours) are often placed adjacent to each other. For example, blue and orange, opposite points on the colour wheel, are often placed adjacent to each other in his paintings. The adjacent placing of these two complementary colours makes for a strident contrast.

*The **colour wheel** is a tool used by artists and designers which arranges the basic hues or colours in a ring showing the relationship they have to each other.*

*Traditionally the ring consists of twelve basic colours. Colours close to each other on the wheel are called **harmonious** colours. (An example of this would be reds, oranges and yellows.) Colours opposite each other on the ring are called **contrasting** or (slightly confusingly) **complementary** colours. Examples here are red and green, or orange and blue.*

*NB We have used both the expressions **contrasting** and **complementary** in this chapter: they mean the same thing.*

It is interesting to see if Maria places these complementary colours in adjacent positions like Willem does. He was her teacher after all, and they were both living in the same period and working within the same genre.

Armed with a colour wheel, I looked at several of her paintings. I quickly noticed that although a pupil of his, she avoids this combination. Her palette consists of harmonious colours, keeping the complementary pairs apart. So, the blue-violet flowers are not adjacent to the yellow-orange ones but separated by red and white flowers. Our own research is beginning to show that this combination of colours is typical of women's work. I have called this combination *quadrant colours* as they are often four spaces apart on the colour wheel (whereas contrast colours, opposite each other on the wheel, are six colours apart). This four-apart, quadrant combination has never been named before but I have noted it over a period of time in women's work and consider it to be worthy of a name.

The impressionists

Several years ago, long before I had become interested in gender aesthetics, I met a friend at the National Gallery in London. We had a coffee and then wandered in to the Impressionists' gallery nearby. Now I happen to be rather short-sighted and often forget to take my glasses from the car so the paintings made only the most general of impressions from a distance. However, of all the paintings in the Impressionist gallery, there was one that caught my eye and drew me in closer. What I saw first were shades of emerald green and blue, and as I moved closer I could make out the shape of two women in a boat with straw hats and blue clothes against a background of shimmering blue-green waters and emerald trees. Moving up close to spot the name of the painter, I noticed that it was Berthe Morisot and this is one of just fourteen paintings in the National Gallery by women, all two and a half thousand of the rest being by men.

Fast forward to the present day and I wondered what had drawn me to this particular painting. A trip to the library revealed that Berthe Morisot was born in 1841 and married Manet's brother, Eugène. She exhibited in all the Impressionist exhibitions except for one after the birth of her daughter Julie and according to her biographer, Jean-Dominique Rey, left an output that was only "slightly less than Manet's". With just three years difference in their life spans and he only nine years her senior, it made sense to compare their artistic output.

I asked two students to independently examine ten paintings by Morisot and ten by Manet (selected at random) and, using a colour wheel, to note down the main colour combinations used. The paintings spanned the period from the 1860s to the 1890s so they were produced within the same short time frame. The number of paintings rated was small so this was in the nature of a pilot study, but the results of the two students showed surprising congruity. Where Morisot's paintings were concerned, neither of the students noted instances where contrasting colours were placed adjacent to one another. When it came to Manet's ten paintings, the first student noted seven occasions on which Manet employed contrasting colour, and the second student noted six.

When I went back and re-examined Morisot and Manet's paintings in the light of these findings, the differences in the way they used contrasting colours become immediately apparent. Take Manet's painting, *Argenteuil* at the Musée des Beaux-Arts in Tournai, Belgium, for example. This painting shows a couple sitting against the backdrop of a harbour with brilliant blue water. The brown and orange in the couple's hats and clothes form complementary colours to the blue in the water, and therefore contrast rather than blend with it. In the same sort of way, the brown and light blue stripes on the lady's dress form complementary colours and contrast with each other. The figures do not blend into their environment, and the same could be said

of *The Plum*, a painting by Manet in the National Gallery of Art, Washington DC. This shows a young lady in pink against a light green backdrop, another juxtaposition of complementary colours with the effect, inevitably, to make her stand out from the background.

Compare these paintings with those by Morisot from the same period. The painting from the National Gallery in London that had caught my eye all those years ago, *Summer's Day*, shows two ladies in a rowing boat wearing clothes that are on the blue-violet spectrum. The backdrop formed by water and trees is painted in shades and tints of green. Green and blue-violet are very close on the colour wheel so the women blend in more with their surroundings than do the Manet figures. The same colour scheme appears in Morisot's *A Woman and Child in a Garden* in the National Gallery of Scotland, and in *Lady with a Parasol Sitting in a Park* from the Metropolitan Museum of Art in New York. What we see in both paintings are characters clothed in blue-violet with a background etched out in green. In the New York painting, the bench on which the lady is sitting is the same colour as her dress and parasol, thereby again reducing contrast between the person and their environment. If we think back to the issue of men and women's relative field dependence, we can see Morisot's paintings as examples of women's greater field dependence and Manet's of men's great independence. As we saw, women tend to prefer things to blend in, and men to stand out.

We could pause for a moment to consider the implications of these tendencies. If men and women like the sort of art that they would produce themselves (an example of the 'own-sex preference' we have referred to earlier), then male gallery curators and art dealers – historically a group in the majority – are likely to prefer men's over women's work, 'hunter' over 'gatherer' work. Maybe this explains why, as we saw earlier, women's or 'gatherer' work constitutes only a tiny proportion of

paintings exhibited in the National Gallery of London and elsewhere. If, historically, women had predominated as dealers and curators, our National Galleries might be filled with women's painting. As things stand, most National Galleries are displays of men's art and should be dubbed "National Galleries of Men's Art" since that seems to be their primary mission. The way of seeing of the opposite sex is largely ignored, possibly because it has less appeal to those deciding on acquisitions.

This is not such a crazy view as it may at first sound. Griselda Pollock, Professor of Social and Critical Histories of Art at the University of Leeds, wrote in her 1988 book *Vision and Difference* that "women had always been involved in the production of art but... our culture would not admit it." She also comments that: "... it was only in the twentieth century with the establishment of art history as an institutionalised academic discipline that most art history systematically obliterated women artists from the record."

Ironically, a large proportion of the viewing public is female and, if my experience is typical, they would derive as much pleasure from seeing women's art as men do from seeing men's art. I am not alone in thinking along these lines. Not so long ago, I had lunch with a well-known art historian at Cambridge University. Did he think that the paintings of men and women were different? He paused as he poured himself a glass of wine. "It certainly appears that women are more sensitive to colour than men and this is one of the things that has fuelled the debate over the centuries as to the relative importance of drawings and paintings."

He went on to describe the heated debate that raged between the Florentines and the Venetians in the sixteenth century as to which of draughtsmanship and colour were more important. This debate was still alive in the seventeenth century but this time it took root in France, with the French Académie playing down the importance of colour. Later, over in England, Locke argued for

the primacy of shape and the lesser importance of colour on the basis that shapes and space were apprehended by the mind whilst colour was apprehended through the senses. Since mind was superior to senses, form must be superior to colour.

By the time we were both tucking into the crème brûlée, the story had reached the nineteenth century and Charles Blanc, then Director of the Department of Decorative Arts at the Ministry of the Interior in Paris. He wrote some of the most influential texts on colour in his time, and I was astonished to hear him say that Blanc described drawing as the masculine part of art, and colour as the feminine, and nearly spilled my coffee when I heard his description of complementary colours as "victorious allies when they appear side by side." That might be a view that men and women might not buy into equally!

It was back to the library to consider a further pair of artists. This time, Mary Cassatt and Degas. Mary Cassatt, although American, spent much of her life in Paris and in 1877 experienced a life-changing event. The painter Degas came to visit her studio in Montmartre and, impressed by her work, suggested that the two of them bypass the rigid jury-based Salon system and exhibit instead alongside the Impressionists. "I accepted with joy," Mary recalled years later. "I hated conventional art. I began to live." She never again submitted anything to a juried show and this single meeting with Degas, a kindred spirit artistically, allowed her to progress from a competent professional to one of the most original artists of her generation.

You can see from their attitude to the Salon system that both artists shared a common set of artistic priorities and this justifies a comparison of their work. As with our examination of Morisot and Manet paintings, this is not a scientific exercise but one that will give a flavour of these artists' use of colour.

Let's begin with Mary Cassatt's *Susan on a Balcony Holding a Dog*, now in the Corcoran Gallery of Art, Washington, DC. This shows a girl sitting on her balcony with a backdrop of trees and

Montmartre. In terms of colours, this painting uses similar colours as the two paintings of Berthe Morisot described earlier and Cassatt has even included a vertical strip in the interior to match the green colour beyond the balcony. This helps bind the environment of the girl to the world beyond, just as in Morisot's *Lady with a Parasol Sitting in a Park* there was a concern to blend the human figure with the immediate environment. Another of Cassatt's paintings, *Five O'Clock Tea*, shows two young women on a settee, their clothes painted in the same blue-violet colours as the nearby wallpaper, mantelpiece and tea set. So once again, they blend in with their environment.

It is interesting to compare these paintings by Morisot with two by Degas from the same period. One is *The Star* and the other, *Dancers Climbing the Stairs*, both in the Musée d'Orsay in Paris. These are well-loved, familiar images with the first showing the star of the show dancing a solo turn on an empty stage. Her tutu is speckled with red and yellow flowers and her black velvet neckband trails to her side, suggesting movement. Colour-wise, the main colours are the blue-green tone of the stage and the red-orange colour of the flowers on her tutu and hair, opposite colours on the colour wheel. The second painting shows dancers climbing stairs to a rehearsal area, with their tutus in light blue and the rehearsal area in orange. Once again, these colours are complementary, opposite colours on the colour wheel.

So, next time you buy a birthday card and see reproductions of these well-loved paintings, ask yourself which you feel most drawn to. It could just be that the choice of colours is playing a subtle role in your preferences.

Twentieth century decorative artists

An explosion of interest in the decorative arts took place in the first quarter of the last century with Roger Fry, painter and art critic, encouraging young artists to earn a living not merely through the sometimes chancy sale of their canvases, but also

through interior decoration and the design of objects such as tables, chairs, jugs, bowls, vases and boxes. The idea was that these should harmonise with wall-paintings, curtains and soft furnishings.

His Omega Workshops whose idealism sadly only lasted a few years, due in part to the outbreak of World War I, presented work principally from the circle of artists around husband and wife designers Vanessa Bell and Duncan Grant. Their near lifetime of artistic collaboration is epitomised by the decoration of almost every surface of their unconventional home *Charleston* in Sussex, now open to the public. A comparison of their work should be fruitful since, like the other pairs of artists looked at, both were working within the same artistic tradition, in this case the Applied Fine Arts. A comparison of a small sample of their extensive output will be intriguing.

In the 1930s, Bell and Grant were commissioned to produce plate designs for Clarice Cliff. There are superficial similarities insofar as both show a floral centrepiece with a border. Look more carefully, however, and you will see that all the elements of Duncan Grant's design are separate and self-contained (sometimes contained within the boundaries of rectangular boxes). Vanessa's meanwhile shows flowers and circles overlapping and crossing the boundaries of their background. If you compare her fabric design with the carpet design Duncan Grant wove for Virginia Woolf at the same time, you will see how they share a common set of motifs but that his are large, bold and detached, and her forms are filled with fine polka dots and small additional details and the circles that make up the border are shown intertwined.

To the end of the twentieth century

Artists have a habit of being drawn to each other romantically and you can probably think of several examples from the early modern period: Augustus John and his first wife, Ida Nettleship

who he met while art students at the Slade; Picasso and painter Françoise Gilot, famously the only one of his women who left him); Henry Moore and Irina Radetsky, a painting student at the RCA. In rare cases, both partners achieved artistic fame, and twentieth century cases include Sonia and Robert Delaunay as well as Ben Nicholson and his first and second wives, Winifred Nicholson and Barbara Hepworth. Given the prominence achieved by both parties in these relationships, it will be interesting to compare the work of these husband and wife teams.

Starting with Sonia and Robert Delaunay. Sonia was born in modern-day Ukraine to humble parents – her father was a foreman in a nail factory and she was adopted by her more affluent aunt and uncle who gave her a privileged upbringing in St Petersburg. Her skill at drawing was spotted by her teacher who initiated her move to art school in Germany, from whence she moved to Paris in 1905. After marriage to a homosexual art gallery owner, possibly to forestall calls to return to Russia, she met Robert Delaunay, became pregnant, divorced and remarried. They became leaders of a movement known as Orphism, one that attempted to soften Cubism with lyrical colour. So the Delaunays' paintings, unlike the mainly monochrome cubist works by Picasso and Braque, consist of bright hues with bold, repeating patterns. There is much that superficially seems to unite these painters. Let us now look at their work in a little more detail.

Robert painted several versions of the Eiffel Tower, with his first one dating to 1909. This first painting shows a brightly coloured tower with adjoining shades of green and red-orange and this bold use of complementary colours and his exaltation of what he called "simultaneous contrasts" were strongly influenced by the works of Michel-Eugène Chevreul, former director of dyes at the national Gobelins textile factory in Paris. Chevreul's classic 'colour theory' text of 1839, *The Law of Simultaneous Colour Contrast*, describes the combination of near complementary hues

as "superior to every other" and, in his own writings some seven decades later, Robert Delaunay notes that "colour simultaneity through simultaneous contrast [...] is the only real way for constructing a painting." So you have Robert Delaunay's abstract painting *Rhythm* which positions split complementaries next to each other and does so with razor sharp precision.

The apparent similarity between Robert's work and that of his wife is in fact misleading. Her paintings never achieve the razor sharp clarity that characterises his work and the slightly whimsical character of her work finds expression also in the fabric patterns that she produced in abundance. In all her work, she seems to delight in using irregular, blurred outlines and curvy shapes and lots of detail. You can delight in looking at a pink scrolling design with blue-violet extended dots, or a blue pattern with myriad red polka dots. There is a mass of detail here, as well as colours that are no more than four apart on the colour wheel.

Interestingly, she was very aware of the differences between their work, claiming that she worked intuitively and that her husband was the scientist. "My life was more physical," she recalled in 1978. "He would think a lot, while I would always be painting. We agreed in many ways but there was a fundamental difference. His attitude was more scientific than mine when it came to pure painting because he would search for justification of theories."

A similar difference springs from a comparison of Winifred and Ben Nicholson's work. These artists were married for eleven years and during the time they were together, his work, like hers, was representational. It was only after he took up with Barbara Hepworth that his style settled into the stark, abstract idiom that was quite unlike that of his earlier years. Before we compare their work, it is appropriate to compare their artistic education.

Both Ben and Winifred Nicholson had been to art school, she to the Byam Shaw School of Art where she completed a degree,

and he to the Slade where he completed no more than the first year. In the time they were married, they exhibited jointly and there is much to unite their early *oeuvre*. Both painted representational scenes and both employed naïve, childlike shapes. When it comes to colour, however, the similarity ends. In his *Still Life on a Table*, now in the Beaverbrook Art Gallery in New Brunswick, Canada, the dominant colour is brown. Compare this with Winifred's *Honeysuckle and Sweetpeas*, now in the Aberdeen Art Gallery, or *Flowers in a Green Jug* (showing an irregular shaped vase with an abundance of small flowers tumbling out of it) and you will immediately perceive a difference. The colour palette in both her paintings consists of bright colours, as against his darker colours, and colours that are no more than four spaces apart on the colour wheel.

Brilliant and subtle colours typify Winifred's work and we know from her writings that this was no accident. Although fine art training at the time tended to subordinate colour to line and drawing, her travels, particularly a visit to India in 1919, led her to explore fresh aspects of tonality and light. By 1937, she was writing about how "colour was used as melody by the Easterns" while Ben Nicholson had launched himself into a prolonged love affair with abstract forms. In fact, his work was characterised by forms that were stark, colourless and angular.

The appearance of 'hunter' characteristics in his work can be found in his use of dark colours and angular forms and is paralleled in his passion for ball games. He loved tennis, table tennis and a game called 'shut-eye golf' in which you had to memorise the shape of an imaginary golf course on paper and then, after shutting your eyes, attempt to draw lines between the holes without hitting an obstacle. The sculptor, Henry Moore, also played the game and described it as relying on "visual memory" as well as "a judgement of distances and angles", skills that he said Ben Nicholson enjoyed using "enormously", and applying in his painting. If you think about it, these are all 'hunter' skills

and maybe what you can observe in his paintings are finely-tuned hunter skills. What you observe in Winifred's paintings, on the other hand, are skills that are of the 'gatherer' variety.

Some people will be squirming at the suggestion of hunter and gatherer fine art skills but an appreciation of varying visual skills may help in understanding the factors that, in a given era, lead certain work to be excluded from galleries. Artistic waves mean that style will vary with time and the curves of the Romanesque, Rubens portraits and the Art Nouveau Paris Metro bronzes, works produced by men, would need to be set alongside contemporary work by women in order to highlight the contrast in style. The mere fact that curves are used does not lend them 'gatherer' status since it is usually the *gestalt* of the work that carries the 'hunter' or 'gatherer' imprint.

It is likewise the *gestalt* of the work that will influence vital decisions by the hanging committee. As we saw in an earlier chapter, men can have a disproportionate influence on hanging committees and curatorial posts and the 'self-selecting' phenomenon is likely to lead men to prefer men's work over women's. We are not suggesting that this is a conscious process but one rooted in a visual fellowship between one hunter and another. There will of course be men who do not follow the hunter mould just as there will be women who resist the gatherer way of seeing. In fact, one could plausibly take the view that women whose artistic style is most closely matched to the hunter way of seeing are most likely to have their work accepted by the hunter-dominated world of the world's Galleries.

A glimpse at the Museum of Modern Art collection in New York provides an illustration of this since 95% of its collection is by men. This is not to deny the celebrity of what is on offer here since the collection is a veritable roll-call of the famous in the fields of paintings, sculpture, design and architecture. You can amuse yourself, and I can commit the ultimate heresy in fine art terms, by identifying the real Hunters amongst them. We might

start with Gauguin's *The seed of the Areoi*, a painting showing a naked lady seated on a blue mat with her feet resting on an orange surface. The striking colour contrasts are there also in Derain's *Fishing Boats* with blue and orange set against each other again. Picasso's *Guitar* would be another piece of hunter art with the normal curves of the guitar reduced to square shapes etched in dark brown.

Other hunter forms, with elongated lines, are seen in the work of Giacometti, Rennie Mackintosh (familiar elongated chairs allowing for privacy), Frank Lloyd Wright (notice the heavy-weight, dark brown 'side' chair with elongated rectangular piece of wood providing the backpiece) and Richard Sapper (his Tizio lamp with dark elongated lines of black metal). This is *some* collection. Walking through MOMA is to walk past iconic examples of the History of Art and Design for the last two hundred years. It is also to be exposed to the unique hunter way of seeing.

Surprisingly – or perhaps not so surprisingly given the prominence of hunter art in the artistic canon – the female work that has been selected by the Museum also displays a love of the linear, extended forms and lack of colour. You have only to see the white crumpled cans of Eva Hesse, the thin, elongated shapes of Louise Nevelson and blocks of white stone by Rachel Whiteread to see examples. In the architecture and design section, likewise, you can see it in the selection of work by Eileen Gray. One of her pieces is a screen constituted of grey and black rectangular blocks while another is a standard lamp *Tube Lamp* with an elongated tube of vertical chrome. From Anni Albers, a leading member of the Bauhaus, and one of the few women in that movement, we have two wall hangings. Both are formed entirely from linear motifs of rectangles and squares and, in terms of colour, the second is constituted entirely of shades of grey. Next, from Florence Knoll, we have a rather severe, square coffee table and from Louise Bourgeois a piece, *Articulated Lair*

(there's a hunter name for you), with large chrome screens supporting black rubber shapes resembling body parts or, according to the narrator on the MOMA video, "swords in a hunter's cave". Speaking of it herself, Bourgeois commented that, "The security of a lair can also be a trap where a hunter is storing his prey," so the pre-eminence of the hunter style in the work by women in MOMA could not really be clearer.

Just occasionally, something closer to a gatherer-type style is on display. Examples include Polly Apfelbaum's circular collage of jewel-coloured velvet pieces, or Eva Zeisel's small salt and pepper shakers resembling a playful family of seals. You could look also for Ellen Gallagher's collage of muted pink squares and see the way that they avoid sharp alignment. Look out also for another of her pieces (unnamed this one) that uses pink dots as part of an irregular oval shape. Enjoy these examples of gatherer art since much of the rest of the Museum is devoted to the Hunter legacy. I say this not because either aesthetic is better than the other but simply because human beings can produce works at either end of the Hunter and Gatherer aesthetic extremes, and life is richer when it serves up works produced in both the hunter and gatherer modes.

MOMA could do this but some of its more overtly 'gatherer' work is actually not on display. For example, the work of Yayoi Kusama, Japan's greatest living artist, are not in view even thought the Museum has 17 pieces of this artist's work. These include smaller works – so easier to find space for – that date back to the 1950s and which use her trademark dots, whether black pen dots on paperboard or mauve spots on a mauve background. Yayoi, now 84 years of age, has been described as the "princess of the polka dots" since so much of her work features this pattern. An early work *Horseplay* was a photograph of Yayoi posing with a horse, with the artist wearing an all in white bodysuit decorated with polka dots, and the horse likewise covered in giant dots. Later, she produced room-size

installations with walls, floor and giant balloons festooned with polka dots and much of her *oeuvre* held by MOMA feature this pattern.

Incidentally, the undercover feminist movement, the Guerrilla Girls, railed against the male domination of fine art although they never used the terms 'hunter' and 'gatherer'. After twenty years of campaigning against the male-domination of the world's art galleries, they say that: "it's even worse in Europe" than in the US. The figures for the National Gallery in London speak volumes. Out of a collection of 2,500 paintings, 14 are by women, giving women a 0.5% showing in this national gallery. These statistics speak eloquently of the dominance of the hunter vision in London. In the US, things may be slightly better, but hunter vision still rules the roost, even in museums of modern art where you would expect a greater balance between the genders given women's greater participation in art in the modern period. However, in the permanent collection of painting and sculpture in New York's Museum of Modern Art, only 19 items on view in 2006 were by women (less than 5%); after the public was made aware of this under-representation, the displays were changed, but for the worse – only 14 of 400 pieces the following year were by women (3.5%). At the nearby Guggenheim, between 2000 and 2006, only 14 per cent of the museum's solo shows were devoted to women.

For those who like the balanced forces of Yin *and* Yang, you can come away from galleries suffering something of a surfeit of Yang. After a day's hunting, with straight shapes, dark colours and elongated forms, it can be revivifying (for women at least) to settle down to scrumptious colours, curvy shapes, compact forms, and a different take on the world.

Gallery curators take note! Nathan Richie, education programs manager at the McCormick Tribune Freedom Museum in Chicago, studied gender patterns in art museum visitation and perceived a link between who works in museums and who visits.

He found that when male curators at art museums started doing exhibitions of motorcycles and cars, male attendance at those museums rose significantly. So what proportion of museum and gallery curators are men? According to Marjorie Schwarzer, Professor and Chair of Museum Studies at John F. Kennedy University in Berkeley, California, the situation in 2007 was that men hold sway over boards of directors, major donor lists and pay scales; they occupied 53 per cent of executive director positions and 75 per cent of CEO seats at the nation's largest and best-funded institutions.

While the management of art galleries may be skewed to men, attendance favours women. According to Eileen Hooper-Greenhill, in a book in 2013 on museums and their visitors, visitors to art galleries are more likely to be women than men. Statistics from individual surveys show a slight excess of women visitors over men with a 2005–06 survey by the Australian Bureau of Statistics showing that 25 per cent of women attended galleries, compared to 20 per cent of men. In the UK, according to a MORI report on Museums and Branding strategy in 2000, visitors to galleries tend to comprise more women (55% vs. 44% men).

Since women compose the majority of visitors to museums of all sizes – such is the allure of culture to the female half of the species – offering a more balanced diet could serve to increase their appeal. Moreover, since women spend more money than men on audio guides and in the gallery shop and café (Schwarzer, 2007), attracting more women would make sound business sense. So in addition to any moral argument that there might be in favour of a greater gender balance in fine art collections with a more even hunter/gatherer presence, there is a strong business case as well.

Our brief foray into the world of Art must now be abandoned in favour of a glimpse at the impact of difference on relationships.

Chapter 10

The world of relationships

It is useless for us to attempt to reason a man out of a thing he has never been reasoned into.
Jonathan Swift

Noticing small details

I had a male friend to stay who seemed reasonableness itself. When my mother was ill and I was visiting her twice a day in hospital, he would shepherd my son around from football to friend to local show and his level of understanding was infinite. In my tiny bathroom, I have two towels that I like to keep folded to make them unobtrusive and neater by blending into the surroundings. Each time I went into the bathroom after he had been in there, it was to find the towels ruffled up and replaced just anyhow. I would then unruffle them and the cycle would start again. I noticed what was going on but I am not sure that he did. Eventually I mentioned it and he couldn't see what the fuss was about.

Misunderstandings like this have echoed down the ages and through different cultures. This is not about laziness, or unwillingness to help in the home, but about different ways of seeing. By now, the reader will probably have spotted the roots of this familiar conflict with women more likely to spot details and to see things in the context of the surroundings and men less likely. So, women's greater *field dependence* will mean that the coloured cushions that are not arranged in the correct sequence will upset them while men, with their greater *field independence*, will see objects out of context from their environment and not notice. So he does not really see the ruffled towel, and the cushions do not even register.

Stories like this one are legion. A lady I was chatting to at work confided some of her frustrations to me one day over coffee. "I'll come home and the house will look as though it has been burgled. It drives me mad. Cushions are everywhere and my seven year old son will have dropped his jacket on the floor. My eight year old daughter doesn't do it nearly so much. The thing is I need to have order at home before I can do anything. It is a priority for me. My husband is organised at work – he's an optician – but nobody could describe him as neat at home."

A similar theme emerged from my Danish friend Anna, speaking of the breakdown of her marriage. "I've been with him for nearly twenty years, and I wouldn't have stopped it unless he had." Next time we met, she told me of a positive aspect to the break-up. "My house would also be reasonably tidy and then David would return home and leave a trail of clothes behind him. You could literally follow his tracks by following the line of jumpers, shirts and socks that he left behind him." She confided that she found this irritating and that it disturbed her visual landscape. David, on the other hand, noticed no disruption to the surrounding visual scene.

While putting the finishing touches to this book, I holidayed with friends and their three children and while we were clearing the meal (the husband had gone off to a local shop to get a special dessert), the wife reminisced about their early days together. "Shortly after I met David," said Sam, "I decided to clear his bachelor pad kitchen. When he returned, he stood in the kitchen door and kept saying that it looked twice the size but he was mystified as to what had occurred since it didn't register that I'd cleared away the clutter since he'd never noticed it anyway. There had been a newspaper covering a used plate and the date on the paper suggested it had been there for more than a week but presumably this disappeared into the background."

We returned to this subject again after dessert. "I remember when we moved into our house thinking how awful the bright

yellow on the walls was. I painted them a neutral colour which was much more restful to live with. Just recently, I reminded David what it used to be like and he seemed to have no recollection of the previous colour so it obviously had had little impact on him."

We were staying in a rented holiday cottage and, after putting her children to bed, she picked up where she had left off: "I like everything to match and so will take care to make sure that when I set the table, everything looks harmonious. David will sometimes say how nice it all looks but he'll usually have no idea why it looks so pleasant." By this time, David was back from his shopping trip and the conversation took another turn. By that stage, I'd heard enough to make me realise that Sam and David had approached visual issues in rather different ways. They had established a *modus vivendi* with Sam taking most of the important decisions.

Decisions in and around the home

Given the private nature of the home, a surprising amount is known about it. In Britain, the National Association of Estate Agents undertook research in 1996 that showed that it was only in 9% of cases that men had a decisive say in the purchase of a house. According to the survey, over three quarters of estate agents in the survey agreed that women were the key decision-makers in house purchase decisions.

As to what goes on inside the house, the Henley Centre in Britain were commissioned to carry out research for Laing Homes in 2001 and reported that the volume of space per person per household was increasing and leading to clearly defined 'his and hers' rooms. 'His' room would typically be a study, or bathroom with TV screen and state of the art gadgetry, while 'her' room would be a super new kitchen. What about common areas? According to the report, women do not want technology permanently displayed in common areas and men "would not be

allowed" to have their computer in the main living room! We should not be too surprised by the fact that women have overall control over what does and does not happen in the home. Research in 1996 highlighted the extent to which lack of consensus is the norm in joint decision-making, and research two years later established the extent to which this conflict is managed by the female partner "to ensure that the outcome follows her expectations."

Recently, I wanted advice from interior designers about a house renovation project and asked them whether they came across discord between men and women about choice of decor. Both the women I spoke to mentioned that men generally conceded to women's choices since they realised that decisions about home decor mattered to them more than to men. The fact that, in their experience, men are prepared to follow women's lead is a bit of a relief since the potential for "lack of consensus" is otherwise enormous from the choice of kitchen, utensils, floor coverings, curtains to furniture, accessories and wall colours!

Often, the discord can be kept under wraps. A talented interior designer, Michelle Chesney, told me that she was planning the interior of her flat with her partner and some differences of opinion were looming into view. In the bedroom, he wanted to retain the square black headboard and also had his eye on a new sofa that was square-shaped and even had square-sided feet. She managed to reach a compromise on the headboard by agreeing on a neutral oatmeal colour set on a rounded headboard, decorated with buttons. The jury was still out on what she would do about the sofa.

Sometimes the differences just erupt. My good friends were choosing a new mixer tap for the kitchen and at first Nina said she would leave the choice entirely to David. However, when he returned from the shops with a minimalist techno metal mixer, operated by slick vertical levers, she realised she *did* care about what the tap looked like after all. Her preference was for

something more rounded, and white. A major domestic stand-off ensued. This couple, who normally hardly ever argue, were horrified at the depth of emotion these taps had stirred up.

Stepping into the garden

The potential for discord has the potential to extend to the garden as well. Recently, I had new turf put down in my front garden since the old one was beyond repair. This was a busy time of year and I did not have time to supervise the work but one day, on returning home, noticed that the new turf was in place. I suddenly realised that something was not quite right and, after some reflection, realised that the sharp lines formed by the new grass was what was bothering me. I gently asked the gardener whether he could add create some softer, more curved lines and the dissatisfaction evaporated as the grass formed curved edges with the flowerbeds.

In the following summer, my near neighbour, Dr Luisa De Giorgi, was showing me round the garden which is her pride and joy. "When I arrived at my house, the garden was a complete wilderness and there was no lawn and no flowerbeds. It took me years to get it the way I wanted." She gives the same rapt attention to her garden as she does to her patients and, as she guides you round, you notice the circular beds in the middle of the lawn and curved edges on the perimeter beds. "I like these shapes and would hate to have straight edges," she comments. At around this time, I had my own front garden landscaped by an excellent gardener from the Czech Republic, Libor Zapletal, and one of the things that he did was replace the rather mangy grass with something more pristine. In doing this, he formed a straight edge to the new grass so that the three large clusters of evergreens which faced you as you came through the garden gate emerged from behind a straight grass edge. I had worked hard to shape the earlier grass so that the edges curved in front of the plants but Libor's efficient work left the area with a fine straight

line. Feeling a tad uncomfortable with this shape (and reluctant to engage in a discussion on gender aesthetics!), I purchased some turf and reinstated the curves!

Another feature of Luisa's garden is the variety of flower species, all tenderly nurtured from seed or cuttings. One year, I had interviewed the head gardener of one of the oldest gardens in London, the Chelsea Physic Garden, and asked whether male and female gardeners have different styles of gardening. The answer was unequivocal: "Women are more interested in adding a border with different varieties of plants whereas men are more likely to use a block of a single plant and branch out to landscaping." It seemed that Luisa's style might be typical of her gender.

Famous gardens

You can see these differences in all sorts of plant-based design. Gertrude Jekyll (1843–1932), who created over 400 gardens in the UK, Europe and America, revolutionised garden design by replacing the parterre of repeating flowers ('bedding out' schemes) with planting 'in drifts' where the same species and colour is planted in small sections. Jekyll is also well-known for the use of 'garden rooms': gardens with a formal layout of pools, sunken gardens, pergolas and summer houses, divided with hedges, pergolas and walls into a number of enclosed spaces. This sense of enclosure gave each 'room' its own personality and style and this, together with the drifts, served to break up large expanses of space, something well in line with the female idiom.

By way of contrast, you could take the garden by Tom Stuart-Smith that won first prize at the 2003 Chelsea Flower Show: grey slate floor and only greenery, no flowers, in the earth. This show is the UK's horticultural equivalent of the Wimbledon tennis championship, organised by the eminent Royal Horticultural Society. Tim Richardson, writing recently in the Society's own magazine *The Garden*, complains that the judges for the Chelsea Flower Show are overwhelmingly male: "a group of middle-aged

men in Panama hats" is his description. The main drift of his article is that modern professional designers are being let down by Chelsea's rather parochial judging, but you could say that he is missing a vital point: that all-male juries tend to judge according to their own preferences for garden design.

Consider, for example, the gardens exhibited at Chelsea in 2012. Luisa had a spare ticket so I went along and jotted down notes of the main gardens on display and the prizes awarded:

Lands' End: A Rural Muse; designer – Adam Frost. Long rectangular pond (gold).

The Brewin Dolphin Garden; designer – Cleve West. Has tall topiary, a grand gate and a well at back with a gaping hole (gold and best show garden).

Homebase Teenage Cancer Trust Garden; designer – Joe Swift (M). Four cedar wood frames (gold).

The Arthritis Research UK Garden; designer – Thomas Hoblyn. Rectangular pond with rectangular stepping stones (silver gilt).

M&G Garden; designer – Andy Sturgeon. The walls described in the programme as "monolithic stone walls" (gold).

The Laurent-Perrier Bicentenary Garden; designer – Arne Maynard. Long lines of copper beeches that follow a long path (gold).

The RBC Blue Water Garden; designer – Nigel Dunnett. Very linear path – rectangular shape with paths off on both sides. Turquoise water + preponderance of orange flowers and mauve (silver gilt).

The *Telegraph* Garden; designer – Sarah Price. Wild flowers. Big square pond but some meandering paths. Not formally laid out (gold).

Sarah Price's garden might just as well have come from a different planet to the others and if you wanted a further contrast

to the female idiom, you could take Edouard François' "Tower Flower", a ten-storey concrete apartment block in Paris's 17th arrondissement. Edouard, an architect and urban planner since 1986, created the name "Tower Flower" himself although it is something of a misnomer since, rather than flowers, every storey has 380 giant concrete flowerpots with tall, vertical bamboo plants. He says that he is experimenting with what he calls "technique végétale", a method that uses plants to attempt to soften the hard lines of buildings but whether the tall, slender plants achieve this effect is open to debate. "Would smaller, more colourful plants have achieved a better effect? Do the tall flowers emphasise the vertical?" my friend Rosy asked as she tilted her neck to see to the top of the ten-storey Tower. We thought with some nostalgia of Alpine chalets with their brightly coloured flowers and had similar thoughts in front of the greenery added by Patrick Blanc to the exterior of the Musée du Quai Branly, a short hop away on the other side of the river. The trend, incidentally, has crossed the Chanel and the long wall at London's "Westfield" at Shepherd's Bush has also been covered by a mass of green plants.

Ever conscious of the extreme controversy surrounding discussions of gender difference, I was eager to find out what garden experts thought. Did they think that you could distinguish male from female-designed gardens?

Garden experts speak out

Strangely, opportunities to pose this question arose shortly afterwards. I saw an advert for a talk by gardener and garden historian, Dr Catherine Horwood, author of *Gardening Women: Their Stories from 1600 to the Present* and posed the question during question time afterwards. "Women tend more to look at a garden as painting a picture," she said. "They are less concerned with the minutiae of planting and more with the overall effect that they are seeking to achieve. That's not to say that male

gardeners aren't successful in doing this but they approach gardening in a different way."

The next opportunity occurred a few months later when some of the gardens in the area I live in, Hampstead Garden Suburb, were opened to the public. This was a chance to visit the garden of Marjorie Harris, ex-Chair of the local Horticultural Society and, although the area she presided over was relatively small, her seven years in office would have provided ample opportunity to experience men and women's gardens. Asked the question, she was unequivocal in her answer. "Woman's gardening is more cottage-gardening – everything melding together, colours for example. There is formality in that there is tidiness in having defined lines (the edges of the grass) but the beds have softer lines and ordered chaos like a billowing skirt." She paused for a moment: "In fact," she said, "you can tell immediately a man's garden from a woman's garden."

"In what way?" I inevitably asked and her response was immediate: "Men's gardens perhaps have more gaps and more repetition of things and flowers don't meld into each other. Also, men might have straight lines rather than curvy ones, with often a square layout that is not as bendy as the one in a female garden. So their gardens have more scientific precision, are much tidier with a lot of one plant and they will tend to look at the whole in a more mathematical way."

Without any prompting, this train of thought led her to speak about the annual garden competition: "One year," she said, "all the judges were men and the women hated the winning entry which was very neat, straight and defined. Come to think of it, the male judges frequently select the male garden as the one they like best."

You could imagine that this kind of partisan attitude could signal trouble on the home front, with turf wars on how best the garden should be designed. Fortunately, if a 2011 survey of 2000 people by Roundup Weedkiller is to be believed, men tend to do

the more physical work such as digging best and taking rubbish to the tip, while women choose the plants and arrange the flowerbeds. This division of labour keeps the potential for disagreement to a minimum.

Back indoors

The potential for differences of opinion do not end there, however. According to a male interior designer, whereas women like to create a 'home environment' men want to solve problems – his examples were a male client who did not want much of a kitchen because he didn't cook, and another who bought a warehouse space and specified that he wanted an area for cooking, an area for making music, an area for eating. Thus a man likes to define a room by what it will do where a woman is more likely to define it by how it looks.

One spring morning, I did what I almost never do which is attend a breakfast meeting. This was not time wasted since I met interior designer Morwenna Brett there. Pitching for sales at that hour of the morning were neither women's forte, and they were glad to subside into squishy armchairs with a cup of coffee. The conversation quickly turned to the different attitudes of men and women to design, particularly interior design.

Morwenna told me that she had just been commissioned by an interiors magazine to recreate some elaborate 18th century bed drapes in her own bedroom for a feature. Ruched curtains in historically accurate French *Toiles de Jouy* fabrics, covered in flowers and shepherdesses, surrounded the bed, all held in place with delicate antique brass fittings. After the photographer had gone, she had proudly showed the bedroom to her boyfriend. His only response was a puzzled: "but what's it *for*?"

If only this was an isolated incident! Unfortunately, Morwenna went on to tell me how her friend Ros had decorated the matrimonial mattress with a gathered valance in order to conceal it but the valance kept shifting, and every few weeks Ros

and her partner had to undertake the laborious, two-person job of lifting the mattress and shuffling the valance back into its proper place. Ros was in despair, and tried to devise ways of keeping it where it should be, but Phil's instant response was: "Why don't we just get rid of the thing?"

If the men are more able than women to dissociate objects from their surroundings, if they prefer straight lines to rounded ones, if women have better peripheral vision than men and better colour discrimination, it's no wonder that decorating a home to both their satisfaction is a minefield. It's no wonder that a couple's first argument arises over something as trivial as the choice of a toaster. Given that many of us women are even prepared to suffer mild discomfort for the sake of aesthetic pleasure – and men will want, primarily, for things to *work properly* – it's no wonder the new exercise bike parked in the middle of the sitting room floor becomes a major source of domestic friction.

Ironing out differences
When hunter and gatherer vision collide there can be a major

eruption. You can understand why since you have the confrontation of two ways of seeing and two sets of values, the 'hunter' and the 'gatherer'. Of course, a proportion of men and women will not conform to the differences we have described but a goodly proportion – as the evidence testifies – will. How can people ensure that differences of opinion are resolved and transmuted into decisions that both can live with?

This is a question that I put to three interior designers and they all took the view that men were generally happy to defer to the opinions of women. This may seem surprising but the points that consistently emerged were that women were more bothered about aesthetic choices than men and so men were happy to let women have their way; a further point was that many men felt that women were better at making aesthetic choices and so were happy to defer to their judgement. One can only hope that these designers have got it right since, otherwise, discord would be reverberating from sitting rooms all around the world.

Where the difference is, however, less easy to resolve, one can only hope that an understanding of hunter and gatherer vision will help ease things towards a solution. She doesn't want the square sofa with rectangular legs so is a compromise possible, perhaps a slightly softer sofa with no legs at all? He doesn't want to fix the decorative valance to the mattress when it falls off so can she take responsibility for this? In any event, this book will provide a language in which to talk about differences – *trichromacy vs. tetrachromacy; field independence vs. field dependence; lack of detail focus vs. detail focus; functional primacy vs. aesthetic primacy* – and so disagreements will at least have an educated ring to them and this, at least, will help to diffuse tensions.

So, reader, armed with information on the new science of perception, try and diffuse tensions and differences with this language of science. It might just take the conversation in a different direction!

Chapter Notes

Chapter 1

GAP – Video of Prince William and Kate Middleton painting in Canada – see YouTube video:
http://www.youtube.com/watch?v=cRJDtVRC8kE
(accessed on 28 August 2013)
Pippa Middleton in Madrid – photo:
http://i.dailymail.co.uk/i/pix/2011/05/14/article-1387173-0C0FE 40200000578-895_634x574.jpg
(accessed 20 October 2013)

or

http://www.dailymail.co.uk/femail/article-1387173/Pippa-Middleton-hits-Madrid-old-flame-George-Percy—girls.html
(accessed 20 October 2013)
See Cath Kidston's website at:
http://www.cathkidston.com/?gclid=CJTkicicrbkCFbLMtAodIng AYg
(accessed 20 October 2013)
"Visuo-spatial differences are acknowledged as the most robust of the sex differences after height" – finds support in Hines, M (2004) for which see the references.

Chapter 2

For images of NuShu, see
http://www.omniglot.com/writing/nushu.htm
(accessed on 29 August 2013)
Experiment on students' business cards: see Moss, and Colman (2001) in the references.
Experiment on web design software: Horvath, G and Moss, G (2007), *Gender and web design software*, CITSA, Florida, 13–15 July.
Japanese study: see Iijima *et al* (2001) in the references.
Study comparing children's colouring of cookers: see Moss

(1996b), "Gender and consumer behaviour: Further explorations", *Journal of Brand Management* 7:2, 88–100.

Interviews with design practitioners: see Moss, G (1999), "Gender and consumer behaviour: Further explorations", *Journal of Brand Management*, 7:2, 88–100.

PhD thesis comparing boys' and girls' drawings: see Majewski (1978) in the references.

Alfred Tonnellé, quoted on p. 8 of Hammer, E (1980) in the references.

A longer summary of the experiments conducted by Moss comparing male and female-produced designs can be found in her book *Gender, Design and Marketing* (2009) shown in the references.

Chapter 3

Professor John Rust – his views were expressed during an email exchange with the author in August 2013 and are quoted, with his permission, here.

Experiment comparing male and female-produced websites – see Moss, Gunn and Heller (2006) in the references.

Experiment comparing men and women's preferences as between websites produced by men and women – see Moss and Gunn (2009) in the references.

Article arguing for unconscious assessor bias in the assessment of Art and Design exams – see Moss (1996a) in the references.

Chapter 4

Estimate of the percentage of women who are tetrachromats as falling between 3–50%: the estimate of 3% is in Neitz *et al* (1998) and the estimate of 50% is in Jameson *et al* (2001), both in the references.

Pease, A and Pease, B (2004), *Why Men Don't Listen & Women Can't Read Maps*, London: Orion Books.

Reference to gender schemas occurs in Moss and Colman (2001) in the references.

"It seems that in utero and postnatal exposure to gonadal steroids (principally testosterone and estradiol) *are* associated with differential personality and spatial abilities in humans and some animal species." This information is explored in Moss *et al* (2007) which presents much of the evidence for evolutionary factors in differences in men and women's visual creations and preferences presented in this chapter. Further details can be found in Moss, G (2009), *Gender, Design and Marketing*, Chapter 8, quoted in the references.

For Professor Verma's study, see Ingalhalikar *et al*, in the references.

For the comment that the sex differences noted in Verma's study are "hard-wired", see Von Radowitz (2013) in the references.

For Professor Witelson's comments, see
http://infoproc.blogspot.com/2005/07/male-female-and-einsteins-brains.html
(accessed 20 October 2013)

For Professor Haste's comments, see
http://people.bath.ac.uk/hssheh/resint.htm
(accessed 20 October 2013)

Chapter 5

Small numbers of women on boards of retailers – see *Huffington Post*, 8 March 2013:
http://www.huffingtonpost.co.uk/2013/03/07/international-womens-day-top-retailers-have-women-free-boards_n_2828992.html?utm_hp_ref=uk
(accessed on 25 August 2013)

Ogilvy –
http://www.brandingstrategyinsider.com/2010/11/david-ogilvys-best-business-advice.html#.UiEL6tKTj3U
(accessed on 29 August 2013)

Silverstein – quote about women as the chief purchasing agent is from his book *Trading Up* (see references) co-authored with N.

Fiske. The quote about women controlling $5 million in incremental expenditure is from *Women Want More: How to Capture Your Share of the World's Largest, Fastest-Growing Market* (2009) – see references – co-authored by Kate Sayre.

Tom Peters – has several chapters on women's massive spending power in his book *Re-imagine! Business Excellence in a Disruptive Age* (see references).

G. Moss's own research on consumer patterns – for more details, see her book *Gender, Design and Marketing* (2009) – see references. Her first publication on men and women's purchasing patterns was Moss, G (1999) in the references.

Dr Andy Palmer – quoted by Ray Massey in the *Daily Mail*, 14 June 2013 (see references) and also quoted in *The Times* on the same date – see a copy of *The Times* article here:
http://www.theaustralian.com.au/news/world/the-car-industry-should-start-designing-cars-for-women/story-fnb64oi6-1226663712971
(accessed on 29 August 2013).

Vincent Dupray – *Peugeot Citroen* magazine, 2008.

David Bizley – quoted in *The Times* article, reproduced in the *Australian*:
http://www.theaustralian.com.au/news/world/the-car-industry-should-start-designing-cars-for-women/story-fnb64oi6-1226663712971
(accessed on 29 August 2013)

David Ahmad – quotes in Allen, 2004.

Anne Asensio – see article by Weernink (2007) in the references.

Valerie Nicolas – quoted in Moss, G (2009), *Gender, Design and Marketing* (see references).

Juliane Blasi – her thoughts are expressed on this video:
http://e89.zpost.com/forums/showthread.php?t=516647

Littlewoods – see
http://news.bbc.co.uk/1/hi/uk/4570663.stm
(accessed on 28 August 2013).

James Adams – see Gladwell (1997) in the references.

Sharp and Scaglione – see Wong (2004) in the references.

Women are the decision-makers on flooring – see Warner (2005) in the references.

"Women influence 75 per cent of the purchases of high-tech goods such as DVDs, flat-screen televisions and complex stereo systems" – see Warner (2005) in the references.

For the description of the Chrysler PT as a "gangster car", see Cato (2003) in the references.

B & Q – see Philips 2008 in the references.

Home Depot – see Holland (2008) in the references.

Chapter 6

Pahl (2000) – see references.

Men and women equally interested in green energy – see Rowlands *et al* (2002) in the references.

Employment numbers in the UK – see Andriopoulos and Dawson (2009) in the references.

Survey by the Institute of Practitioners in Advertising survey of the media buying, advertising and marketing communications sectors showing that women make up approximately half of the workforce but only 15.1 per cent of managing directors or chief executives – see Brook (2006) in the references.

Research by the "UK's Institute of Practitioners in Advertising showed that while women's presence as account handlers had increased from 27 per cent in 1986 to 54 per cent in 1999 (with women accounting for half of those in planning and research), just 14 per cent of art directors and 17 per cent of copywriters were women" – see *Marketing Week* (2000) in the references.

Figures quoted of 83 per cent of 'creatives' being men, a figure said to be worse than 30 years ago – see Cadwalladr (2005) in the references.

"... women's representation in creative roles as a closed shop when it comes to bridging the gender divide" (Doward, J, 2000).

The creative arm of the advertising industry is described as one that "does not seem to be too keen on thinking out of the box on gender issues" (Doward, 2000). A contributory factor may, according to a report on women in the advertisement industry by Debbie Klein, Chief Executive of WCRS, be the "stereotypical laddish atmosphere which is said to be still very much in existence" (Doward, 2000).

A "2002 survey of advertising staff by *AdAge* found that on average 35 per cent of creative staff were female" in the US – see Barletta (2006) in the references.

Tess Alps, the Chairman of media agency PHD, says that men "just don't value the kinds of ads that women write and that women like" – see Cadwalladr (2005) in the references.

Survey of women's attitudes to adverts by Greenfield Online for Arnold's Women's Insight Team – see *Adweek* 27 May in the references.

Reference in June 2008 to the Shredded Wheat advert as appearing in a forthcoming issue of the magazine *Real Simple* appears in an online comment by Angela Natividad found at this link:

http://www.adrants.com/2008/06/shredded-wheat-with-straw-berries-the.php

(accessed on 3 December 2013)

Chapter by Tom Jordan – see references.

Initiative by Universal – see *Admagazine*, 12 June 2013 in the references.

http://www.marketingmagazine.com.my/index.php/categories/breaking-news/9340-women-more-complex-than-advertisers-think

(accessed on 10 January 2014)

Ann Handley on the importance of understanding customers – on the website *Entrepreneur* – see

http://www.entrepreneur.com/article/227100

(accessed on 29 August 2013)

The description of her as "one of the most influential voices in

online marketing" can be found at:
http://www.toprankblog.com/2011/05/interview-ann-handley/
and
http://contentmarketinginstitute.com/2011/06/content-rules/
(both accessed on 29 August 2013)
Kathy Gornik on inertia in companies – see Palmer, J (2003) in the references. The difficulties in changing organisations are explored in Moss, G (2007) and in Moss, G (2009), *Gender, Design and Marketing*.

Chapter 7

Clara Greed – quoted in Groskop, V (2008) in the references.
"Arts for Transit" programme – for interview with the Director, Sarah Bloodworth, see
http://urbanomnibus.net/2011/11/arts-for-transit-a-conversation-with-sandra-bloodworth/
(accessed 20 October 2013)
Villa Mairea billed as "one of the finest houses of the twentieth century" – see Weston, R (2002) in the references.
For photographs of rugs made by Afghan women, see
http://www.oneworldprojects.com/products/afghan-rugs.shtml
(accessed on 28 August 2013)
For the comments of Danish designer Louise Campbell and the Head of the Secretariat, see
http://archives.dawn.com/weekly/review/archive/060622/review 10.htm
(accessed on 29 August 2013)
Myerson's comments on the impact of the office environment on productivity appear in *Workplace design* (2008) for which see the references.

Chapter 8

Annual growth is estimated at between 20% (Van Iwaarden *et al*, 2004) and 50–60% per year (*Economist* 2008). By June 2010, the

global Internet user population reached 1.9 billion: the source for this is

http://www.allaboutmarketresearch.com/internet.htm

(accessed on 28 August 2013)

"This research and subsequent studies": see Moss, Gunn and Heller (2006a); Moss, G et al (2006b); Moss et al (2008); Moss and Gunn (2009).

"It is estimated to produce ten times as many units sold with one tenth of the advertising budget" – see Potter (1994) in the references.

"Hans von Iwaarden and his colleagues, studying websites from the Netherlands and the US, have identified ten factors which create this sense of disappointment among users, and one of these factors is graphics" – see Van Iwaarden et al (2004) in the references.

"Similarity-attraction" – see Byrne and Newman (1992) in the references.

In mainland Europe, female use of the Web is slightly lower, at 38% – see Jupiter Communications (2004) in the references.

"A study I conducted with colleagues looking at the websites created for sectors where women constituted 50% of more of customers" – this is Moss et al, 2006b and Moss and Gunn, 2008.

Gender demographic of social networking sites in 2012 – see

http://royal.pingdom.com/2012/08/21/report-social-network-demographics-in-2012/

(accessed on 28 August 2013)

"Who are the web designers?" – further information can be found in Moss (2009), Gender, Design and Marketing. Data on the gender split of computer specialists in the US and in the UK in the 1990s can be found in Baroudi and Igbaria 1994/5 in the references.

The skewed distribution of men and women in IT has produced a "masculine computer culture" with a "masculine discourse" and a prioritization of technical issues – see Robertson et al, 2001 in the references.

Chapter 9

Jean Clottes – quoted in the *Independent*, 20 January, 1995, p. 21.
Keys, D (1995), A gallery opens after 18,000 years, The *Independent*, 20 January, accessed on 20 January 2014 at
http://www.independent.co.uk/life-style/a-gallery-opens—after-18000-years-1568873.html
Figures of M/F in MOMA and Guggenheim – source is Saltz, Jerry (2006). "Where the Girls Aren't". Retrieved November 14, 2010 from:
http://www.villagevoice.com/2006-09-19/art/where-the-girls-aren-t/

Chapter 10

Survey by Roundup Weedkiller – see
http://www.dailymail.co.uk/news/article-1377513/Women-better-gardening-reveals-survey.html#ixzz1yBYJmBea
(accessed 20 October 2013)

References

Ad Magazine (2013), "Women more complex than advertisers think", 12 June,
http://www.adoimagazine.com/index.php/news/1-breaking-news/9340-women-more-complex-than-advertisers-think
accessed on 28 August
http://www.marketingmagazine.com.my/index.php/categories/breaking-news/9340-women-more-complex-than-advertisers-think
accessed on 10 January 2014

Adweek (2002), "What Women Think", 27 May,
http://www.adweek.com/news/advertising/what-women-think-56700
accessed on 28 August 2013

Allen, D (2004), "How do I become... a car designer?", *Times Online*, 21 October.
http://business.timesonline.co.uk/tol/business/career_and_jobs/graduate_management/article496826.ece

Allport, GW and Vernon, PE (1933), *Studies in Expressive Movement*, New York: Macmillan

Alschuler, RH and Hattwick, LW (1947), *Painting and Personality*, Chicago: University of Chicago Press

Andriopoulos, C and Dawson, P (2009), *Managing Change, Creativity and Innovation*, Los Angeles: Sage

AutoObserver (2007), "Why Did Top GM Designer Leave?" 2 July:
http://www.autoobserver.com/2007/07/why-did-top-gm-designer-leave.html

Ballard, PB (1912), "What London children like to draw", *Journal of Experimental Pedagogy* 1:3, 185–97

Barletta, M (2006), *Marketing to Women: How to Understand, Reach, and Increase Your Share of the Largest Market Segment*, 2nd rev. edition, New York: Kaplan Publishing

Baron-Cohen, S (2006), *The Essential Difference: Men, Women and the Extreme Male Brain*, London: Allen Lane

Baroudi, JJ and Igbaria, M (1994/5), "An examination of gender effects on career success of information system employees", *Journal of Management Information Systems* 11, 3

Birren, F (1961), *Color Psychology and Color Therapy*, New Hyde Park, New York: University Books Inc

Birren, F (1973), "Colour preference as a clue to personality", *Art Psychotherapy* 1, 13–16

Briffault, R (1960), *The Mothers: A Study of the Origin of Sentiments and Institutions*, London: Macmillan

Brizendine, L (2006), *The Female Brain*, New York: Morgan Road Books

Brock, TC (1965), "Communicator-recipient similarity and decision change", *Journal of Personality and Social Psychology* 1, 650–54

Brody, L (1999), *Gender, Emotion and the Family*, Cambridge, MA: Harvard University Press

Brook, S (2006), "Women miss out on top advertising jobs", *The Guardian*, 25 January. http://www.guardian.co.uk/media/2006/jan/25/marketing andpr.advertising

Buchanan, R (1995), "Rhetoric, humanism and design", in Buchanan, R and Margolin, V (eds.), *Discovering Design*, Chicago: University of Chicago Press, 23–68

Byrne, D and Neuman, J (1992), "The implications of attraction research for organizational issues", in Kelley, K. (ed.), *Issues, Theory and Research in Industrial/Organizational Psychology*, New York: Elsevier

Cadwalladr, C (2005), "This advertising boss thinks women make 'crap' executives. It seems he's not alone", the *Observer*, 23 October: <http://observer.guardian.co.uk/focus/story/0,6903,1598649, 00.html

Cameron, D (2007), *The Myth of Mars and Venus*, Oxford: Oxford University Press

Cato, J (2003), "Used Vehicle Review: Chrysler PT Cruiser, 2001–2003", *Autos Canada*:
http://www.autos.ca/used-car-reviews/used-vehicle-review-chrysler-pt-cruiser-2001-2003/
(accessed on 29 August)

Consumer Electronics Association (2003), "What women really want in CE", *Vision* Jan/Feb:
<http://www.ce.org/print/1520_1864.asp

Duncan, C (1975), *The Pursuit of Pleasure: Rococo Revival in French Romantic Art*, New York: Garland

Economist (2008), "Internet overload: surviving the exaflood":
http://www.economist.com/node/12673221
(accessed August 12, 2012)

Erikson, EH (1970), *Childhood and Society*, Harmondsworth: Penguin

Eysenck, HJ (1941), "A critical and experimental study of color preferences", *American Journal of Psychology* 54, 385–94

Felger, R and Moser, M (1991), *People of the Desert and Sea: Ethnobotany of the Seri Indians*, Tucson: University of Arizona Press

Geary, D (1998), *Male, Female: The Evolution of Human Sex Differences*, Washington, DC: American Psychological Association

Gladwell, M (1997), "See me feel me touch me buy me", the *Independent*:
http://www.independent.co.uk/life-style/see-me-feel-me-touch-me-buy-me-1276212.html
(accessed on 29 August 2013)

Gladwell, M (2000), *The Tipping Point: How Little Things Can Make a Big Difference*, New York: Little Brown and Company

Gombrich, E (1995), *The Story of Art*, 16th edition, London: Phaidon Press

Gray, J (1992), *Men are from Mars, Women are from Venus*, London: HarperElement

Groskop, V (2008), "Sex and the city", *The Guardian*, 19 September: http://www.theguardian.com/lifeandstyle/2008/sep/19/women.planning
(accessed on 28 August 2013)

Gunn, R; Azzopardi, S and Moss, G (2007), *The Advertising Effectiveness of Maltese Banks*, Kingston: Academy of Marketing

Halpern, D (2000), *Sex Differences in Cognitive Abilities*, Hillsdale, NJ: Lawrence Erlbaum Associates

Hammer, EF (1980), *The Clinical Application of Projective Drawings*, Springfield: Charles C Thomas

Handley, A and Chapman, CC (2012), *Content Rules*, John Wiley and Sons

Hines, M (2004), *Brain Gender*, New York: Oxford University Press

Hirschman, EC (1993), "Ideology in consumer research, 1980 and 1990: a Marxist and feminist critique", *Journal of Consumer Research* 19 March, 537–55

Holland, S, "Home Depot pursues women": http://www.she-conomy.com/41/home-depot-pursues-women accessed on 28 August 2013

Hooper-Greenhill, E (2013), *Museums and Their Visitors*, Routledge

Horwood, K (2010), *Gardening Women: Their Stories from 1600 to the Present*, London: Virago Press

Hume, D (1987), "Of the Standard of Taste", Part I, Essay XXII, in Miller, Eugene F. (ed.) *Essays – Moral, Political, and Literary*. Revised edition, Indianapolis: Liberty Fund, Inc

Hurlbert, A and Ling, Y (2007), "Biological components of sex differences in color preference", *Current Biology* 17 (16), 623–25

Hurlock, EB (1943), "The Spontaneous Drawings of Adolescents", *The Journal of Genetic Psychology* 63, 141–56

Hyde, JS (2005), "The gender similarities hypothesis", *American Psychologist* 60 (6), 581–92

Igbaria, M and Parasuraman, S (1997), "Status report on women and men in the IT workplace", *Information Systems Management* 14:3, 44–54

Iijima, M; Arisaka, O; Minamoto, F and Arai, Y (2001), "Sex differences in children's free drawings: A study on girls with congenital adrenal hypoplasia", *Hormones and Behavior* 40, 99–104

Ingalhalikar, M; Smith, A; Parker, D; Satterthwaite, T; Elliott, M; Ruparel, K; Hakonarson, H; Gur, R; Gur, R and Verma, R (2013), "Sex differences in the structural connectome of the human brain", *Proceedings of the National Academy of Sciences of the United States of America*, Published online before print, http://www.pnas.org/content/early/2013/11/27/1316909110. abstract

(accessed on 7 December 2013)

Jameson, KA; Highnote, SM and Wasserman, LM (2001), "Richer color experience in observers with multiple photopigment opsin genes", *Psychonomic Bulletin and Review* 8, 244–61

Johnson, P (2003), *Art: A New History*, London: Weidenfeld and Nicolson

Jolles, I (1952), "A study of the validity of some hypotheses for the qualitative interpretation of the H-T-P for children of elementary school age. I. Sexual identification", *Journal of Clinical Psychology* 8, 113–18

Jordan, T (2012), "Maximising the Effectiveness of Advertising for Female Markets", in *Lessons on Profiting from Diversity*, ed. G Moss, Basingstoke: Palgrave Macmillan

Kant, I (1978), *Critique of Judgement* (Translated by JC Meredith), Oxford: Clarendon Press

Kelly, G (1955), *The Psychology of Personal Constructs*, New York: WW Norton

Kerschensteiner, G (1905), *Die Entwicklung der zeichnerischen Begabung*, Munich: Gerber

Kimura, D (1992), "Sex differences in the brain", *Scientific*

American 267, 119–225

Lavie, T and Tractinsky, N (2004), "Assessing dimensions of perceived visual aesthetics of web sites", *Journal of Human-Computer Studies* 60, 269–98

Ling, Y; Robinson, L and Hurlbert, A (2004), "Colour preference: Sex and culture", *Perception* 33, 15–45

Luthar, H (1996), "Gender differences in evaluation of performance and leadership ability: Autocratic vs. democratic mangers", *Sex Roles* 35:5–6, 337–61

Maccoby, E (1998), *The Two Sexes: Growing Up Apart, Coming Together*, Cambridge, MA: Harvard University Press. Discussion of her acceptance speech is published online at http://www.apa.org/monitor/oct00/maccoby.html (accessed on 17 September 2013)

Maeda, J (2006), *The Laws of Simplicity*, Cambridge, MA: MIT Press

Majewski, M (1978), *The relationship between the drawing characteristics of children and their sex*, unpublished doctoral dissertation, Illinois State University

Marketing Week (2000), "Report shows women still poorly represented in ad industry": http://www.marketingweek.co.uk/report-shows-women-still-poorly-represented-in-ad-industry/2016959.article (accessed on 28 August 2013)

Massey, R (2013), "'Make cars women actually want to drive': Motor boss says firms should design cars suitable for high heels and with comfy seats": http://www.dailymail.co.uk/sciencetech/article-2341775/Nissan-boss-warns-firms-design-cars-suitable-high-heels-comfy-seats.html, 13 June (accessed on 29 August 2013)

McCarty, S (1924), *Children's Drawings: A Study of Interests and Abilities*, Baltimore: Williams and Wilkins Company

McCrone, J (2002), "Tetrachromats", *The Lancet Neurology*, 1 (2),

136, June, see
http://www.thelancet.com/journals/laneur/article/PIIS1474-4422(02)00051-0/fulltext
(accessed 14 September 2013)

Midgley, C (2006), "Lobal Warfare", *The Times*, 9 August, available from:
http://www.timesonline.co.uk/article/0,,7-2303878.htmlv
(accessed 16 September 2011)

MORI (2000), "Branding Strategy for Museums and Galleries":
http://www.insights.org.uk/articleitem.aspx?title=Branding+Strategy+for+Museums+and+Galleries
(accessed on 13 August 2013)

Moss, G (1996a), "Assessment: Do Males and Females make Judgements in a Self-selecting Fashion?", *Journal of Art and Design Education* 15:2, 161–9

Moss, G (1996b), "Gender and consumer behaviour: Further explorations", *Journal of Brand Management* 7:2, 88–100

Moss, G (1999), Gender and consumer behaviour: Further explorations, *Journal of Brand Management*, 7 (2), 88-100

Moss, G and Colman, A (2001), "Choices and preferences: Experiments on gender differences", *Journal of Brand Management* 9 (2), 89–98

Moss, G and Gunn, R, (2006a), Some men like it black, some women like it pink: consumer implications of differences in male and female website design, *Journal of Consumer behaviour*, 5 (4), 328-341

Moss, G; Gunn, R and Kubacki, K (2006b), "Angling for beauty: Commercial implications of an interactive aesthetic for web design", *International Journal of Consumer Studies* 3 (1), 248–57

Moss, G (2007), "Psychology of performance and preference: Advantages, disadvantages, drivers and obstacles to the achievement of congruence", *Journal of Brand Management* 14 (4), 343–58

Moss, G; Hamilton, C and Neave, N (2007), "Evolutionary factors

in design preferences", *Journal of Brand Management* 14 (4), 313–23

Moss, G and Gunn, R (2008), "Gender and web design: The implications of the mirroring principle for the services branding model", *Journal of Marketing Communications* 14 (1), 37–57

Moss, G (2009), *Gender, Design and Marketing*, Farnham: Gower

Moss, G and Gunn, R (2009), Gender differences in website production and preference aesthetics: preliminary implications for ICT in education and beyond, Behaviour and Information Technology, 28 (5), 1362-3001

Moss, G (2010), "Variety is the Spice of Life: How Design Diversity Can Enhance Profitability", in *Profiting from Diversity*, Basingstoke: Palgrave Macmillan

Moss, G (2010), "Design Diversity: The Organisational Obstacles", in *Profiting from Diversity*, Basingstoke: Palgrave Macmillan

Moss, G (2012), "Diversity and Web Design", *Lessons on Profiting from Diversity*, Basingstoke: Palgrave Macmillan

Most, H; van Onna, E and Webb, M (2006), "Hotter desks", *Observer*, 4 June,
http://www.theguardian.com/lifeandstyle/2006/jun/04/homes
(accessed on 10 January 2014)

Myerson, J (2008), *Workplace design: an introduction to workplace design*, see
http://webarchive.nationalarchives.gov.uk/20080821115857/
http://www.designcouncil.org.uk/en/About-Design/Design-Disciplines/Workplace-design/
(accessed on 28 August 2013)

Myerson, J and Ross, P (2006) *Space To Work: New office design*, London: Laurence King

Neave, N; Hamilton, C; Hutton, L; Tildesley, N and Pickering, A (2005), "Some evidence of a female advantage in object location memory using ecologically valid stimuli", *Human Nature* 16, 146–63

Neitz, M; Kraft, T and Neitz, J (1998), "Expression of L-cone pigment gene subtypes in females", *Vision Research* 38, 3221–5

Oeser, O (1931–32a), "Some experiments in the abstraction of form and colour", *The British Journal of Psychology* 32, 200–214

Oeser, O (1931–32b), "Some experiments on the abstraction of form and colour: Part II Rorschach tests", *The British Journal of Psychology* 32, 287–323

Ono, H and Zavodny, M (2003), "Gender and the internet", *Social Science Quarterly* 84, 111–21

Orth, U and Holancova, D (2004), "Men's and women's responses to sex role portrayals in advertisements", *International Journal of Research in Marketing* 21, (1) 77–88

Pahl, J (2000), "The gendering of spending within households", *Radical Statistics* 75 (Autumn)

Palmer, J (2002), "Website usability, design and performance metrics", *Information Systems Research* 13 (2), 151–67

Pease, A and Pease, B (2004), *Why Men Don't Listen & Women Can't Read Maps*, London: Orion Books

Peters, T and Waterman, R (2004), *In Search of Excellence*, London: Profile Books

Peters, T (2003, 2006), *Re-Imagine! Business Excellence in a Disruptive Age*, DK Publishing

Philips, L (2008), "B&Q aims to put women in positions of power", *People Management*, 20 March, 14

Pollock, G (2003), *Vision and Difference: Feminism, Femininity and Histories of Art*, London: Routledge Classics

Potter, E (1994), "WELL topic: Commercialisation of the World Wide Web", *The Internet Conference on the WELL*, 16 November

Power, M (2013), "Why do normal men turn sexist when they get in front of a barbecue?" *The Guardian*, 19 July: http://www.theguardian.com/commentisfree/2013/jul/19/barbecue-normal-men-sexist (accessed on 21 August 2013)

Putrevu, S (2004), "Communicating with the sexes. Male and

female responses to print advertisements", *Journal of Advertising* 33 (3) 51–62

Read, H (1953), *Art and Industry*, London: Faber and Faber

Reilly, D and Neumann, D (2013), "Gender-Role Differences in Spatial Ability: A Meta-Analytic Review", *Sex Roles* 68, 9–10, 521–535

Robertson, M; Newell, S; Swan, J; Mathiassen, L and Bjerknes, G (2000), "The issue of gender within computing: Reflections from the UK and Scandinavia", *Information Systems Journal* 11, 111–126

Rowlands, I; Parker, P and Scott, D (2002), "Consumer perceptions of 'green power'", *Journal of Consumer Marketing* 19 (2), 112–29

Ruddick, G (2013), "Tesco-Sainsbury's row draws battle lines for entire retail sector":
http://www.telegraph.co.uk/finance/newsbysector/retailand consumer/10216998/Tesco-Sainsburys-row-draws-battle-lines-for-entire-retail-sector.html, 1 August
(accessed on 17 August)

Schwarzer, M (2007), "Women in the temple: Gender and leadership in Museums", *Museum News*, (May/June) 56–64

Silverman, I and Eals, M (1992), "Sex Differences in Spatial Abilities: Evolutionary Theory and Data", in Barkow, J *et al* (eds.), *Evolutionary Psychology and the Generation of Culture*, New York: Oxford University Press

Silverman, I (2007), "Why Evolutionary Psychology?", *Acta Psychologica Sinica* 39 (3) 541–545

Silverman, I; Choi, J and Peters, M (2007), "The Hunter-Gatherer Theory of Sex Differences in Spatial Abilities: Data from 40 Countries", *Archives of Sexual Behaviour* 36, 261–8

Silverstein, M and Fiske, N (2003), *Trading Up: The New American Luxury*, New York: Portfolio Penguin Group

Silverstein, M and Sayre, K (2009), *Women Want More: How to Capture Your Share of the World's Largest, Fastest-Growing*

Market, New York: HarperCollins

Spry, C (1957), *Simple Flowers: A millionaire for a few pence*, London: Dent

Stilma, MDC (2008), "The influence of the designer's gender", *International Design conference – Design*, Dubrovnik, Croatia, May 19

Tyre, P and Scelfo, J (2006), "Why Girls Will Be Girls", *Newsweek*, 31 July: http:/www.newsweek.com/id/46204?tid=relatedcl (accessed 4 August 2008)

Van Iwaarden, J; Van der Wiele, T; Ball, L and Millen, R (2004), "Perceptions about the quality of web sites: A survey amongst students at Northeastern University and Erasmus University", *Information and Management* 41, 947–59

Von Radowitz, J (2013), "New study confirms the brains of men and women are wired completely differently": http://www.independent.ie/world-news/new-study-confirms -the-brains-of-men-and-women-are-wired-completely-differ- ently-29803083.html (accessed on 9 December 2013)

Warner, F (2005), *The Power of the Purse*, New York: Pearson Prentice Hall

Washburn, SL and Moore, R (2005), *Ape into Man*, Boston: Little Brown and Company

Weernink, W (2007), "Industry should be more female-friendly", *Automotive News Europe*, 27 June: http://www.autonews.com/article/20070627/ANE01/7062 7005/industry-should-be-more-female-friendly#axzz2d UioMwk2 (accessed on 29 August 2013)

Weston, R (2002), *Villa Mairea: Alvar Aalto*, Phaidon

Whissell, C and McCall, L (1997), "Pleasantness, activation, and sex differences in advertising", *Psychological Reports* 81, 355–67

Witelson, S (2005), "Male, female and Einstein's brains"; http://infoproc.blogspot.com/2005/07/male-female-and-

einsteins-brains.html

Wittenberg-Cox, A and Maitland, A (2009), *Why Women Mean Business: Understanding the Emergence of Our Next Economic Revolution*, Chichester: John Wiley and Sons Ltd

Wong, M (2004), "Consumer electronics companies woo women: Women spent more on technology than men in 2003", 16 January:
<http://www.msnbc.msn.com/id/3966261

Van Wyk, G (1998), *African Painted Houses: Basotho Dwellings of Southern Africa*, New York: Harry N Abrams

Other books by GA Moss

Gender, Design and Marketing (2009)
Farnham: Gower

Profiting from Diversity (2010)
Basingstoke: Palgrave Macmillan

Lessons on Profiting from Diversity (2012)
Basingstoke: Palgrave Macmillan

Gender, Design and Marketing –
She's putting forth some game changing information that's
going to ruffle some feathers. But it's information we
desperately need... This book will change the way you look at
design. The results are a wake-up call for everyone involved in
advertising and design. I'm not talking just a little alarm clock.
I'm talking a gigantic gong reverberating around the globe...
I can't say enough about *Gender, Design and Marketing*...
the book is worth twice its price.
Holly Buchanan, Marketing to Women, US

This book should be mandatory reading for any advertiser
or designer who wants to improve their chances of selling their
products or services to a male, or female, audience. Great read.
Thomas Jordan, former Chairman and Chief Creative Officer
of HY Connect, US

This is an illuminating book... [which] makes a very positive
contribution to modern business needs and will be of interest
to marketers, designers, academics, and students of business
and design.
Catherine Canning, Glasgow Caledonian University, UK,
review in the *Journal of Marketing Management*

It uses rich data from different disciplines: psychology, neuroscience, communications, etc. The book provides convincing proof that gender differences are both biologically and sociologically rooted and, therefore, cannot be downplayed. It also presents a refreshing alternative to the overwhelmingly popular social constructionist perspective.

Dr Tarnovskaya, Lund University, Sweden

The research in this book is top notch and I see this book becoming a standard for anyone who needs to understand the importance of designing for specific demographics. A must-read for marketers, advertisers, HR managers, and even game developers.

Bob Garlick, Book review, Canada

**PSYCHE
BOOKS**

The study of the mind: interactions, behaviours, functions.
Developing and learning our understanding of self. Psyche
Books cover all aspects of psychology and matters relating to
the head.